An Enduring Wilderness

TORONTO'S NATURAL PARKLANDS

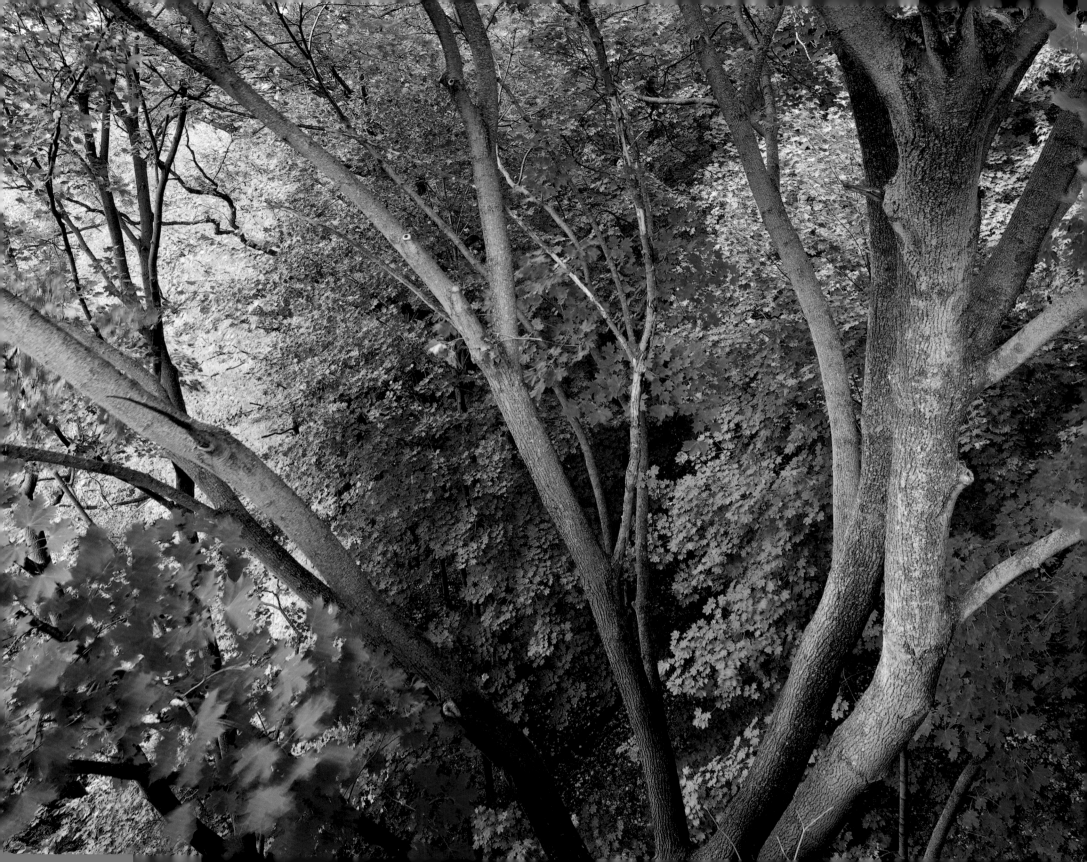

"Turn, look down: there is no city; this is the centre of a forest."

Margaret Atwood, 1970
The Journals of Susanna Moodie

Vale of Avoca from St. Clair Avenue Bridge, 2015

The publication of *An Enduring Wilderness: Toronto's Natural Parkland*s and an accompanying exhibition at the John B. Aird Gallery are supported by the City of Toronto.

The park and natural parkland data contained in this book was obtained and vetted courtesy of the Toronto Parks, Forestry, and Recreation and City Planning Divisions.

Some of the images contained in this book are part of a collection of images at the City of Toronto Archives.

The publication of *An Enduring Wilderness* has been generously supported by the Canada Council for the Arts, which last year invested $153 million to bring the arts to Canadians throughout the country, and by the Government of Canada through the Canada Book Fund. *Nous remercions le Conseil des arts du Canada de son soutien. L'an dernier, le Conseil a investi 153 millions de dollars pour mettre de l'art dans la vie des Canadiennes et des Canadiens de tout le pays. Ce livre est financé en partie par le gouvernement du Canada.* We also acknowledge the support of the Ontario Arts Council (OAC), an agency of the Government of Ontario, which last year funded 1,737 individual artists and 1,095 organizations in 223 communities across Ontario for a total of $52.1 million, and the contribution of the Government of Ontario through the Ontario Book Publishing Tax Credit and the Ontario Media Development Corporation.

Get the eBook free!*
*proof of purchase required

Purchase the print edition and receive the eBook free! For details, go to ecwpress.com/eBook.

Published by ECW Press
665 Gerrard Street East
Toronto, Ontario, Canada M4M 1Y2
416-694-3348 / info@ecwpress.com

Editor for the press: Jennifer Knoch
Author photo: Ryan Walker

Library and Archives Canada Cataloguing in Publication

Burley, Robert, 1957-, photographer An enduring wilderness : Toronto's natural parklands / photographs by Robert Burley ; with writing by Anne Michaels, Michael Mitchell, Alissa York, George Elliott Clarke, Wayne Reeves, Leanne Simpson.

Issued in print and electronic formats.
ISBN 978-1-77041-379-5 (hardback) also issued as: 978-1-77305-039-3 (pdf)
978-1-77305-038-6 (epub)

1. Urban parks—Ontario—Toronto.2. Urban parks—Ontario—Toronto—Pictorial works. 3. Wilderness areas—Ontario—Toronto. 4. Wilderness areas—Ontario—Toronto—Pictorial works. 5. Toronto (Ont.)—Pictorial works.

I. Title.

FC3097.65.B87 2017 971.3'54100222
C2016-906413-1 C2016-906414-X

PRINTED AND BOUND IN CANADA

PRINTING: FRIESENS 5 4 3 2 1

MIX
Paper from responsible sources
FSC® C016245

Photographs by Robert Burley

An Enduring Wilderness
TORONTO'S NATURAL PARKLANDS

With writing by: **ANNE MICHAELS**

MICHAEL MITCHELL

LEANNE BETASAMOSAKE SIMPSON

ALISSA YORK

GEORGE ELLIOTT CLARKE

WAYNE REEVES

ECW Press | Toronto

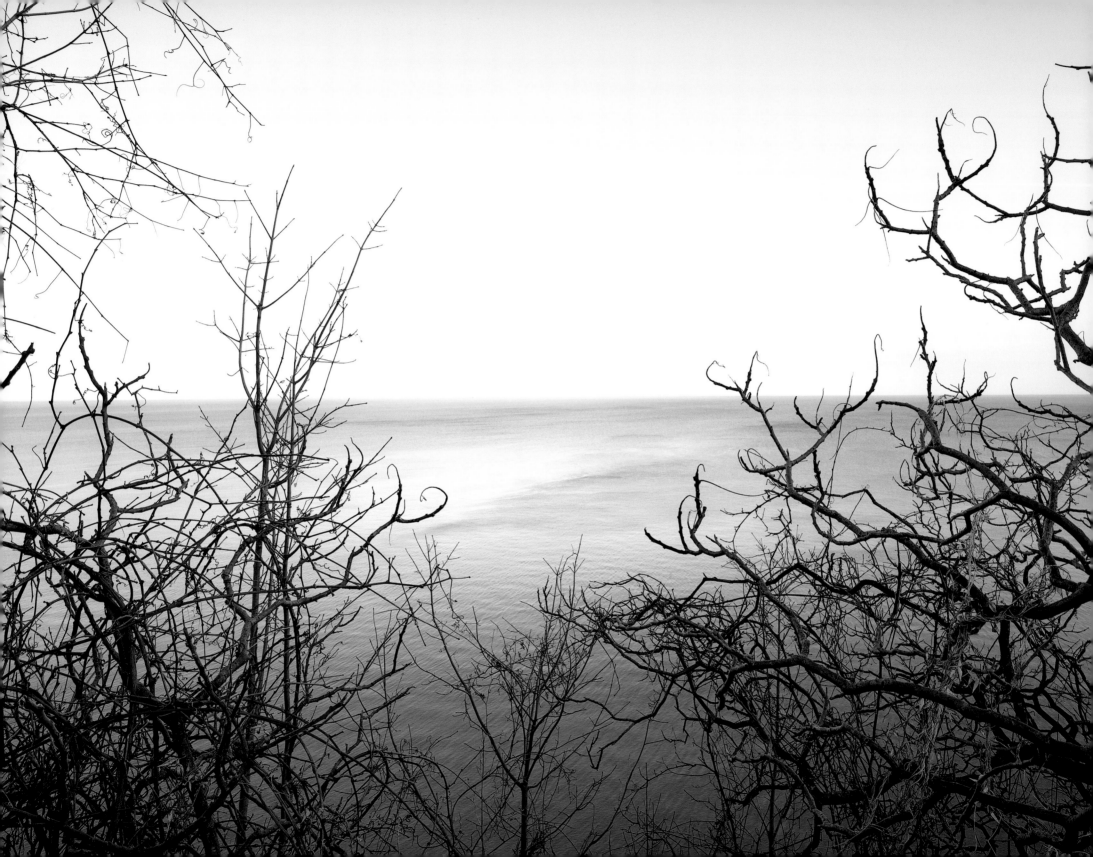

TABLE OF CONTENTS

8 Foreword by Mayor John Tory

9 Introduction by Janie Romoff & Jennifer Keesmaat

11 *Going There to Be There* by Robert Burley

15 Toronto's Natural Parklands

17 **SHORELINE The Lake Ontario Waterfront**

33 *Please, Birds* | Anne Michaels

61 **RIVER The Humber River Valley**

63 *Petting the Bunny* | Michael Mitchell

101 **CREEKS and Lost Rivers**

102 *Life by Water* | Leanne Betasamosake Simpson

119 **VALLEY The Don River Valley**

121 *The Animal Part* | Alissa York

167 **FOREST The Rouge River Valley & Highland Creek**

183 *Navigating the Rouge (Park[s])* | George Elliott Clarke

221 *Imagining, Creating, and Sustaining Toronto's Natural Parklands: A Short History* by Wayne Reeves

231 Appendix | Toronto's Natural Parklands: Environmentally Significant Areas (ESAs)

262 Acknowledgements

263 Contributor Biographies

View of Lake Ontario from Cudia Park, 2013

FOREWORD

Toronto is built around its natural features — ravines, parks, beaches, waterfront, and trails. They give our city unique physical character and identity and shape how our city grows.

When I was a kid, we took the greatest joy from our visits to the Don Valley Ravine. We were just steps from my grandmother's home in East York, but out in the bush we thought we were on a wilderness adventure. We somehow ignored the traffic crossing and the bridges that loomed several stories up. This experience is accessible to millions — Toronto's natural parklands are our shared escape.

We have not always celebrated our parklands or talked about the important role they play for our residents, our resilience, and our quality of life. I want to put these areas in the spotlight and find ways to allow Toronto residents to get to know and experience what I call the physical soul of the city.

With his stunning photographs, Robert Burley showcases the wonders of these sometimes hidden and remote wilderness spaces within our parkland system. Commissioned by the City of Toronto, this book chronicles the landscapes of our city and brings to light the ways wilderness weaves into our urban fabric. Photographs of the four seasons along with poetry and prose by George Elliott Clarke, Michael Mitchell, Anne Michaels, Leanne Betasamosake Simpson, and

Alissa York provide original, thoughtful material that I hope will expand our understanding and appreciation of our natural heritage. You will also find historical background and scientific information about Toronto's natural parklands and the extraordinary variety of plants and animals that share our city.

Our city's population is growing fast, and we must stay ahead of this growth. We must protect the green space we have while also creating new space and new opportunities for our residents to enjoy living and working in the city. To that end, we are moving forward on projects that connect communities to parklands — naturalizing the mouth of the Don River, helping to create Canada's first national urban park in Rouge Valley, and building on our ambitious plan for the Rail Deck Park.

The photographs in this book, which show the parklands in all of their complexity, remind us that we have a shared responsibility to protect and enhance these irreplaceable spaces. I hope these photographs will amaze you, as they did me, and confirm what some of you already know — that Toronto's natural parklands matter to our quality of life. I encourage everyone to experience our quiet green spaces in the heart of a big city.

Mayor John Tory
City of Toronto

INTRODUCTION

At a time when our city is undergoing unprecedented growth and change, we have a greater appreciation of nature in urban areas. From forests, marshes, and meadows to valley lands, ravines, and waterfront, this book documents Toronto's natural parklands and recognizes them as a key aspect of our city's liveability. They help to sustain life in the city, providing us places to nourish our bodies and our souls, supporting myriad plant and animal life, and cleaning and cooling our air and water. They are links to the unique setting and history of Toronto on the north shoreline of Lake Ontario and to a landscape more lightly touched by indigenous residents.

An Enduring Wilderness is part of a larger project to document Toronto's natural parklands at this pivotal time in Toronto's history. This book is also an outgrowth of an enormous range of activity that has taken place over the past few decades, including creating and restoring hundreds of hectares of parkland, building natural surface trails, designating almost a hundred environmentally significant areas, and developing plans to better care for natural areas in the future.

The images and texts that follow tell many stories and remind us why natural parkland is so important to our quality of life, especially as we face the challenges of urban intensification, competing priorities for public investment, and the effects of climate change. Planning for new great public spaces is essential, but we must also continue to invest in the protection and restoration of our natural parklands.

As our city grows, conversations about how to best experience these spaces must continue. The challenge lies in how to increase access to these places while ensuring that their natural qualities are protected and enhanced.

We are on the right track with initiatives such as the *Ravine Strategy* and the *Parks and Trails Wayfinding Strategy*, which will find ways to further increase resilience through environmentally sensitive design, while providing people with new opportunities to access these extraordinary landscapes.

The photographs in this book show the fragile beauty and diversity of our natural parkland. The images illustrate some places not as how we envision them or would like them to be, but as how they are today. They remind us of our shared responsibility to protect and nurture these spaces, and that we need to make them stronger and more resilient for the future.

The ongoing, passionate engagement with these parklands by City staff, our partners at the Toronto and Region Conservation Authority, and community organizations and individuals is just one sign of how much our natural parklands are valued. And it is our honour and collective duty to steward, celebrate, and protect them.

An Enduring Wilderness shows us that nature is a big part of Toronto's urban environment as well as a significant factor in the lives of those who live here. It is our hope these photographs inspire you to visit and nurture our natural parklands. And when you do, take with you the understanding that they are delicate and special places; use them with care, so they can be enjoyed for generations to come.

Janie Romoff
General Manager,
Parks, Forestry
and Recreation

Jennifer Keesmaat
Chief Planner &
Executive Director,
City Planning

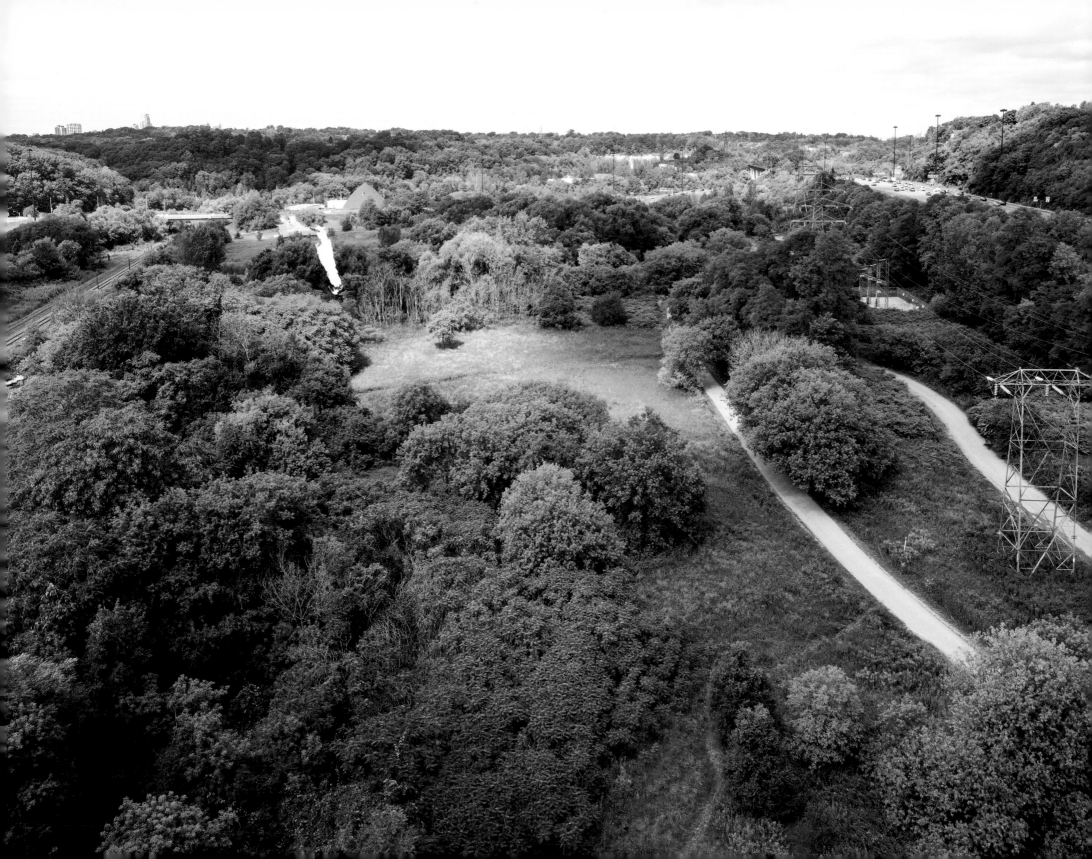

by Robert Burley

Going There to Be There

I look through my camera down into the Don River Valley. I'm standing on the north sidewalk of the Prince Edward Viaduct — more popularly known as the Bloor Viaduct — a bridge built between 1915 and 1918 to span the valley and connect Toronto's east neighborhoods to its downtown core. The traffic on the bridge is urban and frenetic; the valley floor, caught on my viewfinder 40 metres below, is natural and idyllic. I'm physically fixed in the city proper, but my mind is lost in the primal ravine, a lush green expanse with its own complex system of creeks and rivers extending for miles into the city in all directions. I'm standing in a spot I ought to know well: it's less than a ten-minute walk from my home and on a thoroughfare I cross and re-cross at least twice a day. Travelling "up here" my movement is constrained, like a chess piece, by the urban grid. "Down there" the travel restrictions are fewer, and more mysterious: I can wander, amble, meander, and explore.

I discovered the world below when I first moved to Toronto, in the 1970s. Since then, for most of my adult life, I've lived within a mile or two of it. From my present position I can see the spot where I began photographing for this project some four years ago. I'd parked my car on a service road just off the expressway entrance ramp to the northwest, and I'd headed with my camera into an open meadow dissected by footpaths leading toward the river. It was a warm day in August 2012, and I was wearing shorts and sneakers, which initially meant I was more than comfortable. Until, that is, I decided to step off the path and into an area overgrown with Manitoba maples,

dog-strangling vine and, of course, stinging nettles, another ubiquitous gift of the valley. In five minutes my calves were on fire with inflammatory histamines, but I didn't stop — I was so busy making photographs. After about 20 minutes I decided to take a break. I looked around me, and even up above me, but for the life of me I couldn't figure out where I'd come from. I tried walking 20 metres in one direction, but didn't recognize anything; I took a similar walk in the opposite direction — still nothing looked familiar.

I had no idea where I was. Or, rather, I knew exactly where I was: I was lost.

Not just lost, but lost in a place less than two miles from City Hall, and about a mile from my home of 25 years. The succession of responses I had to this fact was as interesting as they were disturbing: panic (I'm lost!), then disbelief (how the hell can I be lost?), and, finally, delight (I'm *lost*). And then, truly finally: I have been here before. As a child growing up in small-town eastern Ontario, I'd experienced this kind of short-term displacement on a hundred hikes through the woods — this uncanny knowledge that the wilderness was perpetually on my doorstep. To rediscover this as an adult was somehow even more uncanny. When I was "lost" in the woods as a child, the magnitude of my secret was modest: I was surrounded by a population of 4,000 people — at most — who were unaware of the adventure they were missing. Now, "lost" in the Don Valley four decades later, there were three million captive people who had no idea of the magical freedom a stone's throw away from them.

It was the perfect disconnect.

View of Lower Don Parklands from Prince Edward Viaduct, 2016

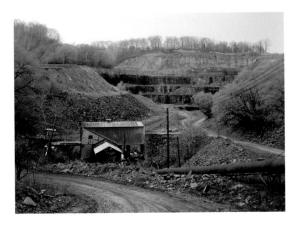

Don Valley Brick Works, 1983

Over the last 25 years, numerous areas in the parkland system have been re-naturalized. The image above shows the Brick Works as an active industrial site in the early 1980s and the image below shows the recently opened park on the same site.

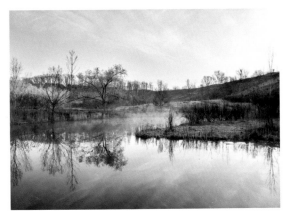

Don Valley Brick Works Park, 2016

During the intervening four years, my dozens of photographic rambles have been defined by two perspectives: the view looking down into the vast tracts of Toronto's green space, and the view from an explorer's eyes. It has been a study in surprise. Though a long-time resident of Toronto, I was progressively more astonished by the extent to which the city I live in was shaped by nature.

The surprise started at my first meeting with the project team from the City of Toronto Planning and Parks, Forestry, & Recreation departments. I was presented with a list of 86 sites, which were "limited" to just the wild or re-wilded parts of the parklands. After a quick scan of the list, I realized I hadn't visited over two-thirds of them. No great worry, I thought. I had all kinds of written information, along with traditional maps, not to mention satellite imagery and wayfinding apps. I was certain my photographic task would be a straightforward one that could be completed with time and effort. However, I'd neglected to account for the overwhelming scale and complexity of the parklands. Making landscape photographs requires an awareness that's only acquired by walking and exploring, a process that in turn demands time and attention, two of the scarcer commodities in today's world. Google Earth views don't really help when your subjects, like the rivers of Heraclitus, are never the same twice. There is a reason Ansel Adams once described landscape photography as "the supreme test . . . leading to the supreme disappointment." And I was about to explore and document the equivalent of approximately 30 Central Parks, many of which had been fragmented

and interwoven into residential, industrial and high-density developments over an area of 630 square kilometres. The ravines, Robert Fulford writes in his book *Accidental City*, "are to Toronto what canals are to Venice and hills are to San Francisco. They are the heart of the city's emotional geography." But Fulford also writes, "Torontonians have difficulty seeing their environment. We look at it in pieces and fail, through inattention, to see it whole."

Connecting this disconnection, seeing the city environment "whole," is what the book is, hopefully, about. It comes at a time, when, as landscape historian John Stilgoe puts it, our technology-driven propensity for "tuning out" the natural and even physical world is spiking. Mind you, it could be argued that Torontonians have been tuning out the natural world for close to half a century. In the 1970s and the early '80s parkland areas were still being described by city politicians and planners as "space left over after planning." They were seen as inconveniences: Their natural forms stubbornly refused to conform to the urban grid. "Nature" at the time was supposed to be accessed either through the city's smaller, formally designed parks — or via a two-hour drive north to cottage country.

While the digital age has seduced some into tuning out the landscape, others, especially urbanites, have found refuge in nature. Over the last 25 years, as more of Toronto's parklands have become enclosed by dense urban development, they have simultaneously become active Arcadian retreats for those residents living close, and not so close, to them. In response, city planners have started to connect the parkland areas with new multi-use trails

and bridges, and to provide new street access points to areas previously described as impenetrable. Paradoxically, neglect might have forced Toronto's ravines to adapt and even thrive. Toronto today enjoys one of the largest urban tree canopies in North America and has possibly the greatest access to inner-city landscape experiences of any city on the continent. Contrary to my wishful daydream on that warm August day four years ago, I was not really the only person enjoying the ravine magic. Nudge a native Torontonian, and you will find stories of childhood play involving woods, creeks, and rivers in the ravines — secret places that were all their own, as mine were.

One such Torontonian was conservationist Charles Sauriol, who formed a deep bond with the parklands long before they were known as such. Sauriol's lifelong relationship with the ravines began when he was an east-end kid exploring Taylor Creek in the early 20th century. He wrote extensively about his experiences with the 45th troop of the Boy Scouts who took him camping in the upper Don Valley, visiting boy-mythic places like the Big Hill, the Pine Wood, and the Swimming Hole. (We had a Big Hill and a Pine Woods in our town, too.) As an adult, he purchased a small cabin at the fork of the Don River and became Toronto's weekend Thoreau. Except Sauriol found his Walden Pond *inside* the city. Over a period of some 40 years, Sauriol not only wrote about the ravines, but became a major

advocate for their importance to the fabric of Toronto. He researched their history and meticulously identified myriad species of plant life and birds; he even undertook tree-planting programs to re-forest parts of the hillsides close to his cabin.

Sauriol recognized the importance of the parklands long before planners referred to them as "green infrastructure" or economists had assigned urban trees a monetary value for their role in energy savings and improvement of air quality.

Landscape architect Frederick Law Olmsted, the designer of Central Park in New York, once called urban forests "the lungs of a city." Charles Sauriol would have gone further. He would have described Toronto's ravines not only as lungs, but also as the city's heart and lifeblood. For Sauriol the parklands weren't ancillary to the city, they *were* the city. He wrote, "As the years go on and the population increases, there will be need of these lands and more; and in life where so much appears futile, this one thing will remain."

Having spent four years witnessing the therapeutic magic of the ravines he treasured, I can better appreciate his statement "I would just go there to be there." I hope that this book does its small part in encouraging people to venture out on a warm summer afternoon or a bracing winter morning, to descend a few hundred metres from home, step off the grid, and do the rarest, most valuable thing any urban dweller can do in the course of his or her distracting life: Get lost.

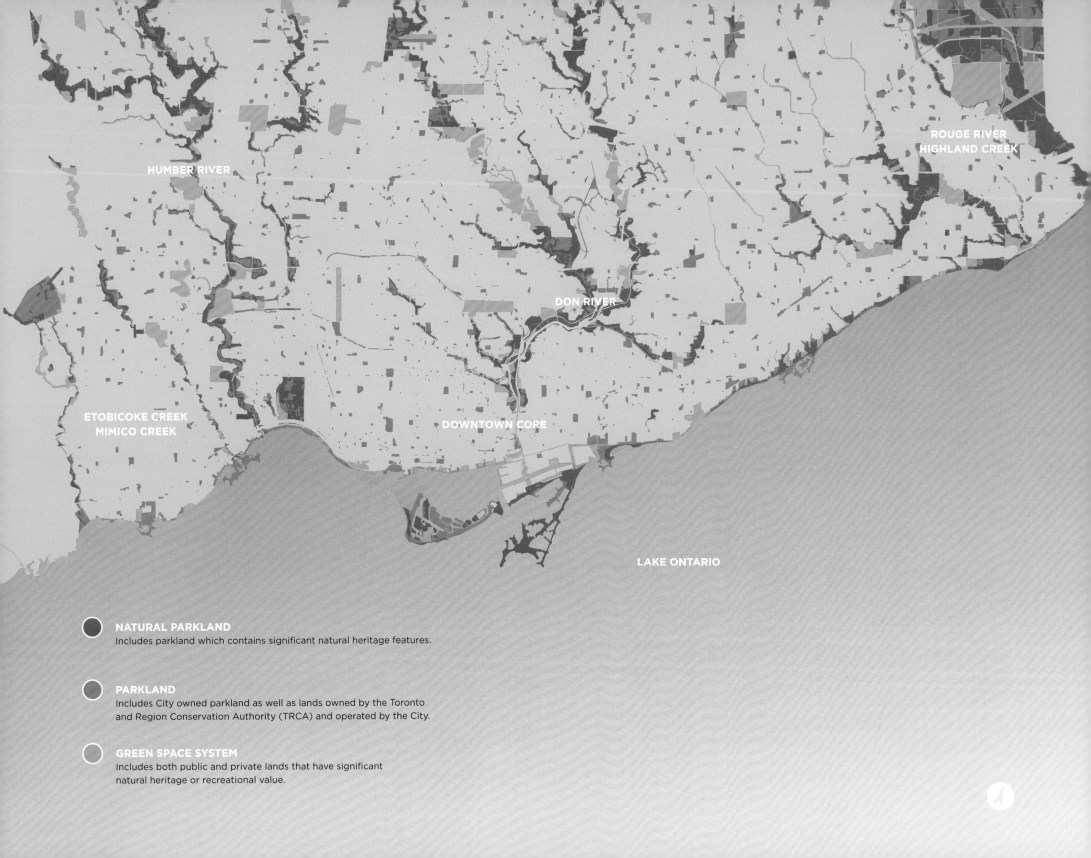

ROUGE RIVER
HIGHLAND CREEK

HUMBER RIVER

DON RIVER

ETOBICOKE CREEK
MIMICO CREEK

DOWNTOWN CORE

LAKE ONTARIO

NATURAL PARKLAND
Includes parkland which contains significant natural heritage features.

PARKLAND
Includes City owned parkland as well as lands owned by the Toronto
and Region Conservation Authority (TRCA) and operated by the City.

GREEN SPACE SYSTEM
Includes both public and private lands that have significant
natural heritage or recreational value.

Toronto is unique in terms of the size and scope of its natural parklands. Approximately half of the City's 8,110 hectares of parkland is natural. These natural parklands form an extensive web of green space that reaches almost every neighbourhood. Everywhere from the furthest corners of the urban grid to deep in the downtown core, Toronto residents have access to a variety of natural landscapes, including forests and wetlands, beaches and bluffs, and creeks and rivers. Many of these parklands contain extensive walking and cycling trails, outstanding viewpoints, interpretive signage, and historic sites.

Most of the natural parklands are owned by the Toronto and Region Conservation Authority (TRCA) and are managed by the City of Toronto for park, recreation, and conservation purposes. Adjacent lands are owned and managed by the City, TRCA, public agencies, or private landowners. With a population of 2.8 million and projected growth expected to reach 3.4 million by 2041, Toronto's natural parklands are taking on new importance to Toronto residents as the city manages the ongoing challenge of increasing use and urbanization.

"As the years go on and the population increases, there will be need of these lands and more, and in life where so much appears futile, this one thing will remain."

Charles Sauriol

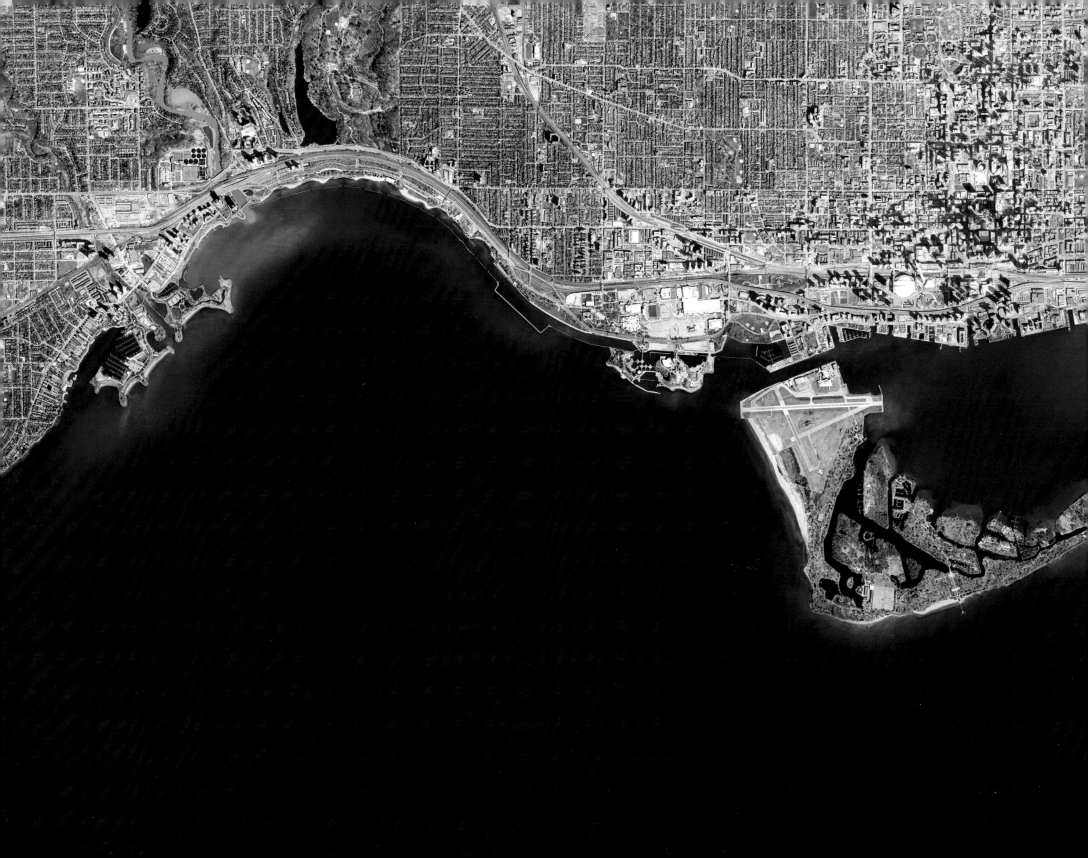

Bluffs Sequence
(Cudia, Cathedral Bluffs, Bluffers, Scarborough Bluffs Parks)

Cherry Beach — Clarke Beach Park

Colonel Samuel Smith Park

East Point Park

High Park

Leslie Street Spit & Tommy Thompson Park

Sylvan Park — Gates Gully

Toronto Islands
(Centre Island Meadow, Hanlan's Beach, Wards/Mugg's/Snake/Algonquin Islands)

Shoreline

THE LAKE ONTARIO WATERFRONT

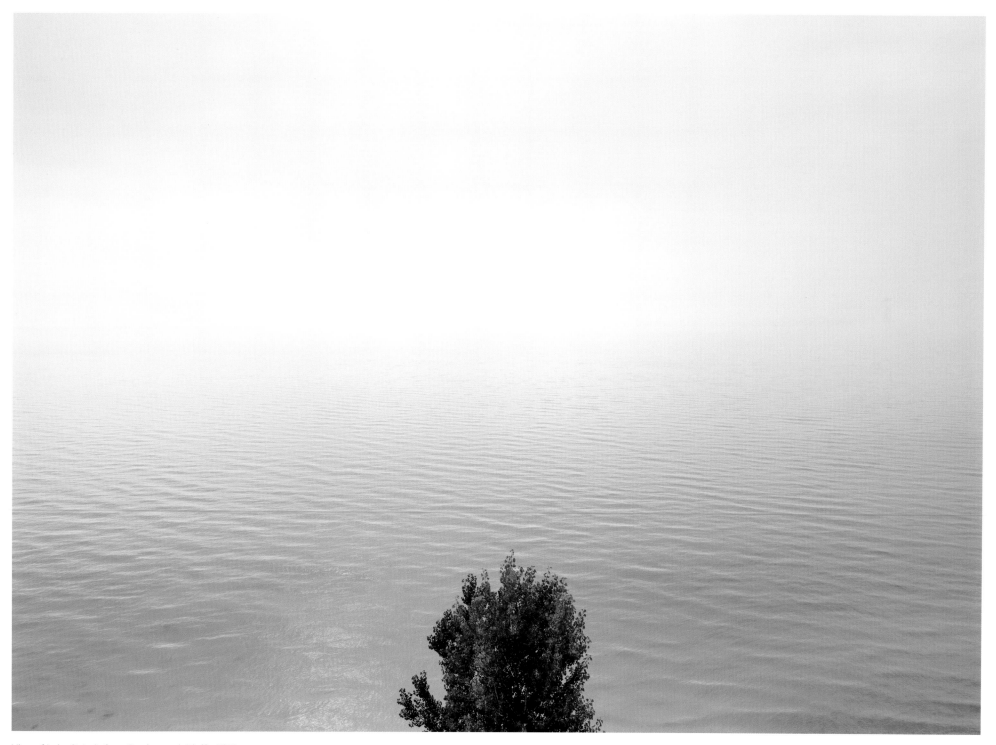

View of Lake Ontario from Scarborough Bluffs, 2013

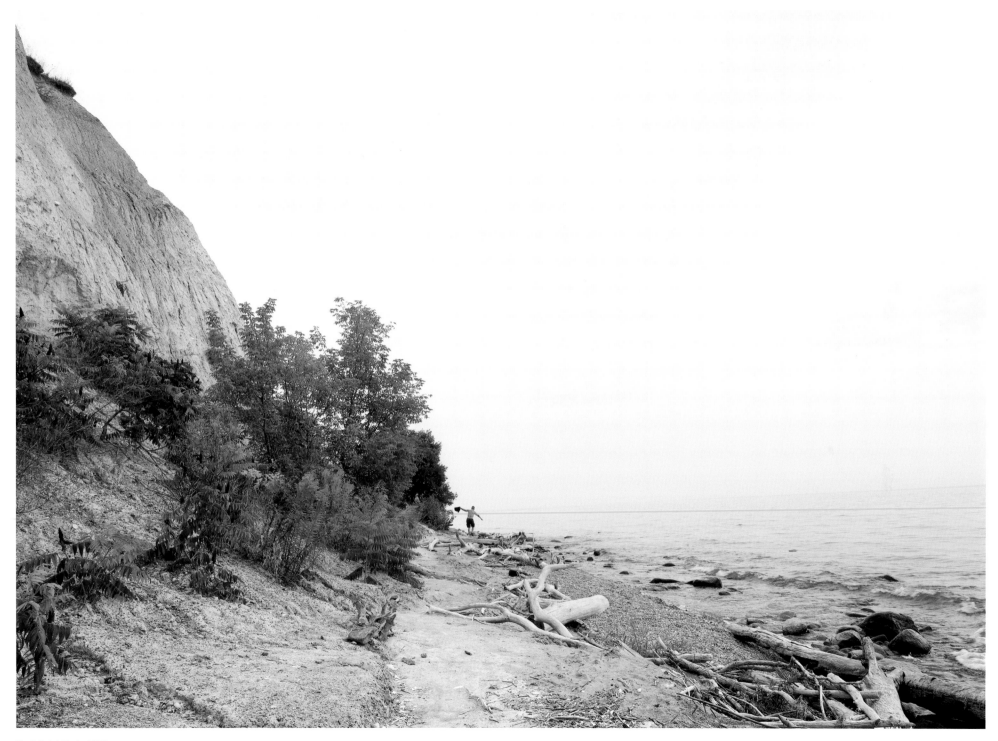

East Point Park, 2016

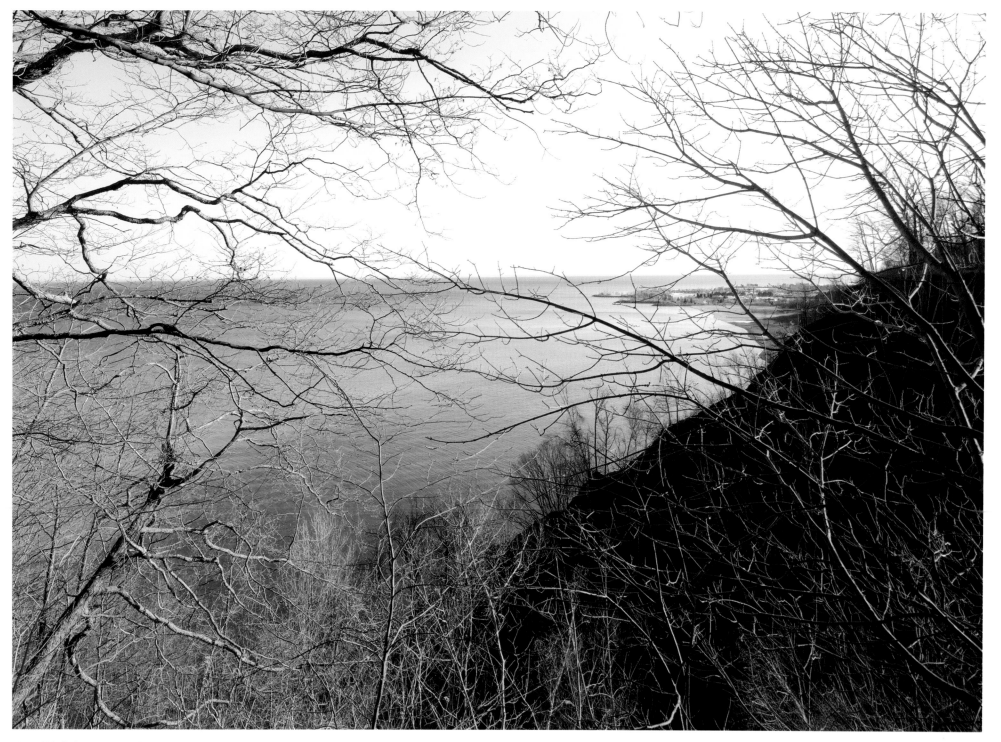

View of bluffs from Cudia Park, 2014

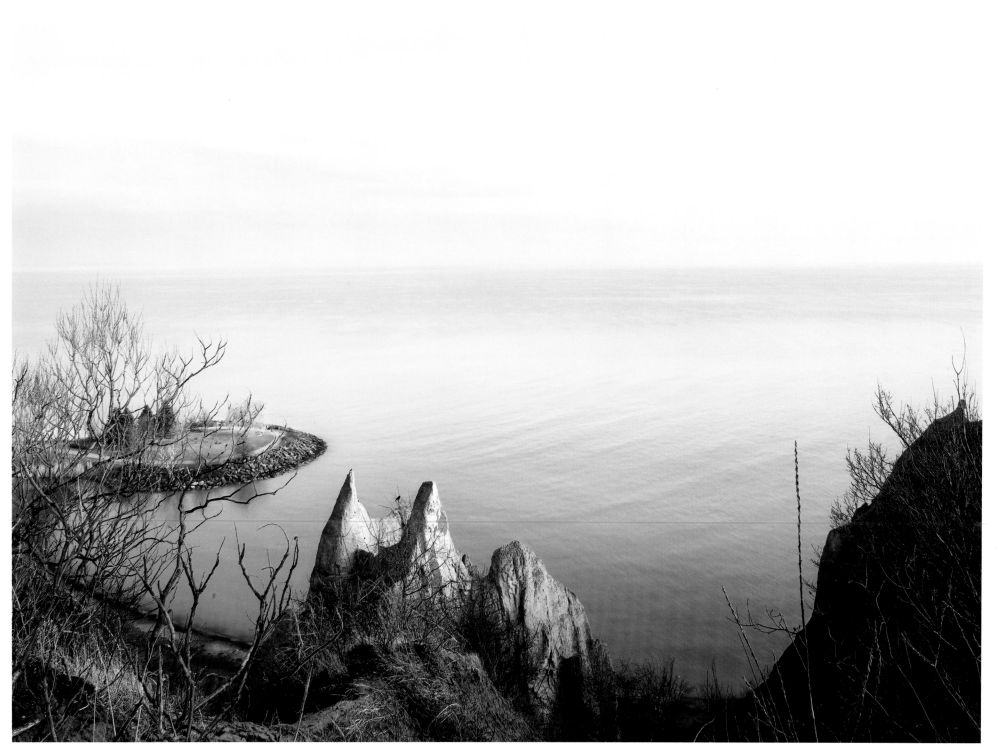

Scarborough Bluffs Park, 2014

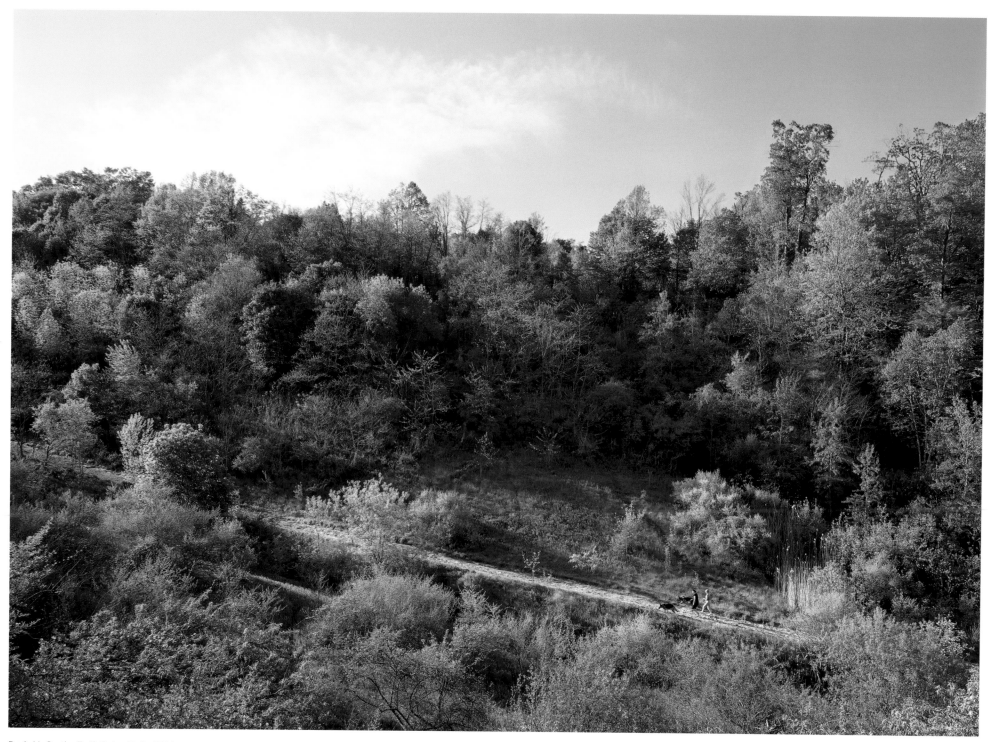

Doris McCarthy Trail, Gates Gully, 2014

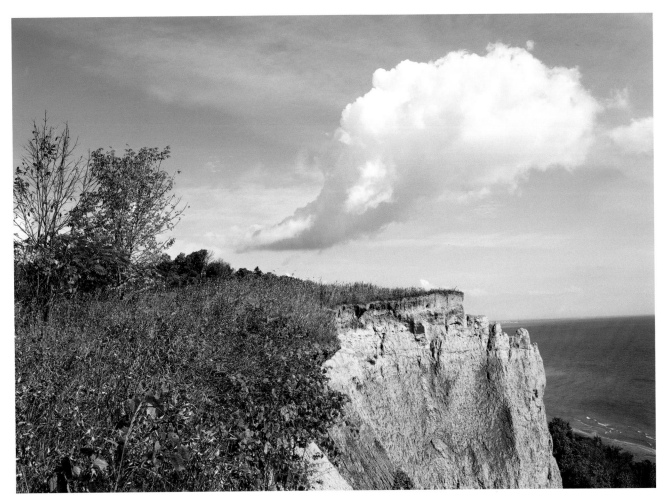

Cloud over Cathedral Bluffs, 2014

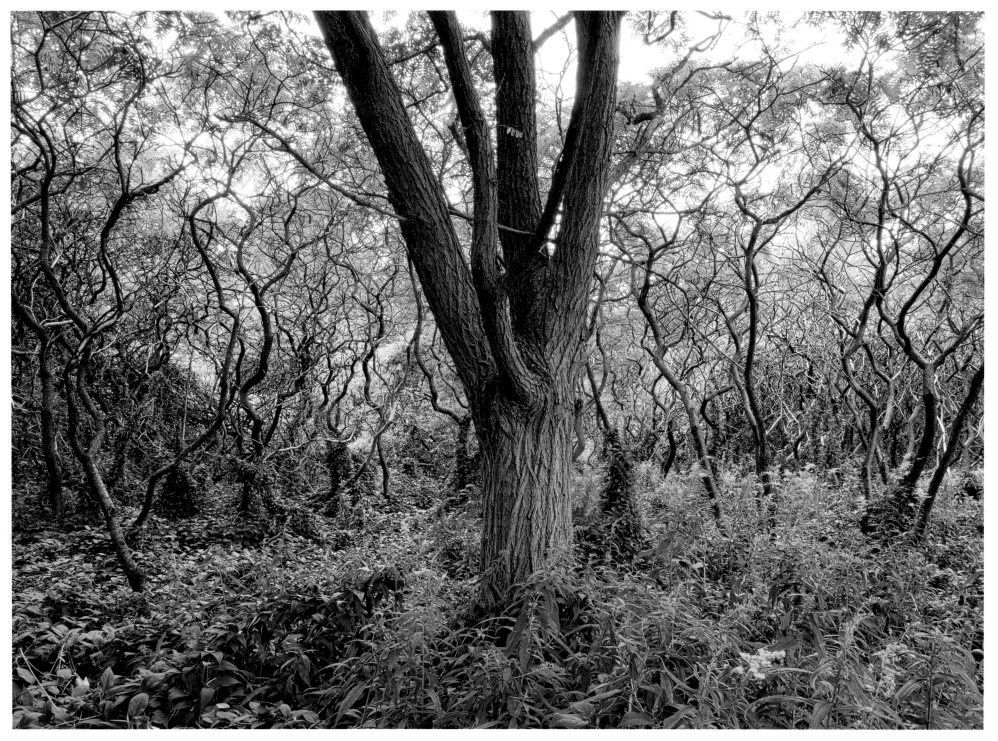

Black locust among sumacs, Sylvan Park, 2013

Bluffer's Beach, 2013

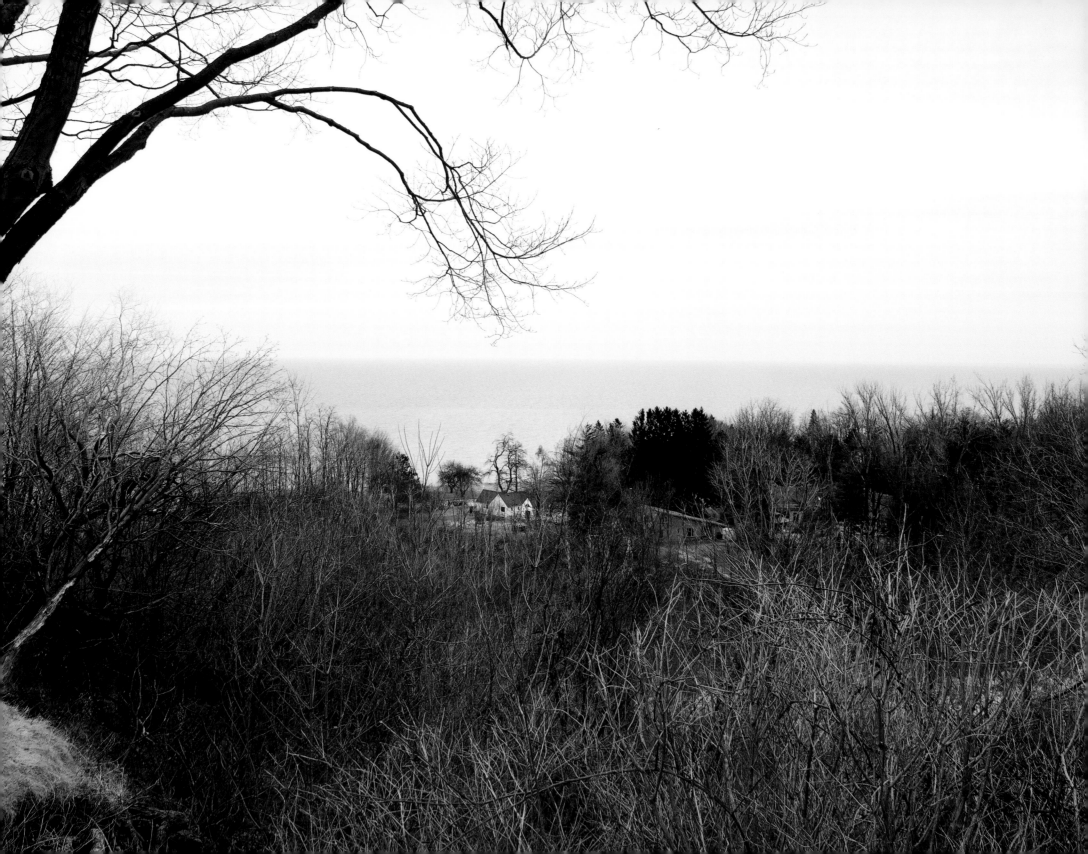

by Anne Michaels

Please, Birds

"I'm too excited tonight to bear it alone. Today I went crashing around in the weeds and thorns and burrs and ended up in a heavenly spot, twelve acres on a corner between the bluffs and a great lovely ravine . . . Height! Woods! Lake! Please, birds."

Doris McCarthy: My Life

Slip between the quiet houses, dart among the trees. The trail follows the stream, the stream cuts through the ravine, the ravine cuts through the bluffs, descending through a core sample of Toronto geology, a core sample of memory, to the lake.

It is when the tunnel of trees begins to open — a ragged notch letting in the sky — that we begin to hurry. We run downhill, the lake swelling across the horizon with every step.

The trail through Bellamy Ravine is named for the Toronto painter Doris McCarthy, who built her house and studio nearby, overlooking Lake Ontario. One can easily imagine what this shore must have meant to her. A lesson in looking, and in opening one's heart again and again to a place. This area — the ravine and the surrounding shoreline, including the parks Cudia, Cathedral Bluffs, Sylvan, Bluffer's, Scarborough Bluffs, and Gates Gully — was known to her from childhood expeditions with her father. They explored together, canoeing and camping along this wild margin whose meaning was inseparable from those adventures, that bond. A daughter taking in, and learning, what her father loved.

She bought land above the lake and built a cottage and, later, a studio. She christened the cottage in defiance, triumphantly adopting as its name her mother's disapproving judgment: Fool's Paradise. She bought the land for her future, for the possibility of love, for being her father's daughter, for her work.

When we emerge from the trees of Bellamy Ravine, we can follow the lakeshore east or west — a glorious walk on a cool windy day, the wind refreshed from having travelled so far across open water. A massive metal sculpture, *Passage*, marks the place where the trail emerges from the woods, so that, after a long walk along the waterfront, one can easily find one's way back, slipping once more through the curtain of trees to the path, steeply uphill now of course, to reappear on a perfectly ordinary suburban residential street in Scarborough, as if nothing at all has happened, as if we hadn't just stepped back in time

View of Fool's Paradise (Doris McCarthy Home),
Gates Gully (Bellamy Ravine), 2014

millions of years, plunged and scaled the escarpment, and walked on the floor of ancient Lake Iroquois. And all this wonderful long afternoon, we have met along the way — a rare freedom in a city of millions — not a single soul.

I was a child on the shore of this lake half a century ago. It was a whole day's excursion then, out to the Scarborough Bluffs from downtown; and then, as now, a journey into quietude and the large view.

A great adventure — to stand on a lake bottom, to look up at a cliff edge that once was a beach, to experience the sheer drop into time.

In the heart of the city we can forget we live by water until, between office towers and city streets and trees, we are surprised yet again by that sudden gasp of blue. And then my impulse is always to head toward it, watching it spread across the skyline like a great certainty; the lake can't be ploughed over, filled in, made to disappear, like so much of the ever-changing urban landscape. It remains just as I remember, a solid distance, with the city crumbling away at its highest edge.

In the years I've lived here, Toronto has grown from a city of just over 300,000 to almost three million. Hurricane Hazel convinced city officials of the foolhardiness of building in the city's floodplains, and this land became many of our city's parks. Living for decades in a place, one experiences a particular vanishing; changes over many years accumulate, an idiosyncratic, affecting, lamina. Every

public building, every hidden café, every street corner where some of the most significant events of my life have occurred and where words were spoken that changed the course of my life in an instant, is now gone. But the green spaces, the ravines, the rivers and, of course, the lake, are pockets of memory still extant.

In the 1700s, moose and elk began to disappear from the Toronto area; in the 1840s began the decline of the gray wolf, and in the late 1800s the last sightings of the migrant panther. By the beginning of the last century, the cougar, wolf, bobcat, black bear, and northern river otter had all but disappeared.

And before these disappearances, were the woolly mammoth, the mastodon, the giant beaver, the "Subway Deer" — *Torontoceros hypogaeus* — and the muskoxen that roamed the tundra in Toronto during the last ice age.

Today, the bluffs and the surrounding parks and ravines hide, among other small mammals, the red fox; coyote; deer; cottontail rabbit; meadow vole; beaver; skunk; eastern chipmunk; the red, eastern gray and black squirrel; the rapidly declining groundhog; and the rapidly encroaching Virginia opossum. And many species of birds, including the falcon, the red-tailed hawk, the blue heron, and the extraordinary sight of the bank swallows tunnelling with their beaks, wings, and claws into the soft cliffs, boring out burrows for their nests in the bluffs.

"Even in the city," wrote Ernest Thompson Seton in

1840, "the wild things came; they entered into my life in a way that startled those who were not so minded . . . I found joy in all these possibilities."

Toronto's parks, and its ravines and shore, are pathways allowing animals to move through and in and out of the city, asserting their habitat, encouraging biodiversity, and making possible the continued coexistence of animals and humans in the urban centre. One might argue that our parkland also makes possible the coexistence of humans with each other — necessary green space that contributes to our inner and outer well-being, and to managing pollution, climate, noise.

The parks are thick with Queen Anne's lace, nightshade, beech, oak, and willow. We follow the gushing spring stream, the sedate August flow, the thin black line through the snow.

The longing that vanishing incites — whether for species or landscape or the private map of one's own urban past — is also a longing for the intimation of the future. Childhood's great hope of time, its lifetime ahead; and our sense of the utterly new, the feeling of being shocked and alive, plunging headlong into experience. Perhaps the body never quite forgets this specific longing and that is why the lake always makes me want to run, straight into the hope of love, for that is what the past vouchsafes, no matter what age you are, no matter what form that love takes. And that is what time is: both the wound and the scar.

A sudden downpour, the dark tin of the lake battered by the rain, 17 or 18 years old, shocked awake, standing soaked to the skin on a crowded streetcar. Dripping from a dousing in the stream at the bottom of the ravine, six or seven years old, standing in the mud-stink, suddenly alive to time and the whole city above. Walking home from a night skate in the park, the great fact of love hurtling toward me in the January dusk, too cold for snow. The city parks, the lake, that careening forward.

Now, in the Bellamy Ravine, I run down the path with my children, in essence — impossibly — nothing lost, though I am also utterly, joyously, remade by my love for them. I pray they will know exactly this feeling, of not being afraid to run straight toward the future, and *to love as if we'd choose/even the grief*. May they know what it is to be soaked to the skin with love — for a time and for a place.

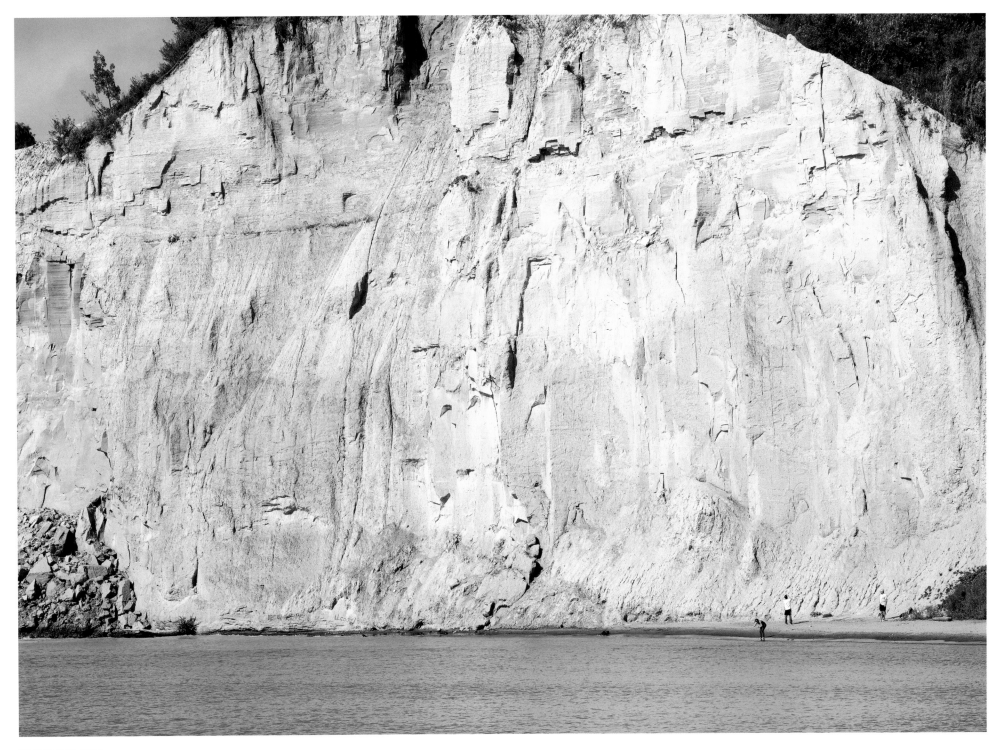

Bluffer's Park, 2013

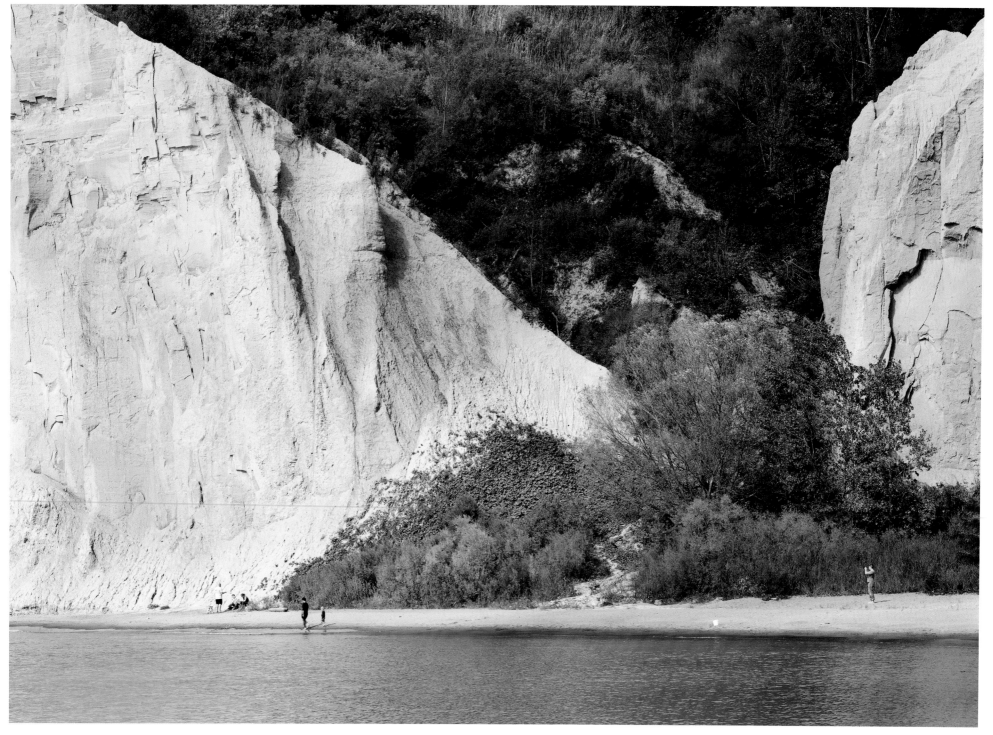

Bluffer's Park, 2013

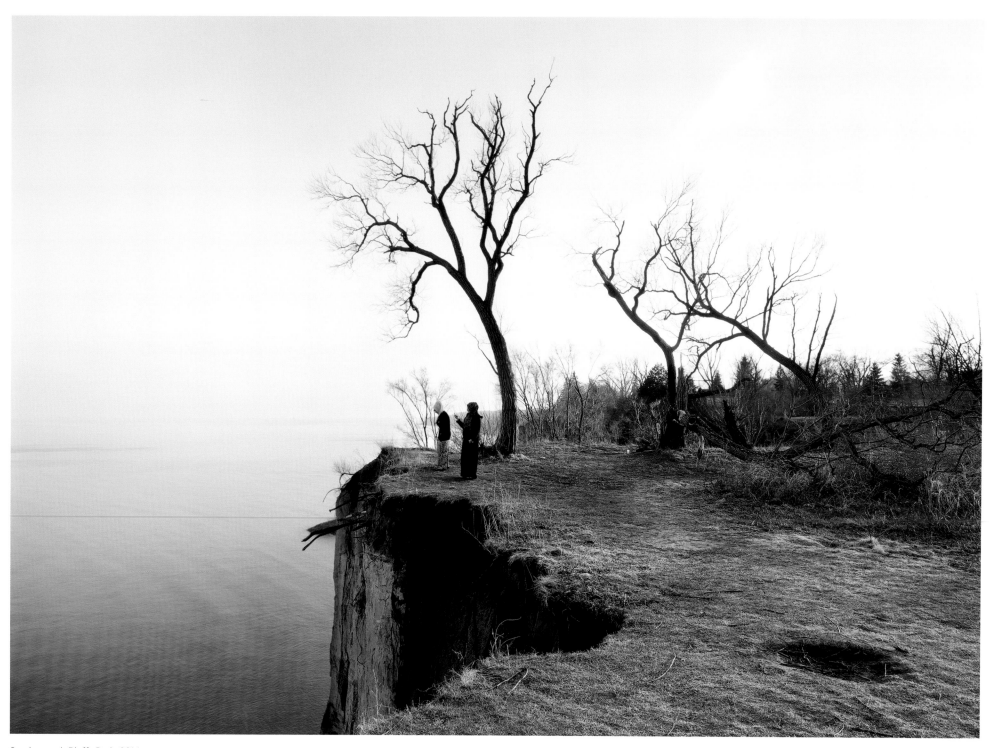

Scarborough Bluffs Park, 2014

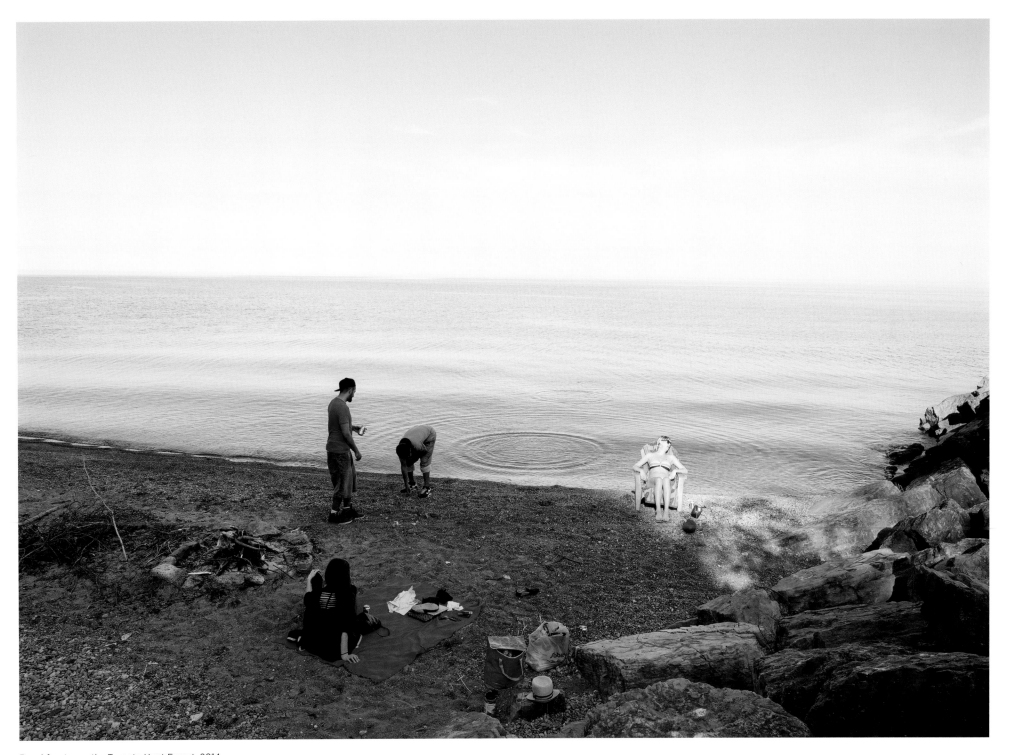

Beachfront near the Toronto Hunt Forest, 2014

Meadow, Tommy Thompson Park, 2014

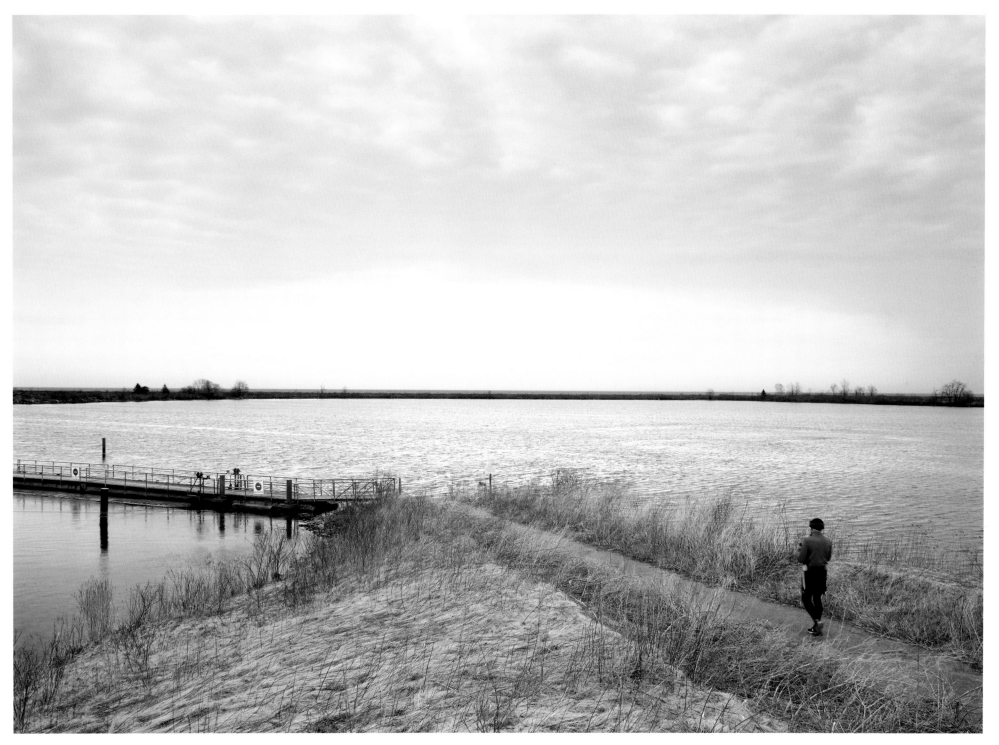

Jogger, Tommy Thompson Park Floating Bridge, 2014

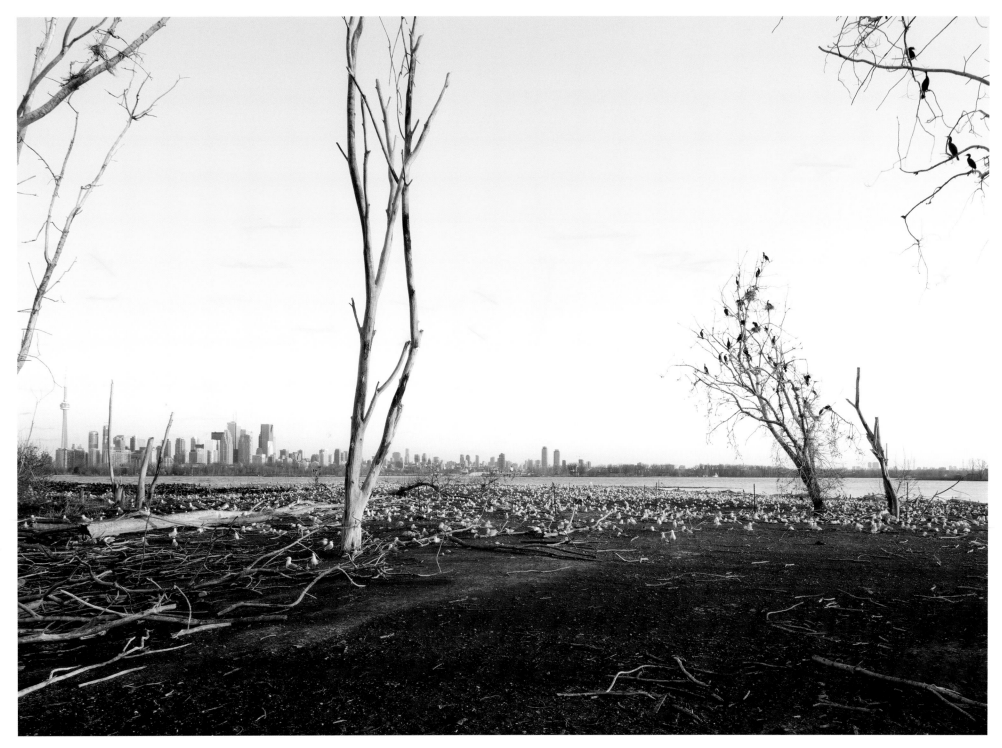

Cormorant nesting area, Tommy Thompson Park, 2014

Hanlan's Beach, Toronto Islands, 2014

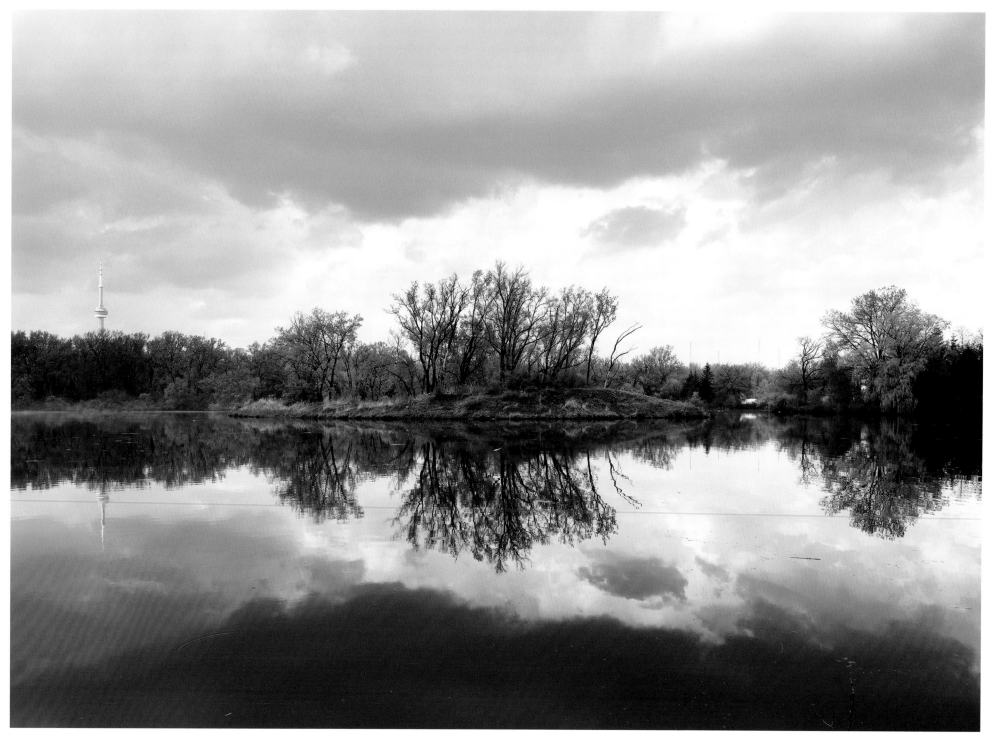

Hanlan's Island and Bird Sanctuary, Toronto Islands, 2014

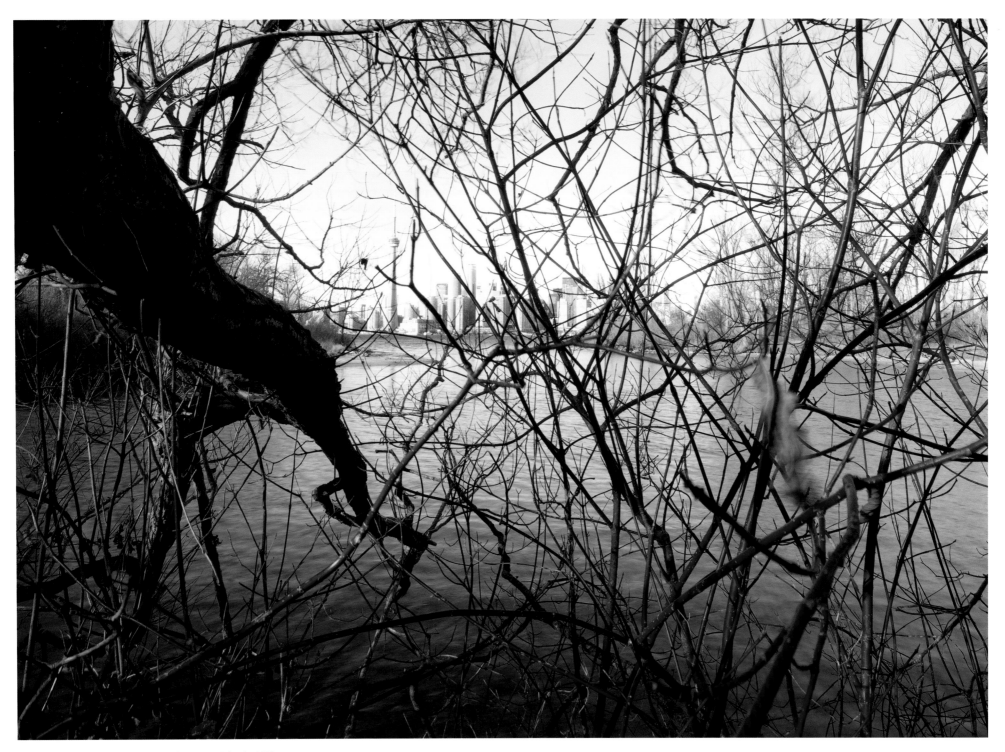

View of downtown from Ward's Island, Toronto Islands, 2015

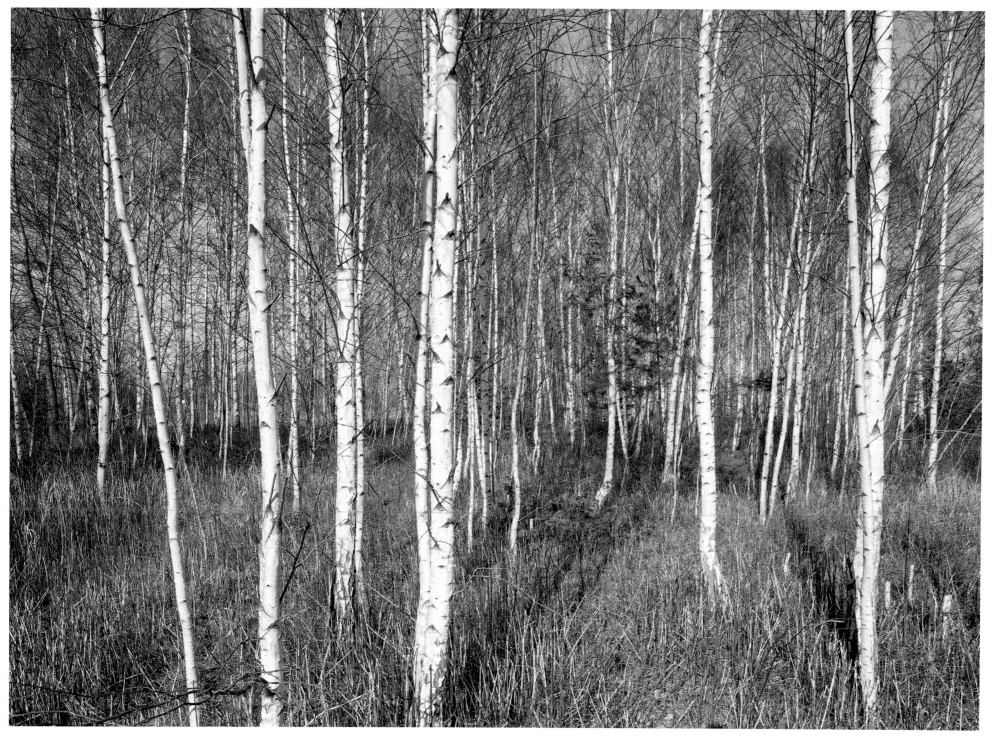

Birch trees, Ward's Island Park, Toronto Islands, 2015

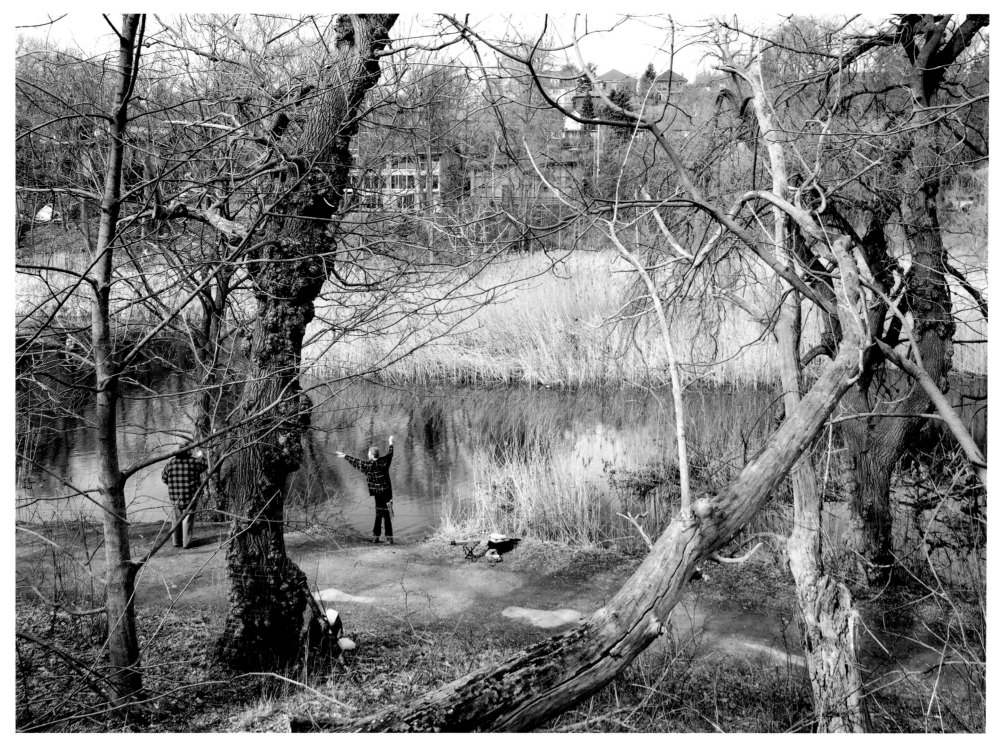

Fishing on Grenadier Pond, High Park, 2014

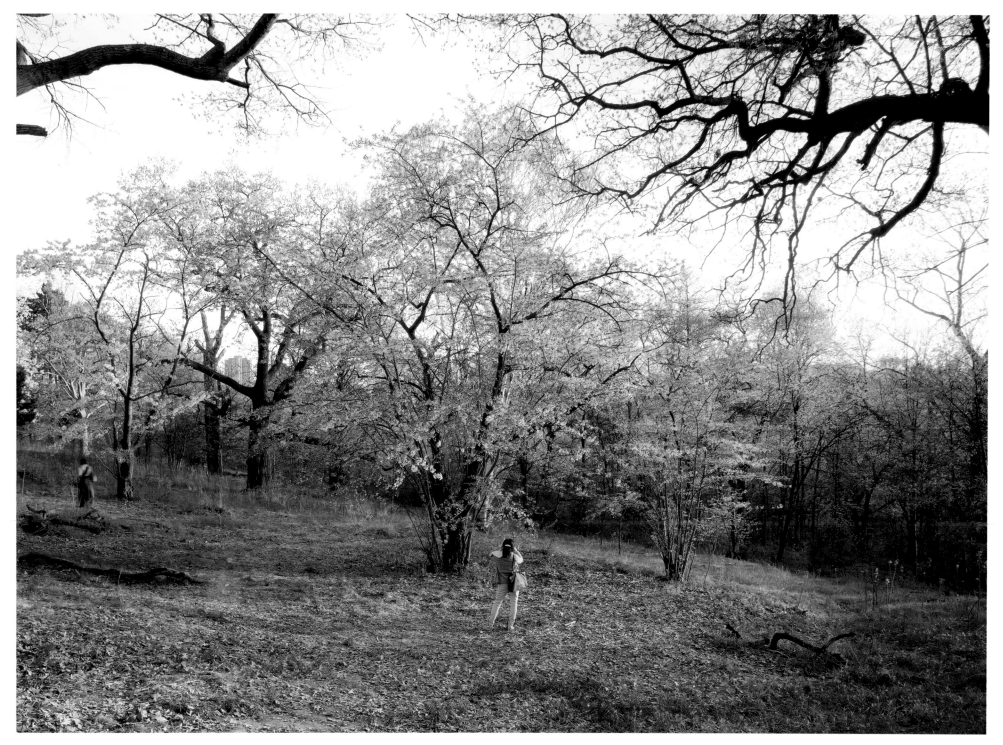

Cherry tree, High Park, 2013

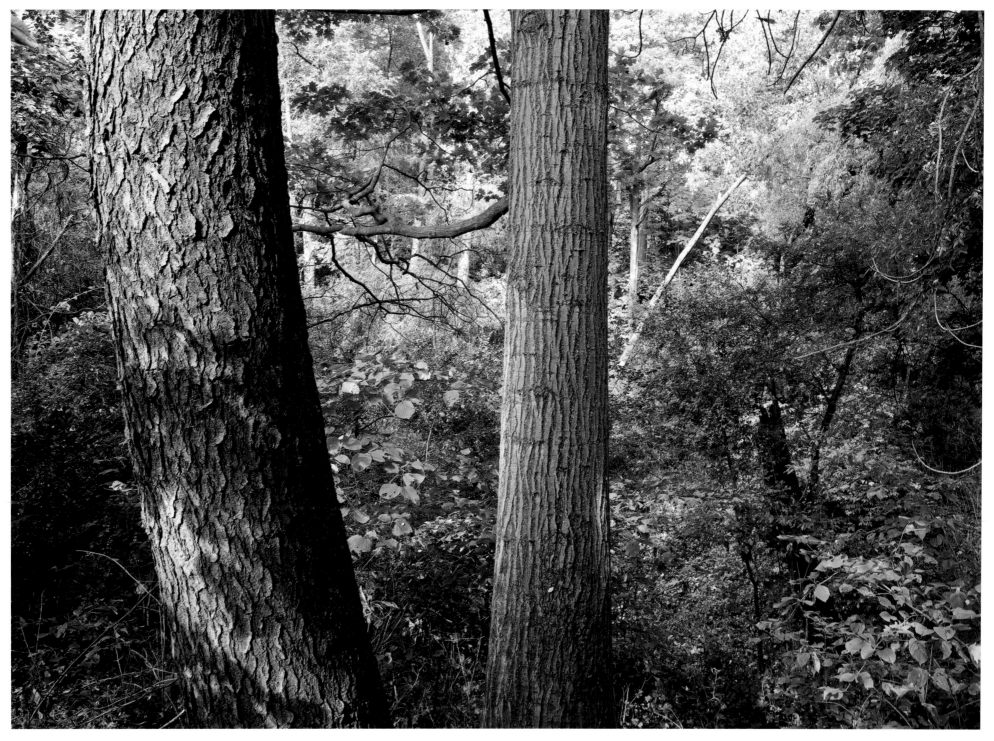

Forest behind Colborne Lodge, High Park, 2014

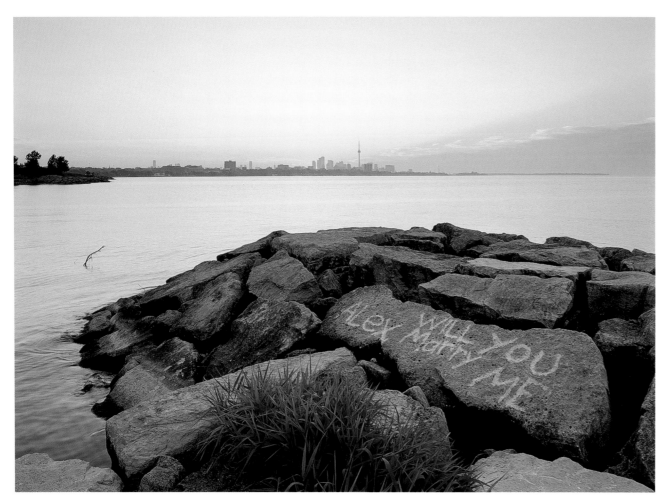

Marriage proposal, Humber Bay Park Trail, 2013

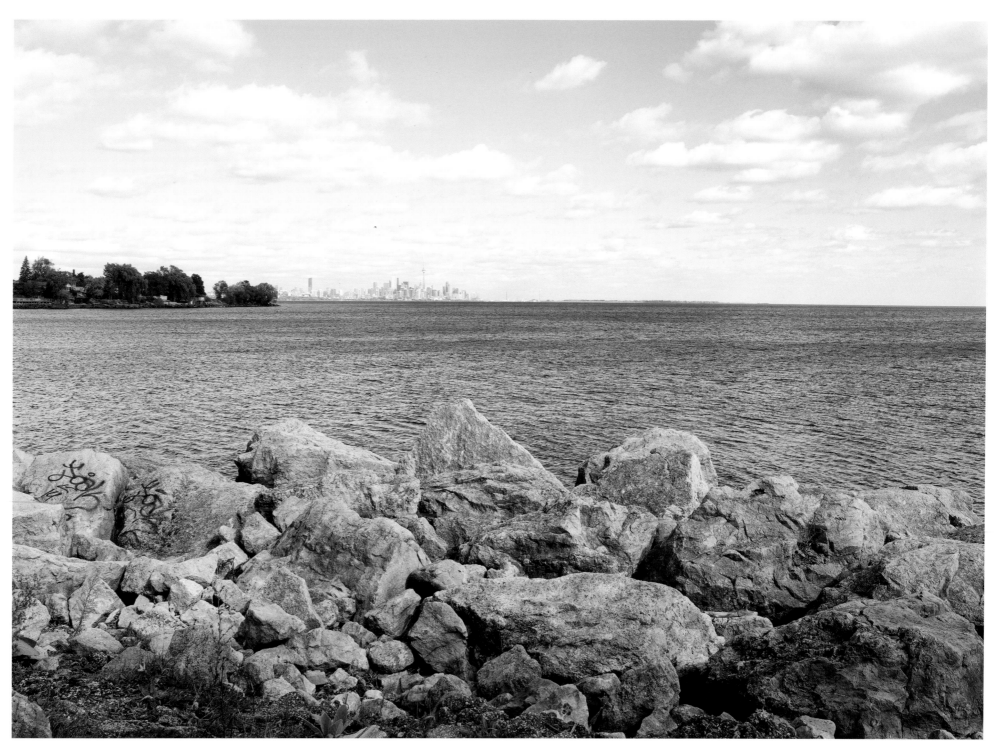

View of downtown from Colonel Samuel Smith Park, 2014

Chapman Valley Park

Home Smith Park

Humber Arboretum

Humber Marshes and South Humber Park

Humberview Park

King's Mill Park

Lambton Woods

Rowntree Mills Park

Summerlea Park

West Humber Parkland

River

THE HUMBER RIVER VALLEY

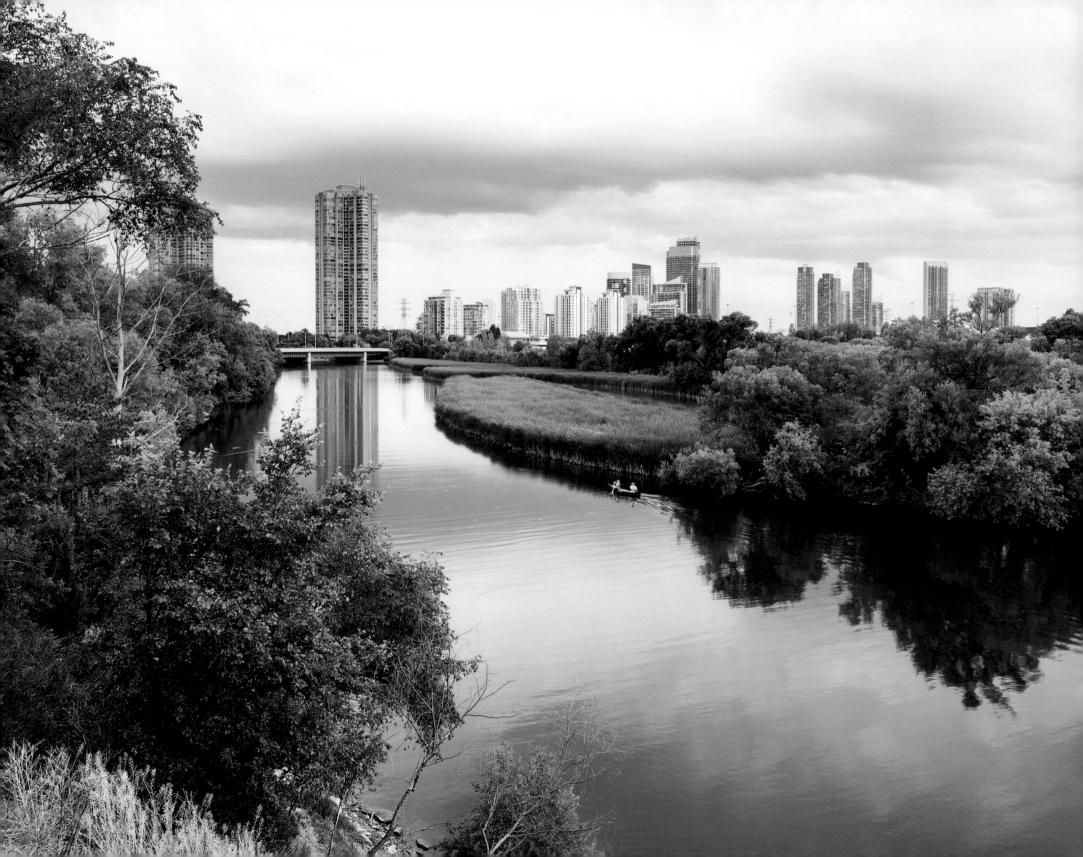

by Michael Mitchell

Petting the Bunny

1949

My grandmother holds my hand as we trudge up the Avenue Road Hill. Old DeWitt streetcars crawl up the far side of the road while the downtown-bound ones on the west descend with a shriek of brakes. We are ascending the ancient Lake Ontario shoreline because, like thousands of children before me and many thousands after, I want to pet the bunny.

Sir George Frampton and J.M. Barrie's bronze sculpture of Peter Pan and his various animal and fairy friends has lived since 1929 in a small park on the northwest corner of Avenue Road and St. Clair. The bronze statue is patinated dark green, but the little rabbit at his feet glows gold from the caresses of so many tiny hands. Glenn Gould Park, as it is now known, is among the smallest and least wild of all Toronto parks, but it was my introduction to the magic of those green islands relieving Toronto's great grey gridiron.

2014

My companion and I lift a pair of kayaks onto my van's roof and drive down to the beach west of the Sunnyside Bathing Pavilion. After a short carry we slip off into a mid-summer world of water. Five minutes of paddling and we turn north into the mouth of the Humber.

I used to do this often in the early 1990s. I'd put in three or four hours' work in my studio and then team up with one of several work-at-home women in my Dufferin Grove neighbourhood for a paddling lunch on the Humber.

We'd be back at work within two hours after a journey into another realm.

We enter the Humber through a proscenium of bridges. In less than a thousand feet there are ten, beginning with the Humber River Arch Bridge, a handsome cycle and pedestrian link between old Toronto and the newer suburbs to the west. It is the only bridge I have ever passed under that is as beautiful from below as it is from above. Next are several huge, engineered steel box spans that support Lake Shore Boulevard and the Gardiner Expressway to the north. Collectively they create a weird tunnel of limpid light that dances to the deep tom-tom beat of the heavy traffic overhead. The remaining bridges support streetcars, Go Trains, and The Queensway.

We emerge from their Stygian darkness into a wild wetland. Within a handful of minutes we have seen not only the familiar herring gulls, terns, and cormorants scouting the river mouth, but also night-herons, great blues, egrets, and turkey vultures. A few hundred feet upstream a kingfisher dashes through the tall stands of bulrush. I can hear red-winged blackbirds and see mallards chuffing along ahead of us as a small bush moves upstream in a muskrat's mouth. We swing around a river bend, and the city vanishes behind the high, forested banks. It's as if three million people have gone missing. We are travelling in the 400-year-old footsteps of Étienne Brûlé. It's easy to imagine the whispering footfalls of the Huron and the Neutral moving parallel to us on the Toronto Carrying-Place Trail.

Humber Marshes at the mouth of the Humber River, 2016

The Humber bubbles into life in a cold escarpment pond in Mono Township. On the way to the lowest Great Lake, it absorbs some 750 small streams. It is soon large enough to power a gristmill and many were built along its course, the first by John Graves Simcoe in 1797. All are now ghosts: the last one standing, Hayhoe Mills in Woodbridge, succumbed in 2008.

The Humber drains nearly a thousand square kilometres and does such a good job of it that when Hurricane Hazel hit on October 15, 1954, the great thunder of water racing down the Humber Valley took out entire bridges and streets, leaving 81 dead and a billion of today's dollars in damages. I remember driving in from Cooksville that mid-October with my father, and him failing repeatedly to cross the Humber as all the bridges were closed or out. Broken houses rumbled in a river of mud. Defeated trees and upended roots pleaded with grey skies. We finally got downtown via a Bailey bridge temporarily installed over the river.

As a result of that flooding the conservation authority was established and miles of the valley became public parklands. Hazel also gave us trees. The Humber Valley had been so deforested by the mid-20th century that the land had no capacity to hold water — hence the catastrophic flooding. Now small forests absorb rains and stabilize the banks. Despite her death and destruction, Hazel was also a gift and inspiration. She has given us miles of bike paths that snake up the river course and let us glide in and out of the light and cross and re-cross the river for 30 kilometres.

On my 2014 paddle up to Bloor Street my companion and I slip into an east side lagoon full of water lilies fenced in by cattails. House owners high above have small jetties at the water's edge and treehouses halfway down the hundred-foot banks. There's a beautiful cedar-strip canoe chained to a tree. Old men fish from the west side banks and the odd salmon jumps. The humble Toronto Humber Yacht Club presents its backyard jumble to the paddler not long before Bloor takes a steel leap over the valley and a plain Jane second bridge to the north transports the subway. A weir north of Bloor Street ends the voyage. The vigorous current swings my old boat around and sends me downstream toward home.

Much of the valley north of Bloor that I'm retreating from has had the conventional park grooming treatment — lawns, clustered plantings, paved trails, and access parking. It is south of Bloor that the valley is at its wildest. The Carolinian forest is reclaiming the steep banks on the east and the riverbank flats on the west. On this July day, I drift downstream through the bosky course surrounded by down from ducks, geese, and the many cottonwoods along both banks. The soft weedy species are leading the recovery as they do everywhere. Since nature is full of opportunists, the big guys, the hardwoods, are secretly waiting in the wings. If the lower Humber is left alone their day will come again.

There's a famous rephotographic project from the 1970s and '80s that sent American photographers out to precisely remake a large number of the classic American

West exploration pictures of the mid- and late 19th century. When the large plate views of Watkins, Jackson, Muybridge, and Weed were remade, the recovery from the logging and mining of the previous century was remarkable. Huge glacial valleys that had been completely deforested were now covered in trees. Time and weather had also somewhat naturalized piles of mine tailings and back-dirt. And here in Ontario, where the Huron had cut and burned much of the native forest for their corn fields and hunting meadows before Europeans arrived, there has since been a significant rewilding of huge tracts of southern parts of the province.

Although most of these recovering lands are in the greenbelt north of the city, those that give respite and comfort to the largest number of people are those within the greater city's limits. Imagine what it would be like for the tens of thousands of New Canadians warehoused in the high-rises of what *The Globe and Mail*'s Doug Saunders calls arrival cities — Thorncliffe Park and certain Scarborough neighbourhoods, for example — if they, unspoiled by inherited Muskoka cottages and Georgian Bay Islands, didn't have the ravine parks or the Rouge and Bluff Parks to retreat to on hot summer weekends.

One of the many Toronto put-downs in circulation is that it's a city with a physical setting that's boring and beige — no seven hills, sea-kissed peninsula, clifftop setting or mighty bisecting river. It's what British travel writer Jan Morris once called the "Flat City." When Torontonians rush to its defense, they invariably invoke its vast network of ravines. They are beautiful, and as we reclaim them for dog-walking and cycling we have also, ever since the founding of Harbourfront, been in the process of reclaiming the Great Lake into which they drain. We do have a coast, and it is there that we find what I believe is the city's most important physical feature, our Scarborough bluffs. Not only because of their commanding heights, three times that of Niagara Falls, and vivid witness to that great global topography-shaper, *erosion*, but also because they have given us the Toronto Islands, and indirectly, the Leslie Spit. The ravines are their mere prologue.

I've paddled Toronto's recovering wild places for over three decades. In that time I've been attacked by swans on the lower Humber, gasped at the Don's club-footed entry into the harbour, and almost been crushed in my kayak against the Cherry Street seawall by a Great Lakes bulk carrier. Many places I've had to stroke through garbage and fuel slicks. I used to paddle the Centre Island lagoons so often in the early '90s that I actually had trained a waiter at the restaurant near the bridge to bring a cold beer down to my kayak whenever I appeared. It's important to stay hydrated.

My first paddle of 2014 is a bracing Easter Sunday trip up the Rouge River from Lake Ontario to Kingston Road. While working upstream around a bend in that river, I encounter a down-bound canoe guided by two Indians — not members of our First Nations, but two guys from South Asia enthusiastically working on being Canadian. Stroking around some bends farther up that river, you can easily imagine being somewhere in Algonquin, the city is that hidden and the pines that tall.

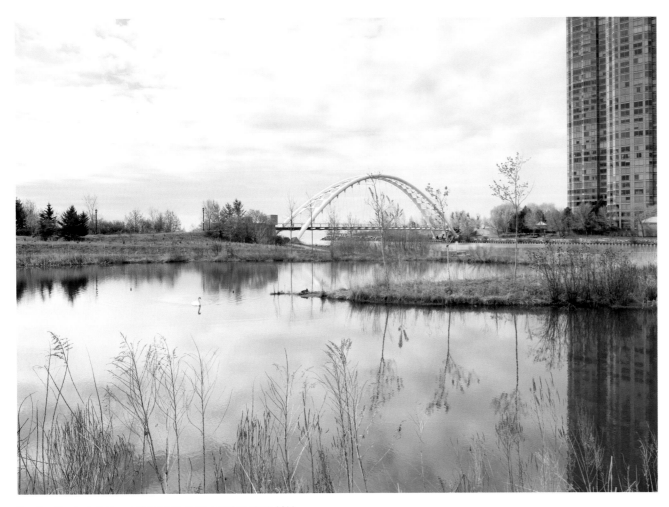

Humber Bay Arch Bridge at the mouth of the Humber River, 2014

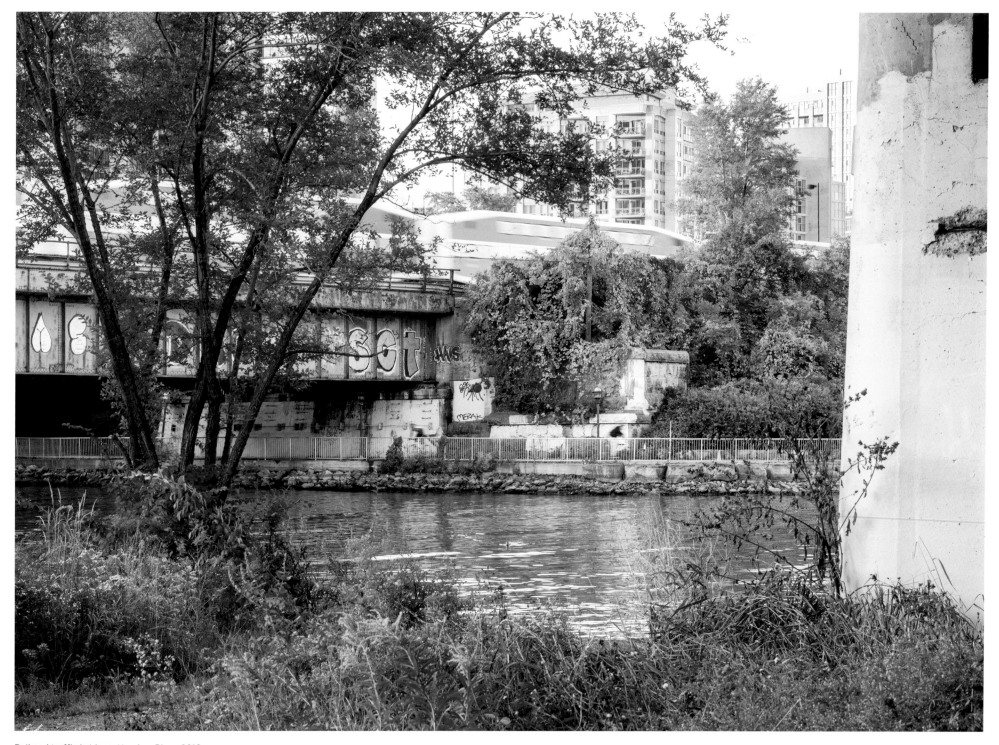

Rail and traffic bridges, Humber River, 2016

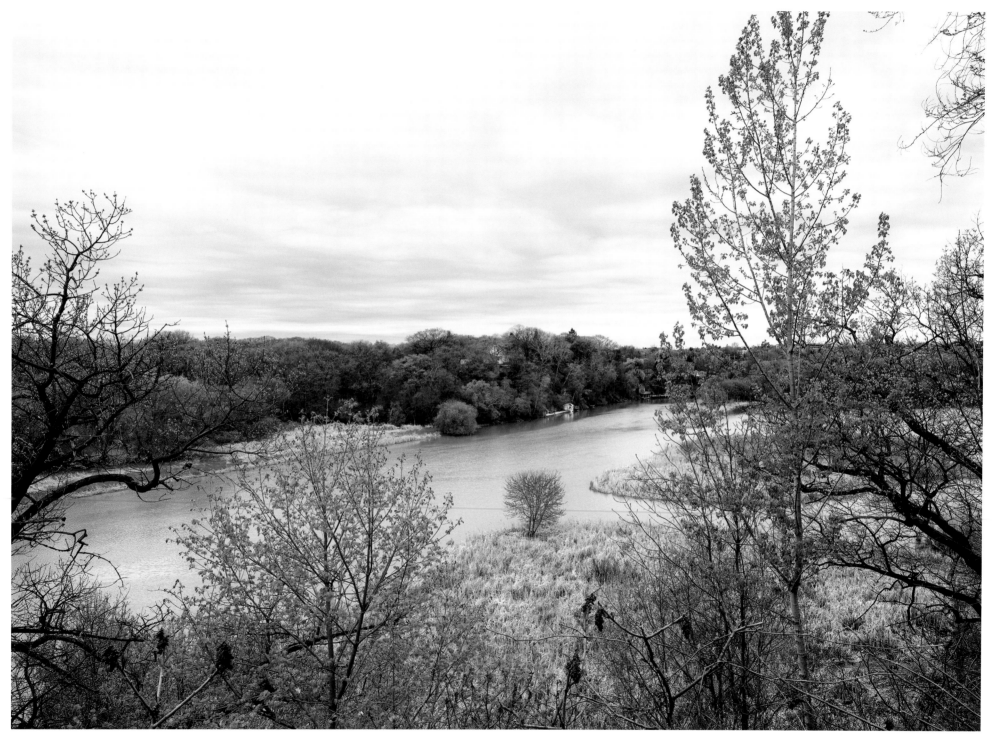

Humber Marshes and South Humber Park, 2013

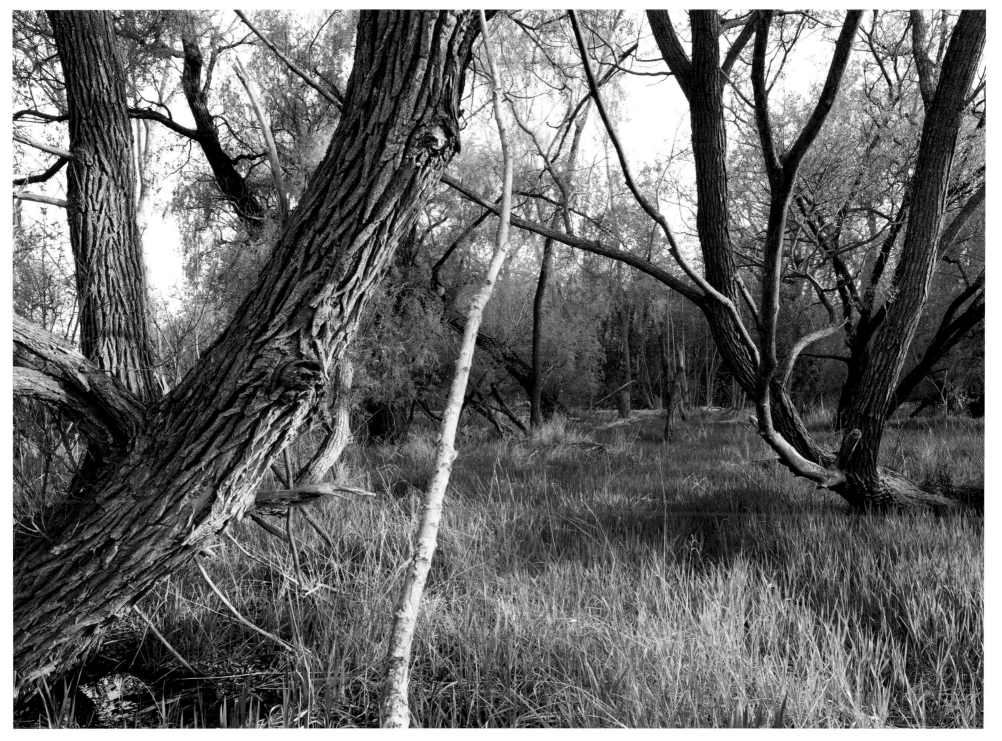

Willows, South Humber Park, 2014

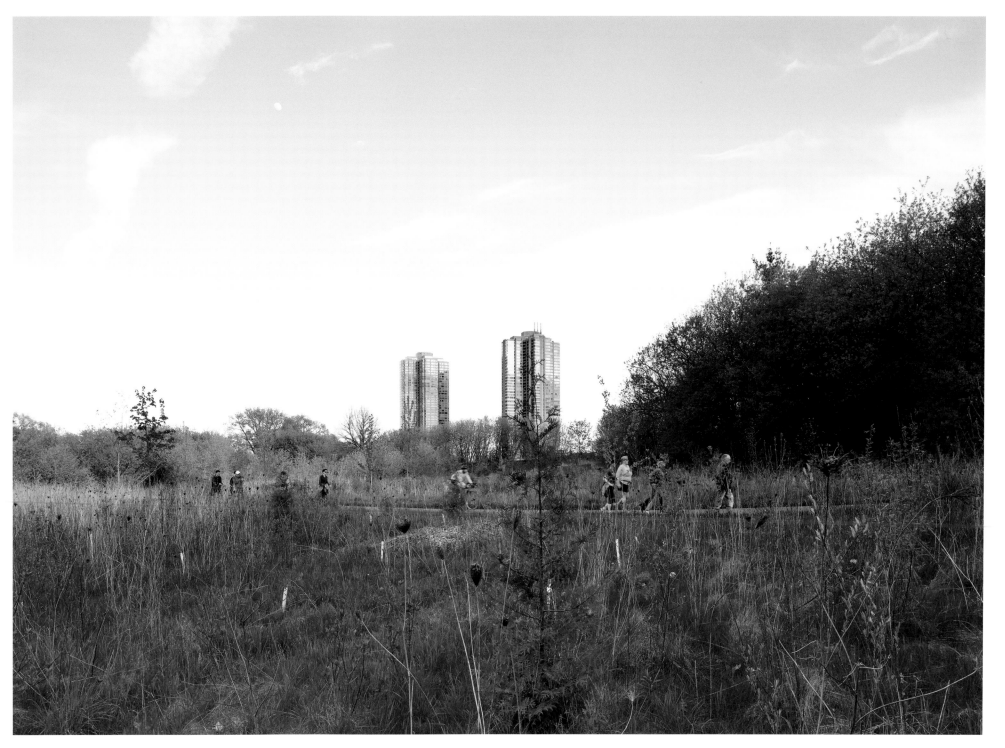

Joggers, South Humber Park, 2016

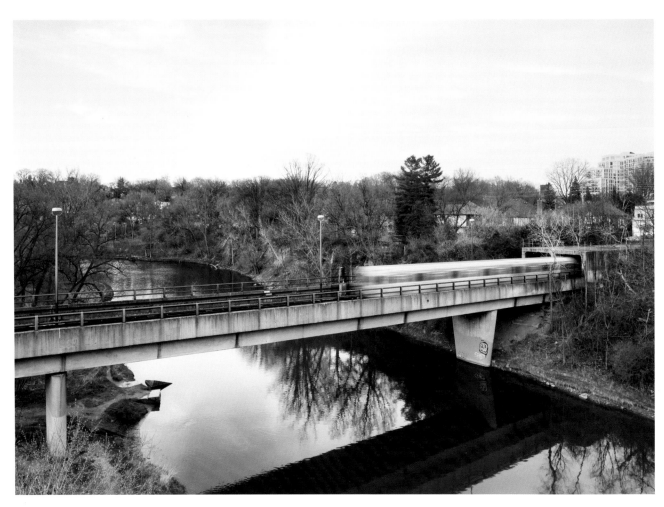

Looking north from Bloor Street bridge, King's Mill Park, 2016

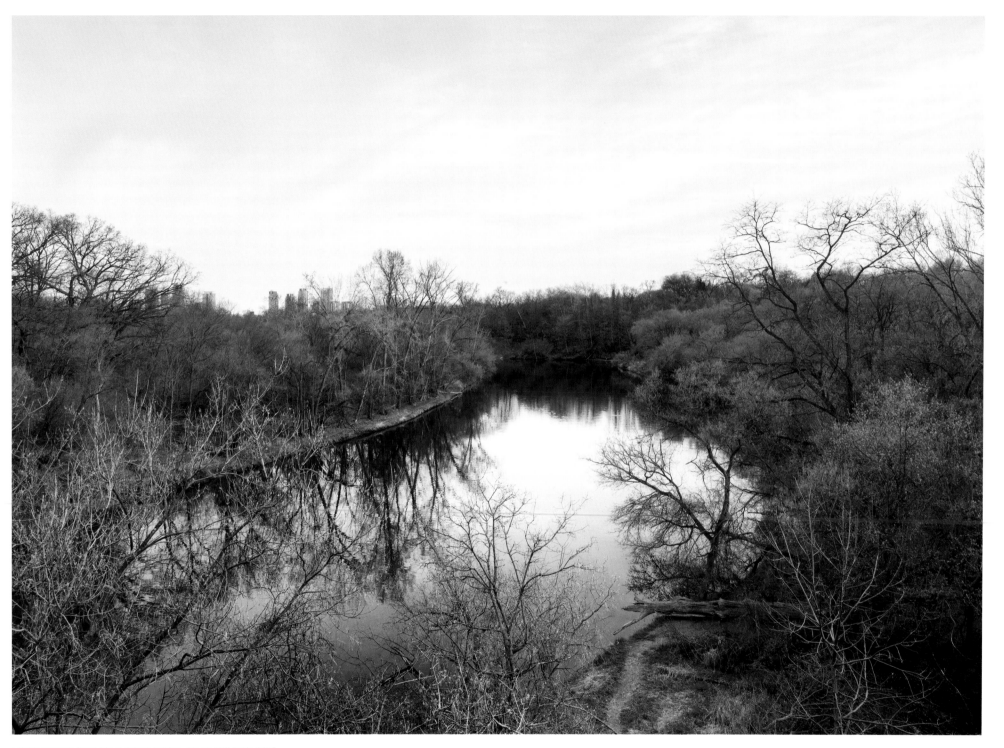

Looking south from Bloor Street bridge, King's Mill Park, 2016

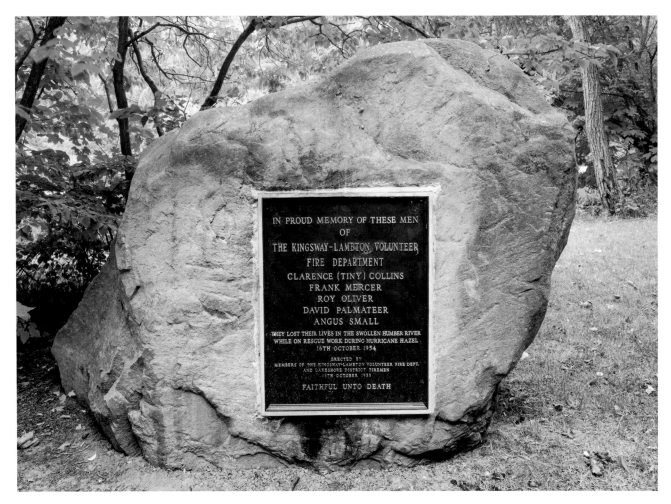

Memorial to volunteer firefighters, Home Smith Park, 2016

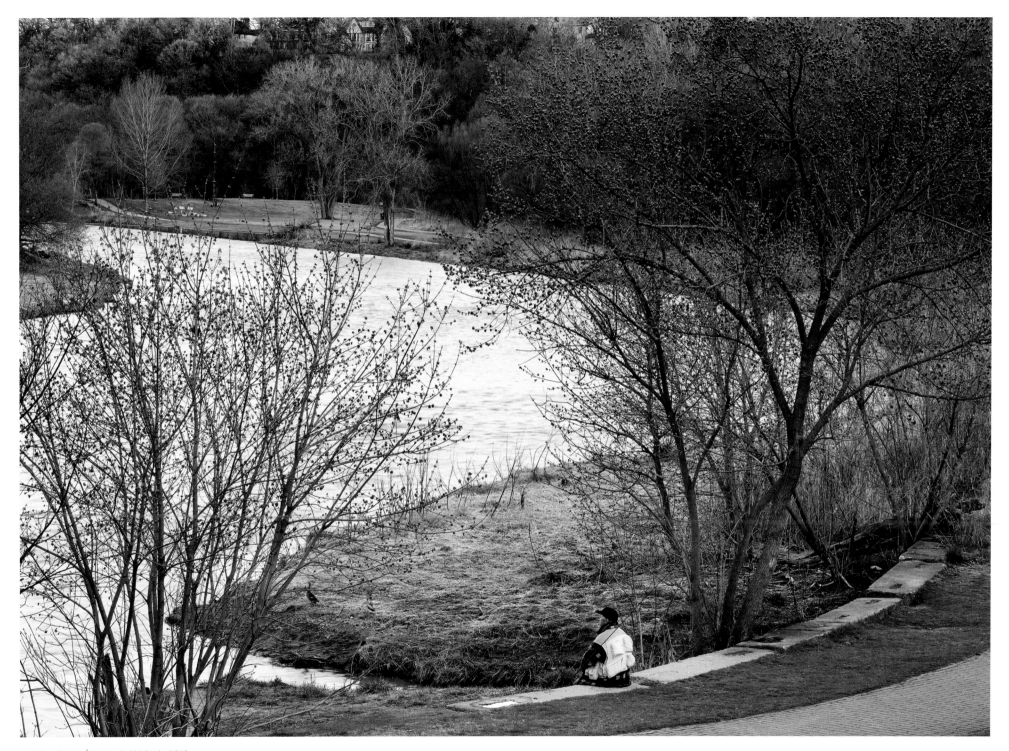

Humber River, Étienne Brûlé Park, 2016

Lambton Park, 2015

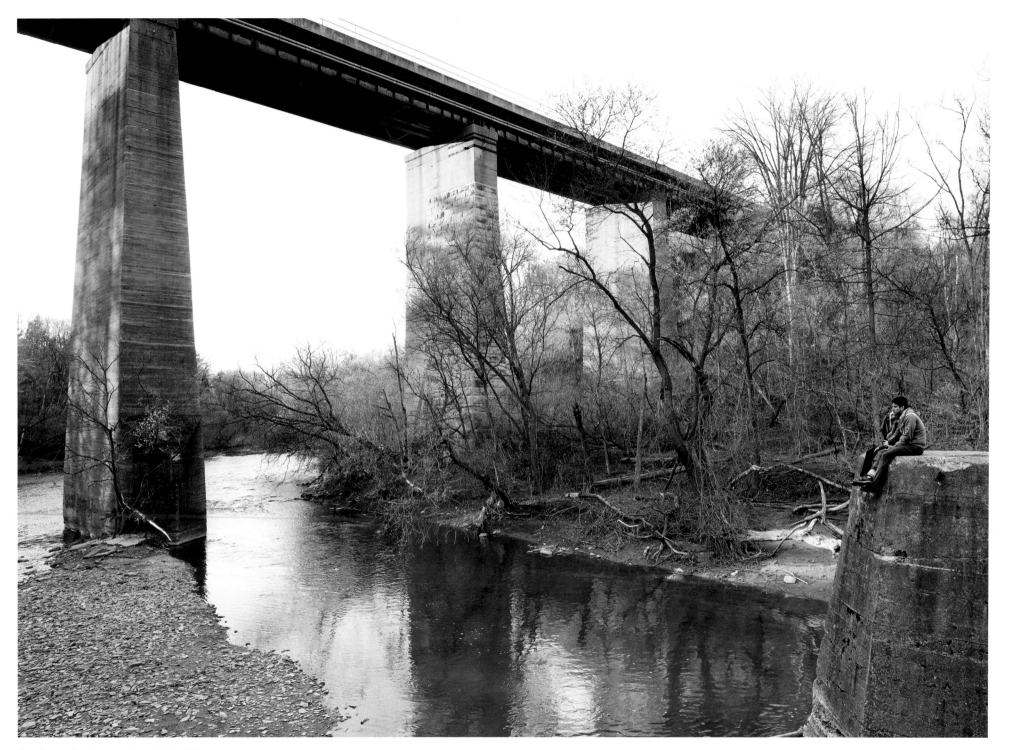

Couple, Humber River, Lambton Park, 2016

Graffiti artist, Lambton Woods, 2016

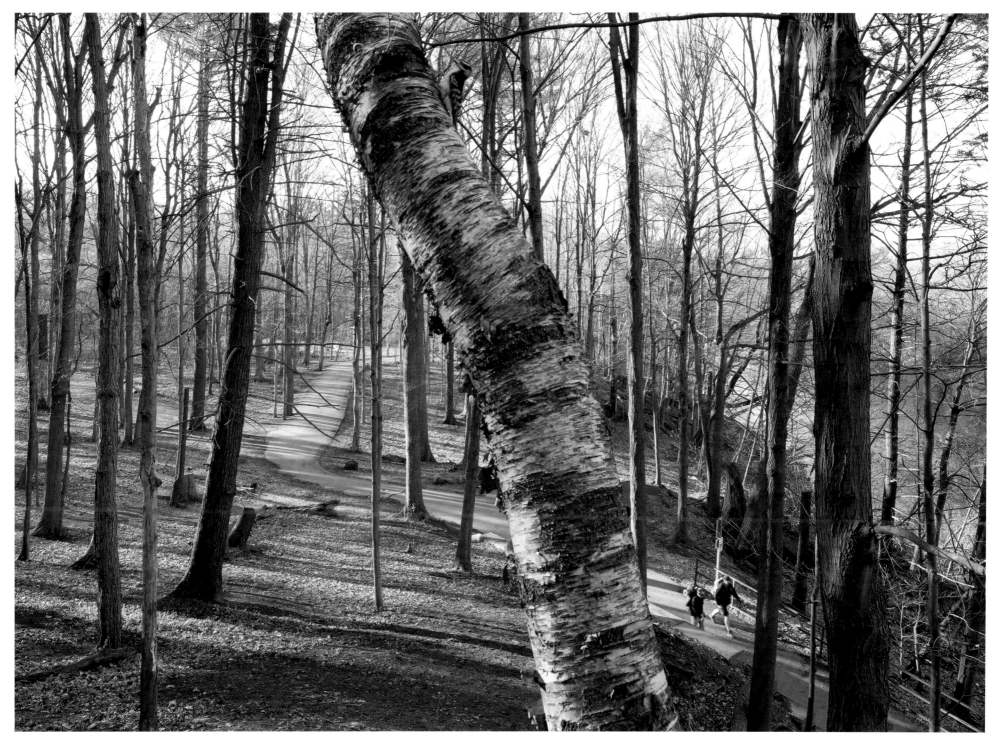

Humber River Trail, Lambton Woods, 2016

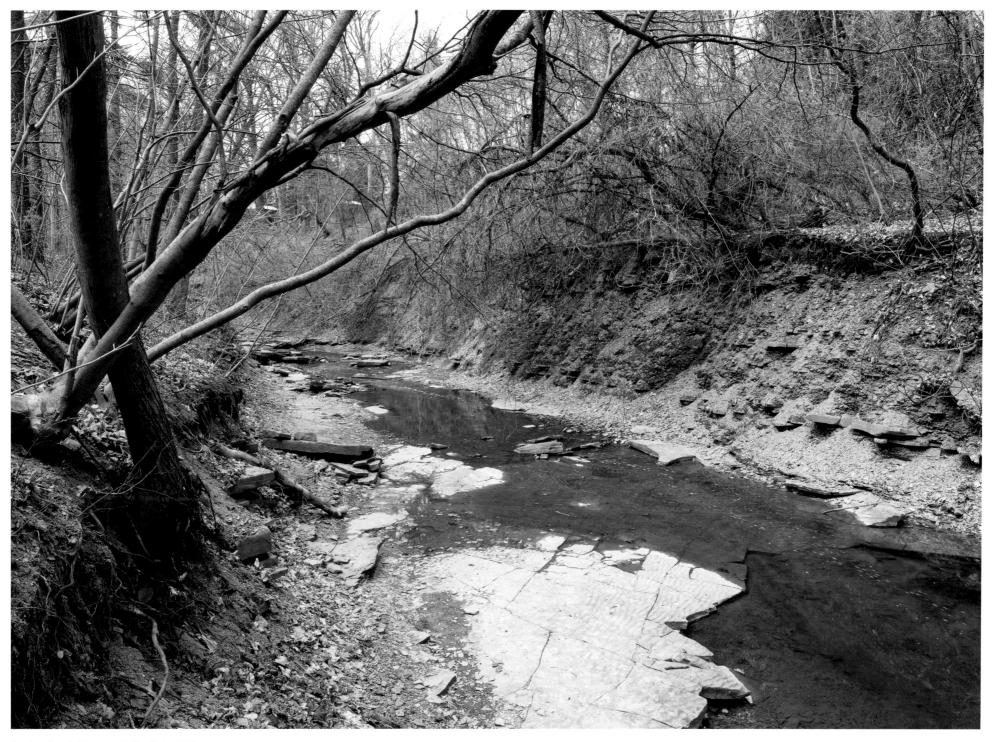

Humber Creek, Chapman Valley Park, 2016

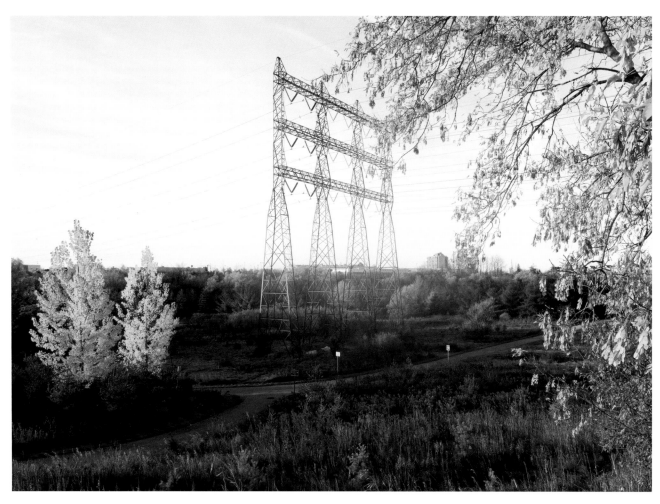

Hydro tower, West Humber Parkland, 2016

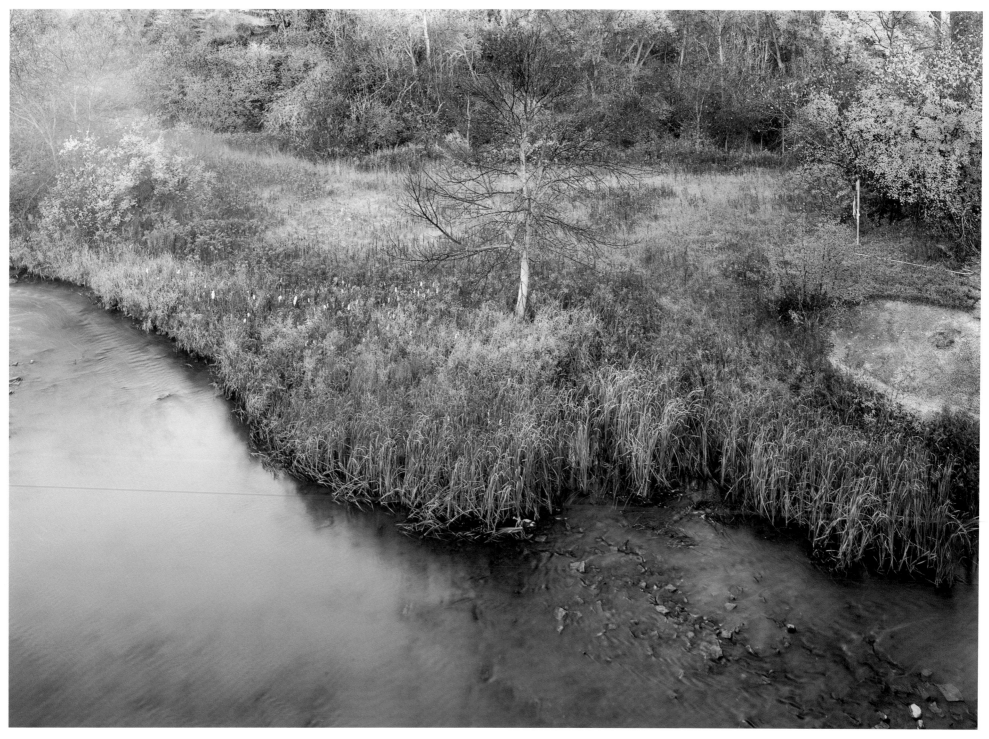

West Humber Parkland, 2016

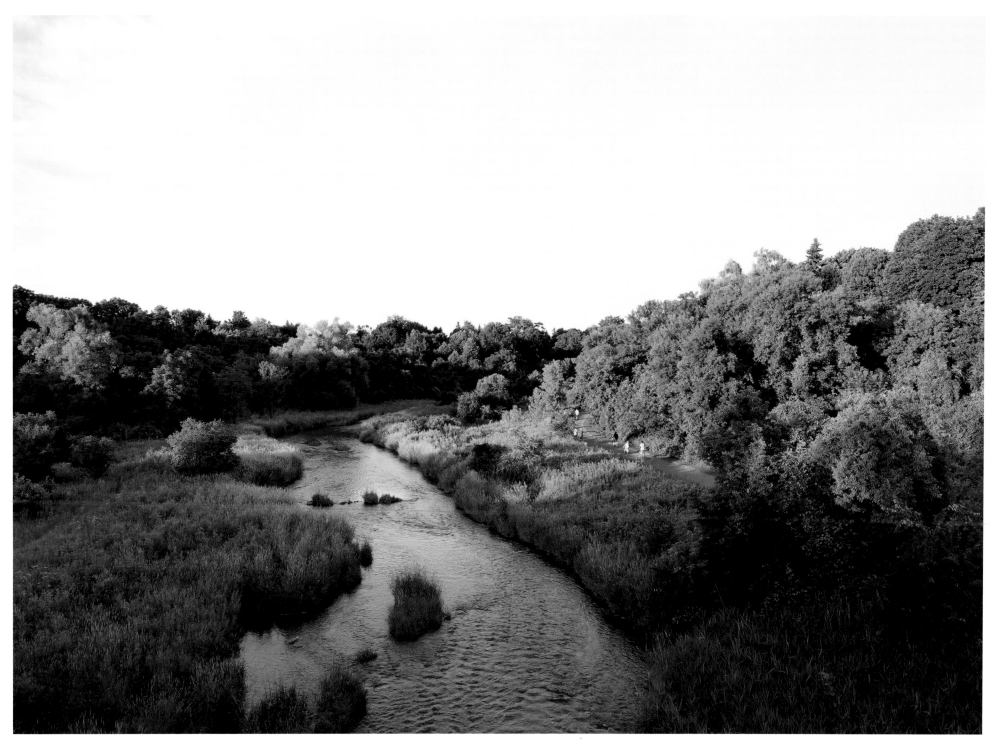

West Humber Parkland from Albion Road, 2014

Scarlett Mills Park, 2016

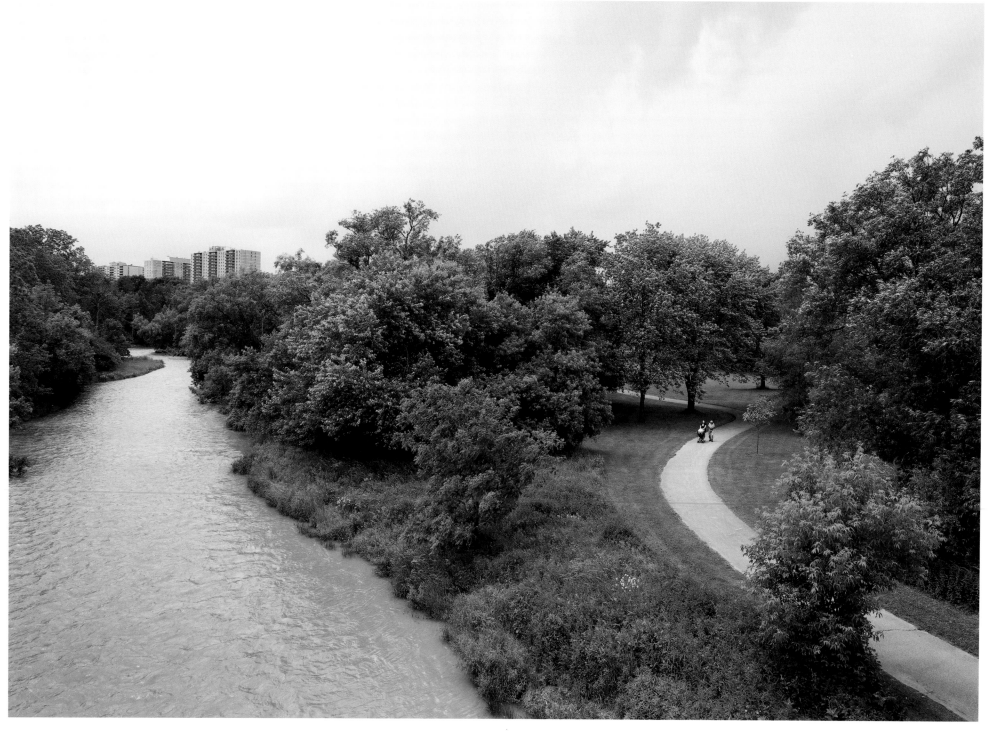

Rowntree Mills Park, 2014

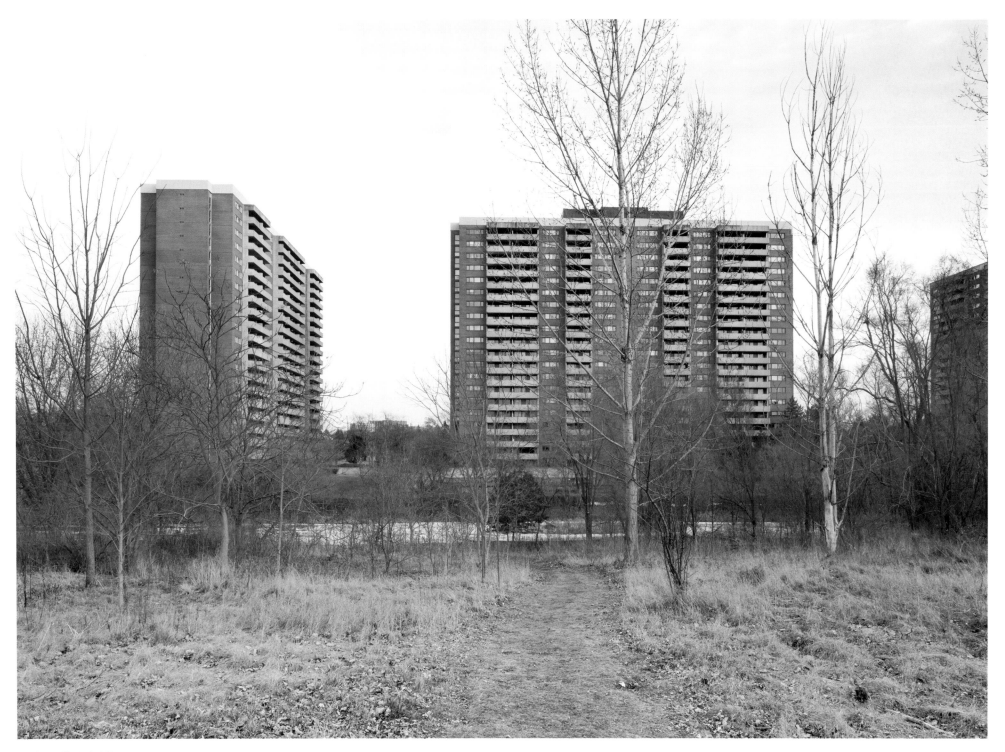

Scarlett Mills Park, 2015

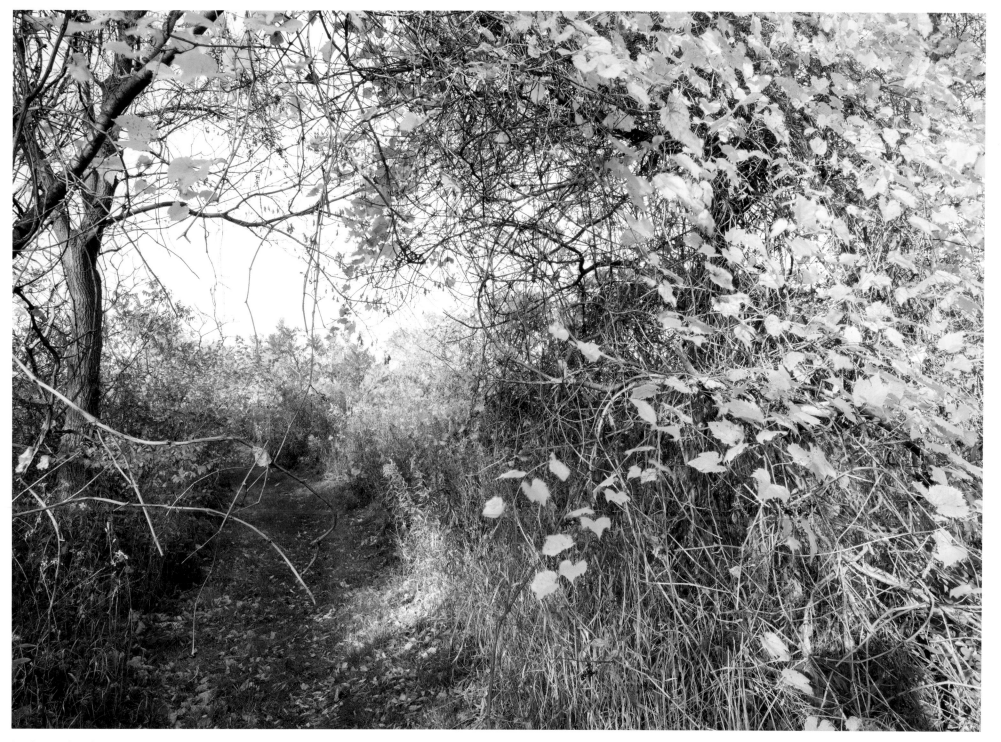

Humberwoods Park, 2015

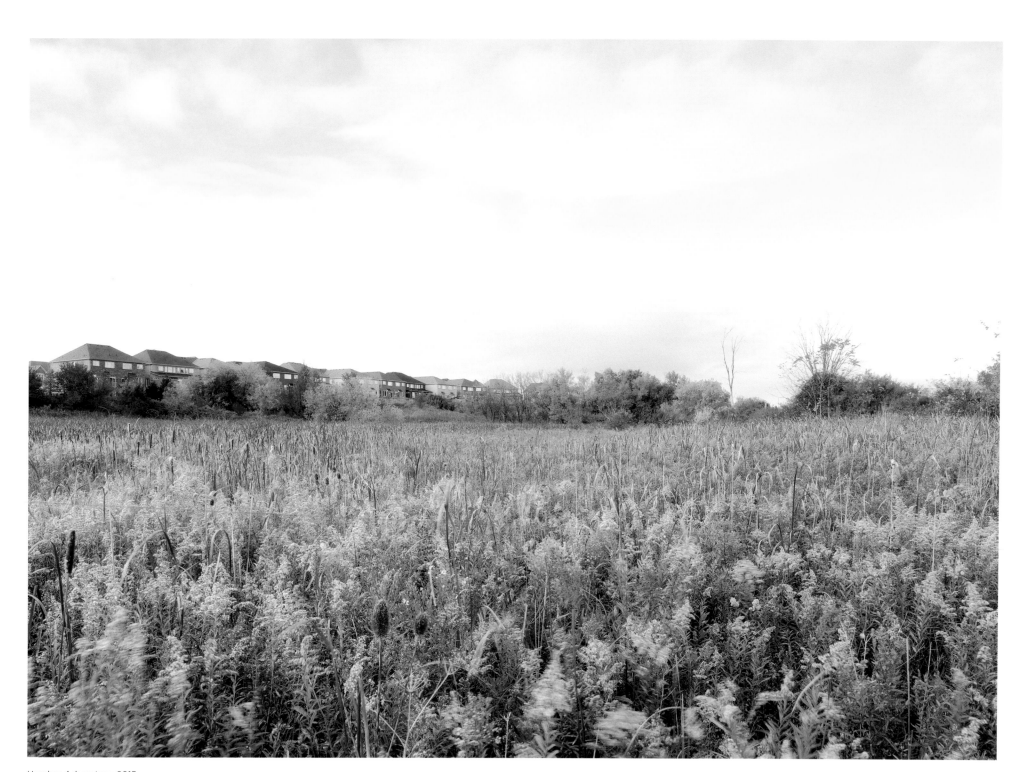

Humber Arboretum, 2015

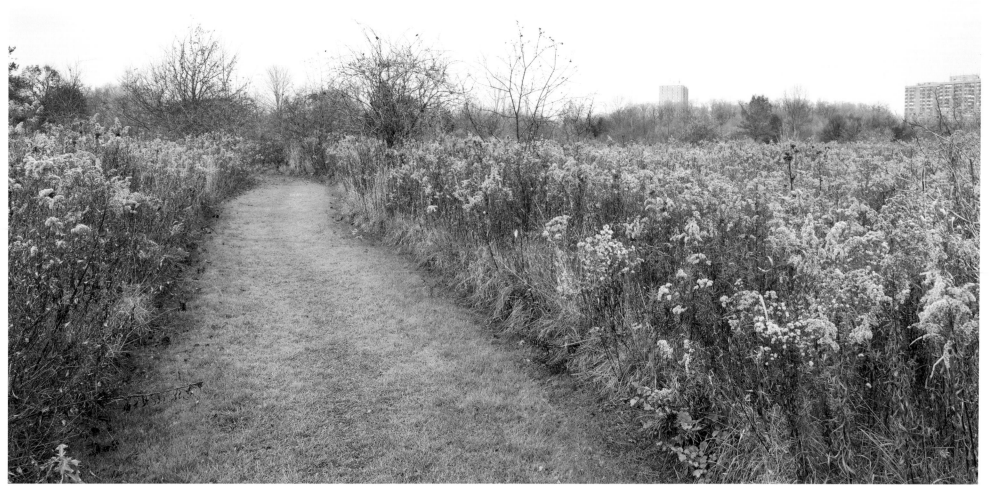

Humber Arboretum, 2014

Black Creek

Cedarvale Ravine

Centennial Park

Glen Stewart Park

Mimico Creek

Nordheimer Ravine

Williamson Park Ravine

Creeks

AND LOST RIVERS

by Leanne Betasamosake Simpson

Life by Water

The humidity is irritating because I'm wearing chest waders in Toronto in the heaviness of late June. I'm standing in Black Creek, the part that has cement sides and a cement bottom like a sidewalk, not like a little river. We are surrounded by the weight of a city that is not ours, an over-mapping of sirens, smog, grass and high rises.

Here I am, a young Michi Saagiig Nishnaabekwe, in my territory, standing in this river that is a part of me, that my ancestors drank out of and travelled on. I'm here as a biology student, which is a mistake, but I don't know it yet. I just like fish and I've landed the summer job my classmates dream of — working on a stream rehabilitation project for the Metro Toronto and Region Conservation Authority. This will look great on my resume, which I recently learned we now call a CV. I note to myself that I should feel both happy and grateful. I do not.

Today, our stream rehabilitation involves walking part of the creek. We pull car tires and shopping carts from the current, pick up needles and beer cans from the shore, and take inventory of things like temperature, turbidity, and current in a scientific way. We wear gloves and sunscreen. I know none of this helps anything. It just makes us feel better, or at least some of us.

I think: It is an honour to walk this creek. Even though. Even though.
I think: It is an honour to witness. Even though. Even though.

There were thousands and thousands of creeks networking into these rivers, pumping into Chi'Niibish, whom we lovingly share with the Mohawks. This river is lucky because, like me, it is still here. This river is lucky because is not one of the dead. Erased is better than dead and opaque is better than erased. It is not rerouted into a culvert. It is not diverted into a sewer. Its life merges into the Kobechenonk, where it should, rather than ending at the Ashbridges Bay Wastewater Treatment Centre.

I think: my ancestors would not recognize this place.
I think: my ancestors would not recognize me as their own.

As I walk, I call to the missing and the murdered to walk with me: adikwag, jijaakwag, omashkoozoog, moozoog, makwag, ma'iinganag, nigigwag, miinawaa, gidigaa bizhiwag. I call to all the ziibiinsan and ziibiwan.[1] I call to the eels and the salmon.

They all come.

We are parading down the creek together, on the concrete, in the heat, and no one notices. We are parading down my veins and arteries, through my heart and lungs, cycling through red and blue, effortlessly shifting states as the need arises, and no one notices.

I think: You are on top of me, but I'm still here.
I think: Soon the thunderbirds will bring refuge.

I leave my waders and gloves and jeans and socks on the bank and wade into your middle. I lie down in you, and you borrow my breath for just a second. The sun scorches my face, its light, my open eyes. I breathe. And then I bring my wet fingers to my lips and put you in my mouth, swallowing. We are beautiful the way we are. We resist because we both breathe. We exist because we recognize each other. We exist because despite everything, we refuse and love at the very same time.

[1] caribou, cranes, elk, moose, bears, wolves, otters, bobcats; creeks, rivers

Black Creek Parkland, 2016

Black Creek, Smythe Park, 2016

Mimico Creek, 2016

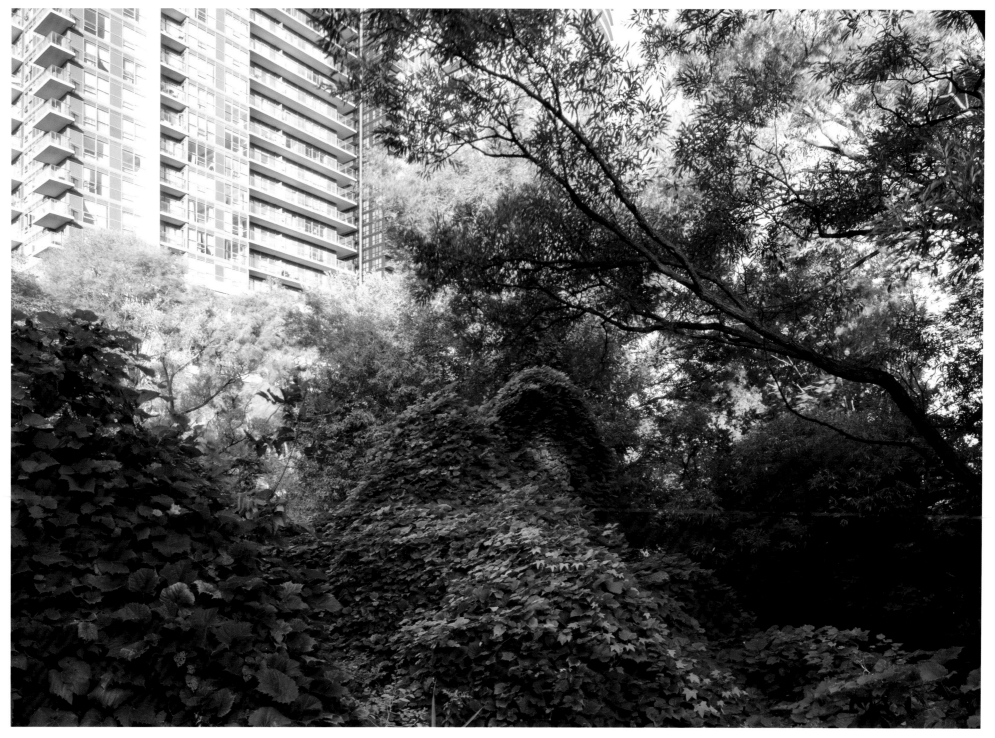

Mimico Creek, 2016

Etobicoke Creek, Centennial Park, 2016

Etobicoke Creek, Silverthorn Area, 2016

Cedarvale Park, 2016

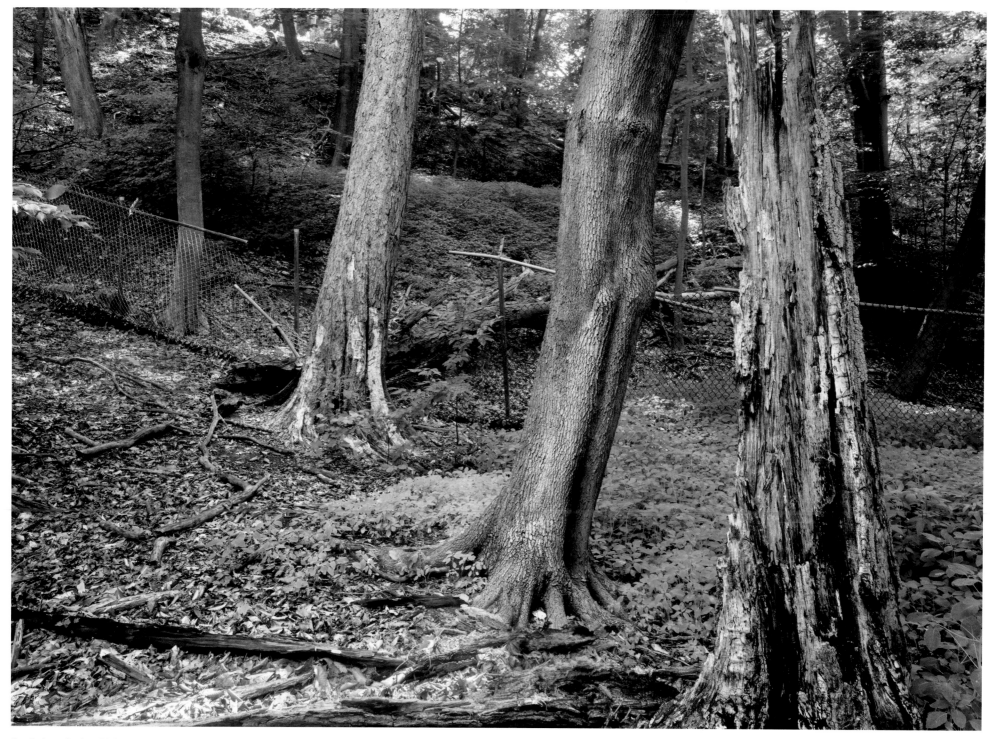

Nordheimer Ravine, 2016

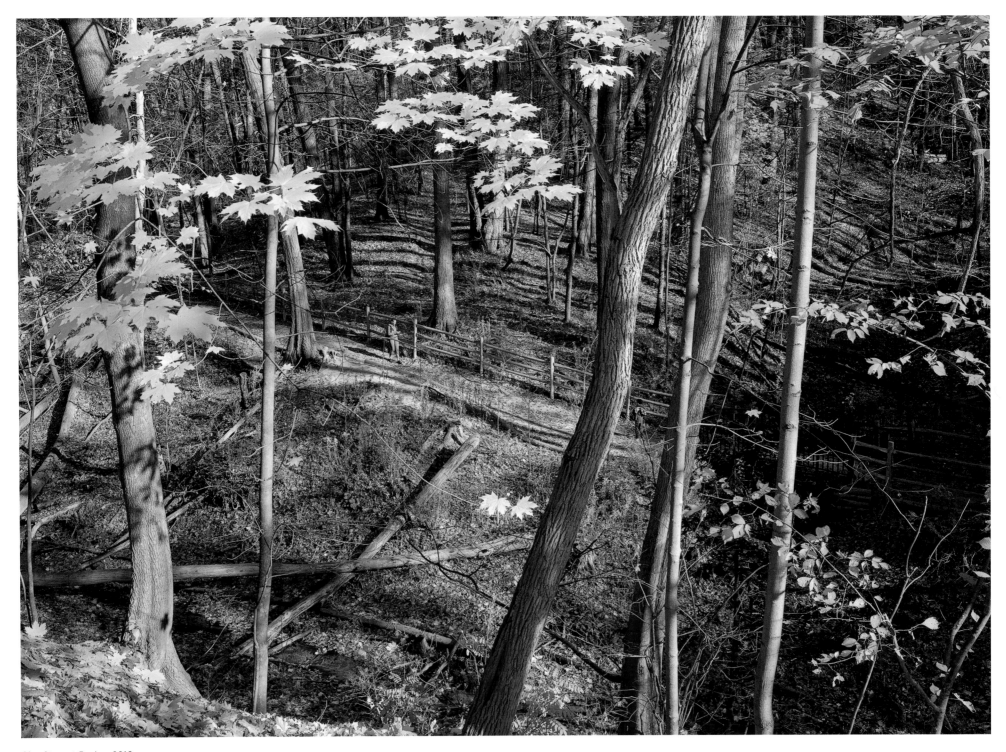

Glen Stewart Ravine, 2016

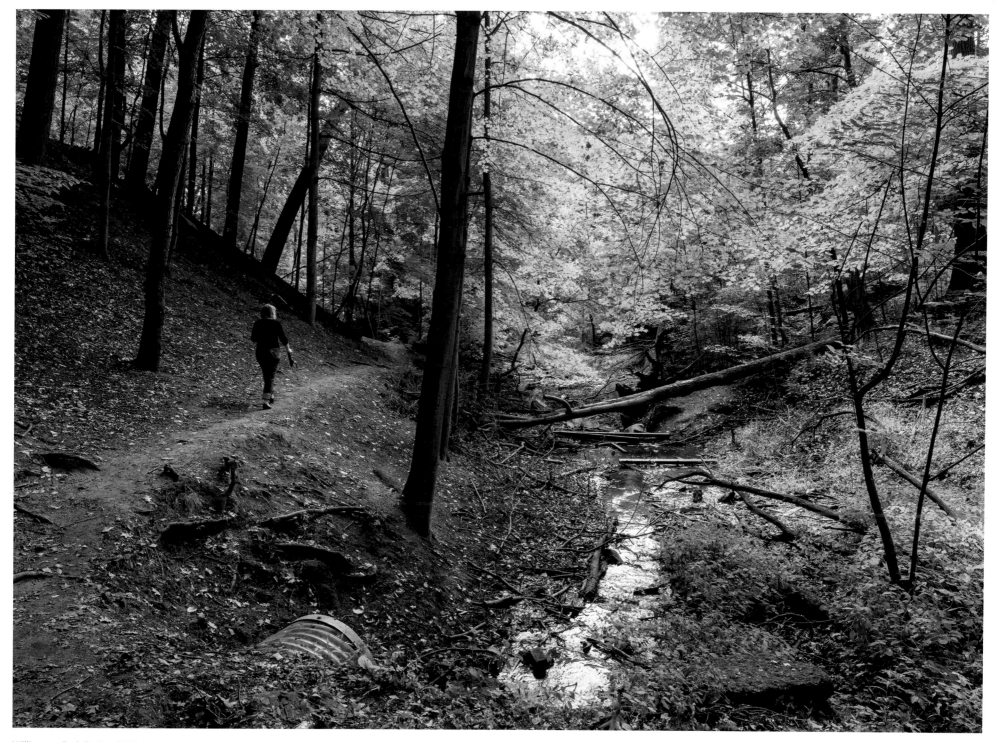

Williamson Park Ravine, 2016

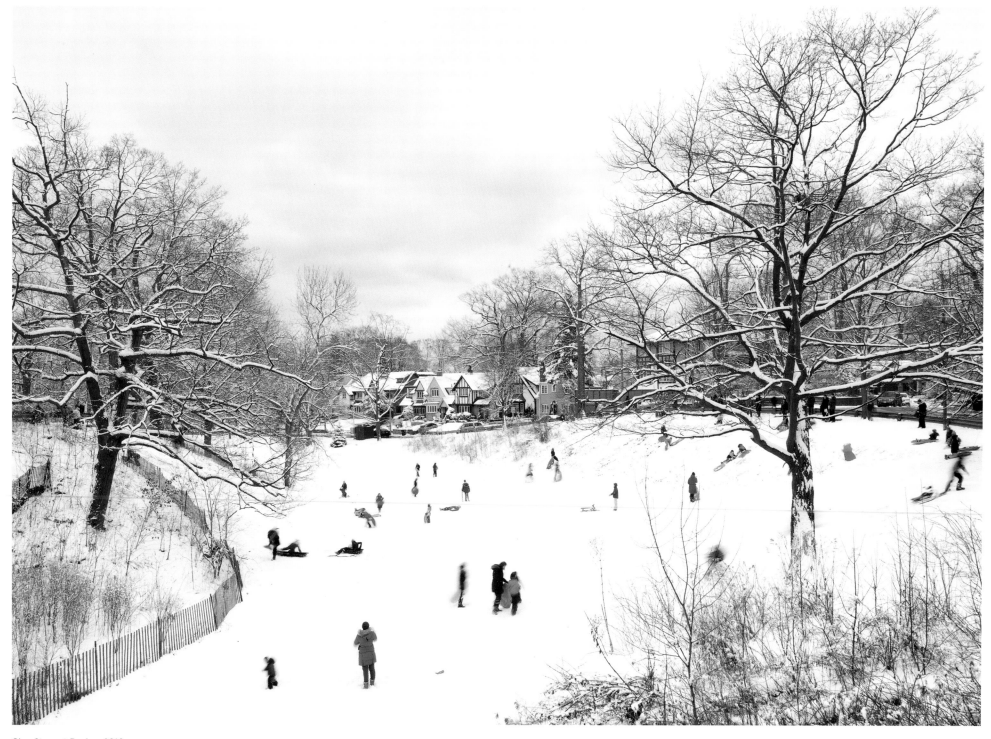

Glen Stewart Ravine, 2016

Betty Sutherland Trail

Brookbanks Park

Charles Sauriol Conservation Area

Earl Bales Park

East Don Parkland

Edwards Gardens & Wilket Creek Park

E.T. Seton Park

Glendon Forest

Lower Don Parklands
(Crothers Woods, Chorley Park, Don Valley Brick Works)

Moore Park Ravine

Rosedale Ravine Lands

Sunnybrook Park

Taylor Creek Park

Todmorden Mills Park

Vale of Avoca

Valley

THE DON RIVER VALLEY

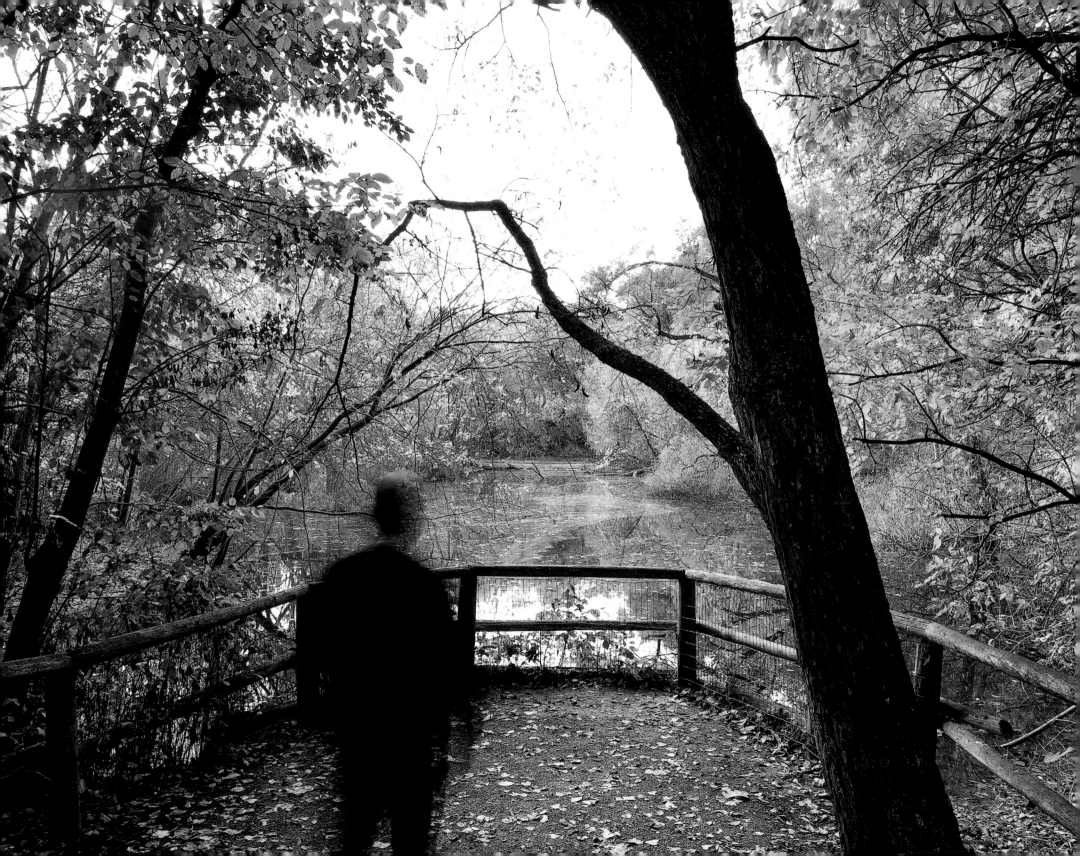

by Alissa York

The Animal Part

Childhood is the animal part of life. Whoever penned that line also let it loose to wander in my mind. It's one of those quotes that rises unbidden, pleasing in its construction, if not entirely whole. When we're small we belong, as our fellow creatures do, to our senses — but only if we include the imaginative vision of the mind's eye. We live in our perceptions, but also in the stories they evoke.

I'm forever in the Don Valley's debt. New to Toronto's east end, I crossed over that wide, wooded cut, stared down through the subway window and thought, *What lives down there?* When fall revealed campsites among the trees, the "what" expanded to include "who." Before I knew it, my third novel, *Fauna*, was under way. Through it, I found a way in to my adopted city — a way to begin calling Toronto home.

As the novel evolved, it became clear that passing over the valley was no longer enough. Notebook in hand, I ventured out onto the Riverdale Footbridge and descended the airy gridwork of the stairs. I followed the riverside path, looking, listening, lifting my nose to the breeze. Later, I wound my way through adjacent neighbourhoods — Chinatown East, the peaceful pairing of the Toronto Necropolis and Riverdale Farm. Gathering, gathering. Carrying my findings back to my desk.

When the writing was done and *Fauna* took the shape of a book, I left my room again — this time to meet with readers, many of whom held the Don Valley dear. One after another they told me how the valley had raised them. Older readers spoke of a time before the parkway, when the woods were quieter and more wild. *We'd follow trails, build hideaways. We'd be gone all day.*

A few years later when I was deep into the next novel, the Don Valley called me back. Luminato Festival was running a program in the schools; Noah Richler, then curator of literary programming, wondered if I'd like to take a class on a walk.

It turned out to be two classes, two separate trips. First came the grade fives — children at what is often referred to as "a lovely age." These were Toronto kids: they (or their parents, or their grandparents) were from all over the world. I met up with them and their teacher on the western slope of the valley, in the lee of the big barn at Riverdale Farm.

"Today we'll be thinking like writers," I announced. "As we walk through the valley, we'll be stopping to observe and to imagine, and we'll have help from some writers who've written about this place." Reaching into my book bag, I began with a short passage of my own. "Let's start by walking in someone else's shoes — or should I say paws." I pointed uphill. "See that picket fence? Imagine it's dark, and imagine there's a coyote on the other side."

To my delight, most of them listened to the end of the scene. Closing the book, I set off, leading the grade fives past the shaggy donkey, the goats and their pretty new kids. Together we took the path to the valley bottom. Beside the murky pond, I gathered them about me again.

Riverdale Park West, 2014

"Everyone have your notebooks? Okay, I want you to look around, *really look*, and write down five things you see."

We repeated the exercise with hearing, smell, and touch, sidestepping the inherent hazards of having children taste their surrounds. When their senses were wide open, I read to them from Anne Michaels' *Fugitive Pieces* — two essential paragraphs about the city where they live:

> It's a city where almost everyone has come from elsewhere — a market, a caravansary — bringing with them their different ways of dying and marrying, their kitchens and songs. A city of forsaken worlds; language a kind of farewell.
>
> It's a city of ravines. Remnants of wilderness have been left behind. Through these great sunken gardens you can traverse the city beneath the streets, look up to the floating neighbourhoods, houses built in the treetops.

The last line had the grade fives lifting their eyes. Is there anything so gratifying as reading to children? Standing witness to the story's spell?

The grade eights were a harder sell. Girls stood checking their phones as we assembled by the barn. While the teacher called for attention, I spotted the requisite trio of tough boys, two of them lithe and mouthy, the third heavy-set and impassive — a bouncer's aspect on a 13-year-old. Already on the path to adulthood, this group was less than eager to step into a coyote's paws. The pond in all its sensory splendour did little to impress them. When I read to them of Toronto's untold cultures and sunken gardens, it was hard to be certain how much they took in.

We carried on, up along the footbridge, down the clanging stairs. Standing on the riverbank, I read to them from Margaret Atwood's *Cat's Eye*, the scene wherein Elaine's friends bully her into braving the valley alone:

> I start down the steep hillside, holding onto branches and tree trunks. The path isn't even a real path, it's just a place worn by whoever goes up and down here: boys, men. Not girls.
>
> When I'm among the bare trees at the bottom I look up. The bridge railings are silhouetted against the sky. I can see the dark outlines of three heads, watching me.

I closed the book, and for a moment the grade eights were watchful, even thoughtful. This, they could relate to. The animal part of life can be cruel.

• • •

The grade fives followed me like goslings when I led the way off the paved path onto a narrow trail. Their trust made me careful. "There's a patch of nettles here," I called back down the line. "Watch out for branches snapping back."

Where the track opened out at the riverbank, we broke from the bushes and scrambled down to a strip of sand. The river wound by, tea-coloured, sparkling; the sun was strong. Suddenly it was a day at the beach.

Again we checked in with our senses. Again we made note of our surrounds. The grade fives raked their fingers through the sand, turned river stones over in their palms. After a time I read to them from Ernest Thompson Seton's *Wild Animals I Have Known*.

"'Old Silverspot was the leader of a large band of crows that made their headquarters near Toronto, Canada, in Castle Frank, which is a pine-clad hill on the northeast edge of the city.'" I pointed up the western slope. "You guys know Castle Frank subway station, right? Right up there? Just think, that used to be the edge of town."

I paused while they got their bearings in space and time, then read on, arriving at Seton's transcriptions of the old crow's various calls. Taking a breath, I did my best to give them voice. When the giggles died down, I put a question to the group. "What kinds of creatures do you think live down here?"

"Crows," said a girl in dark braids. She gave me a mischievous smile.

"Very good, somebody was listening."

Her friend pointed to a pair of mallards a little way downstream. "Ducks."

I nodded. "Ducks, yes."

"Dogs!" a boy shouted, grinning. He was smaller than his classmates, excitable.

"Sure, plenty of dogs pass through here every day. But some of their relatives live here all the time. Foxes. Coyotes too."

"If I was a coyote," the small boy cried, "I would meet a girl coyote and we would have a wedding in the woods with all our animal friends!"

"A coyote wedding," I said. "How cool would that be?" Then I told them about the true courtship — the female tilting her head back, offering up an unearthly cry, the male leaping and yowling in response. "Owoooo," the children and I sang together. "Ow-ow-owooooo."

I didn't attempt a howl with the grade eights — not after the smirks and stares my cawing had provoked. Instead I led them back into the woods, heading north along the narrow track. The air was soft with oxygen; leaves dulled the parkway's thunder to a drone. When we passed an abandoned campsite, no one spoke. Thinking of Lily, the teenage runaway in *Fauna*, I stopped and waited for the stragglers to catch up.

"Who do you think lived here?" I asked.

Silence. Then a boy's voice from the back of the group: "Some drunk."

It was a fair guess — bottles winked among the weeds. "Maybe," I said. "Maybe not."

"A homeless?" said a girl in a pink headscarf.

"Could be. Get out your notebooks, everyone."

Somebody groaned.

"Just for a minute. Try to write down what it's like here. Write how it feels."

We emerged from the trees in the shadow of the viaduct's span. I had one reading left, and I'd saved the showstopper for last.

"This book takes place when they were still building the viaduct," I told the grade eights, "about a hundred years ago. So when you look up, don't see the whole bridge, just see half. And picture one of the men who works there — the one they call the daredevil — hanging in a halter underneath the edge."

No question, I had their attention now. "It's night-time," I went on, "and a group of nuns are out walking in their long black robes and veils — only they get confused in the dark. They walk out onto the half-built bridge, out into the wind."

Opening my dog-eared copy of Michael Ondaatje's *In the Skin of a Lion*, I read to them from perhaps the most famous passage in Canadian literature — the scene wherein Nicholas Temelcoff catches the falling nun:

> The new weight ripped the arm that held the pipe out of its socket and he screamed, so whoever might have heard him up there would have thought the scream was from the falling figure. The halter thulked, jerking his chest up to his throat. The right arm was all agony now — but his hand's timing had been immaculate, the grace of the habit, and he found himself a moment later holding the figure against him dearly.

It's such a human story — exceptional man rescues innocent young woman from a certain, senseless death — but it's an animal tale too. Primate falls, other primate catches her, together they swing to safety. Either way, the grade eights got it. Even the tough boys gasped.

Weeks later when I was safely back in my grown-up, street-level life, a package arrived in the mail. As part of Luminato's program, the children had made postcards to commemorate our trip. Bright elemental prints on one side, writing on the other, no names attached to the work. Standing in my kitchen, I turned over card after beautiful card.

Down in the Don Valley, one child wrote, *I saw a river going the way it wanted.*

Down in the Don Valley, wrote another, *I felt like a bird.*

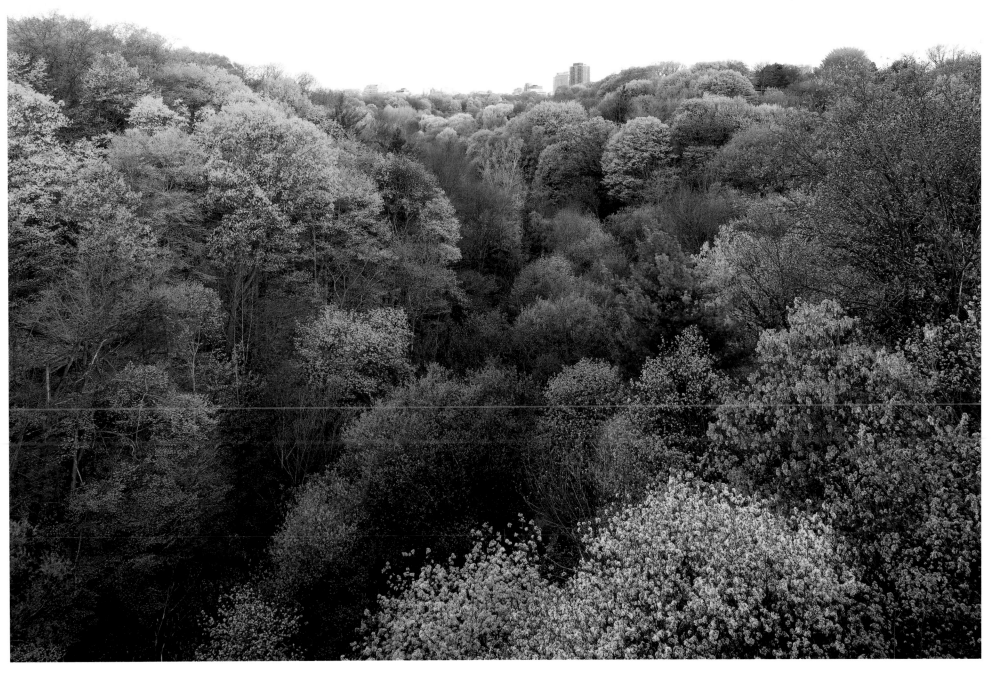

Park Drive Reservation Lands looking west, 2013

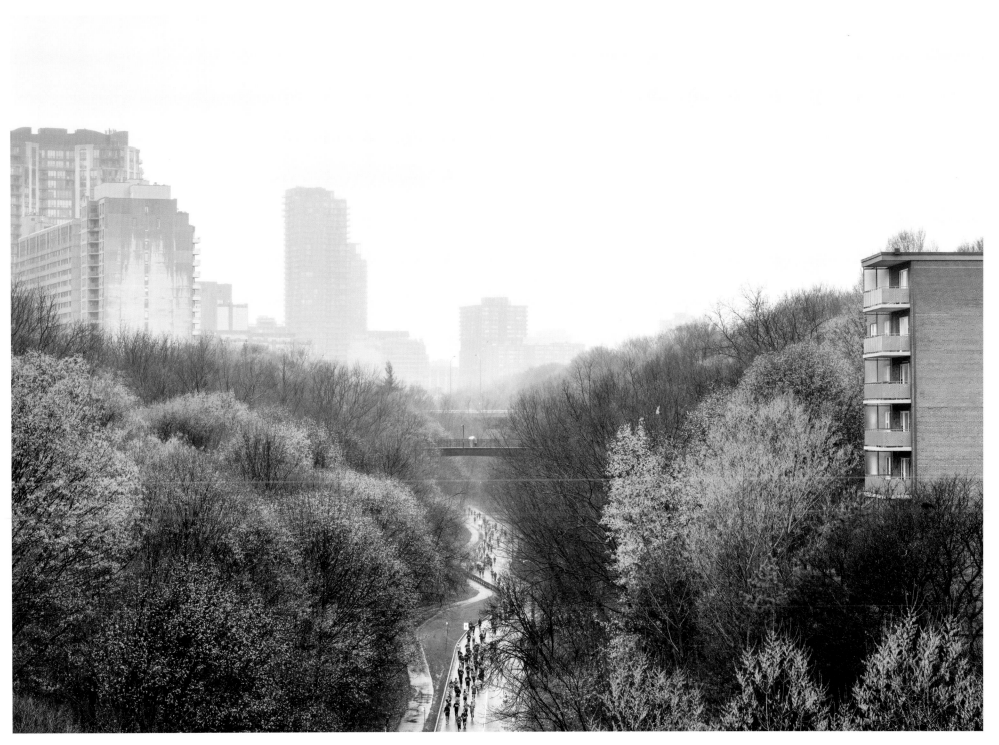

Marathon run, Rosedale Valley Ravine Lands, 2016

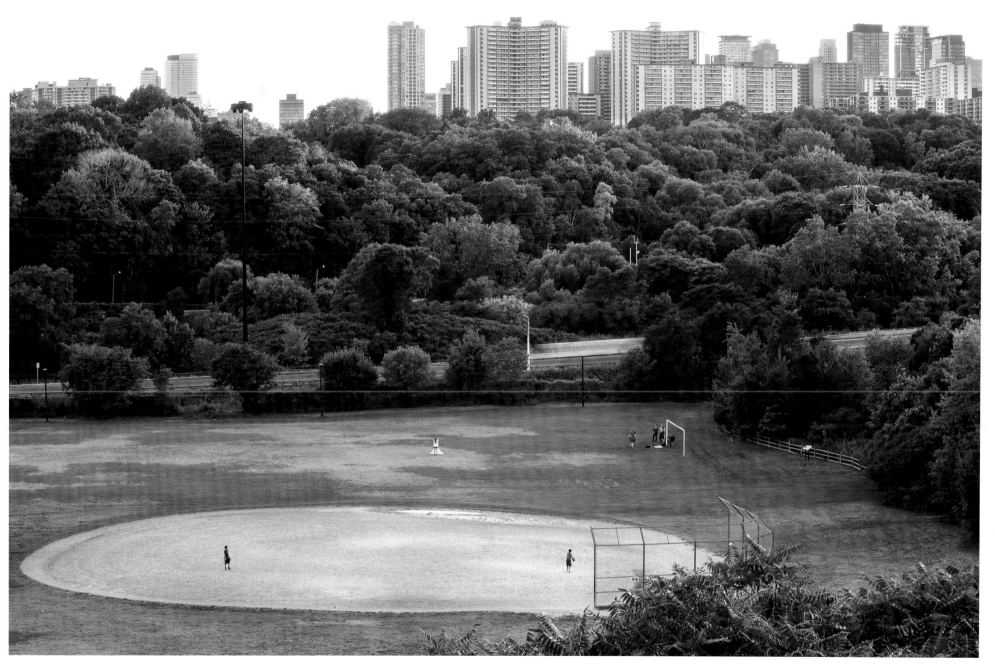

Lower Don Parklands from Riverdale Park East, 2012

Lower Don Parklands from Leaside Bridge, 2016

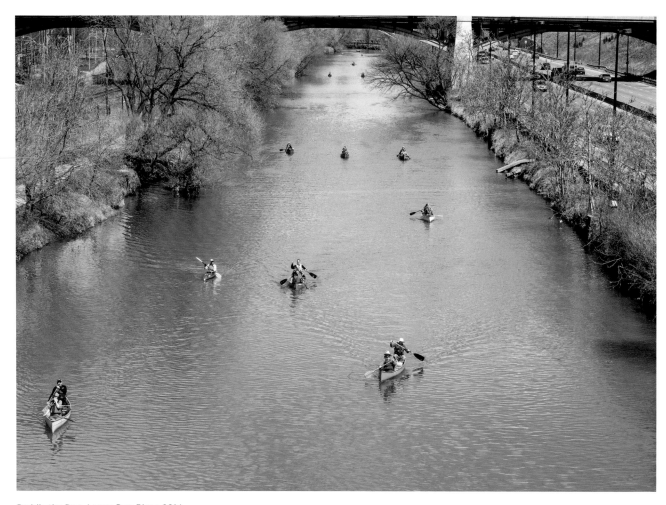

Paddle the Don, Lower Don River, 2014

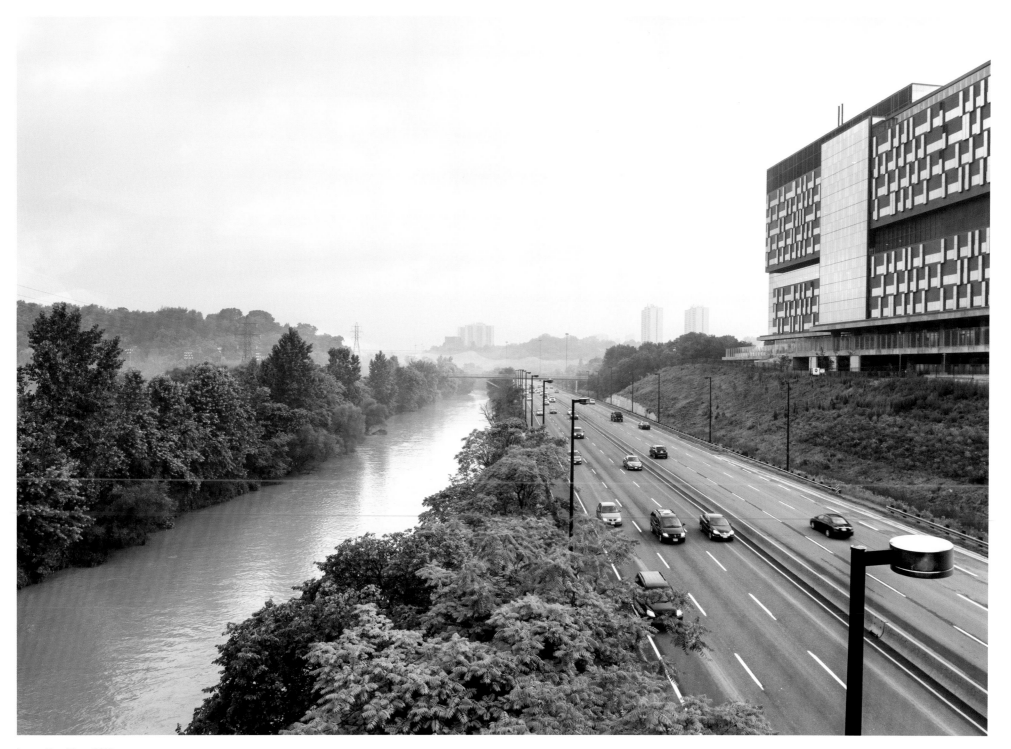

Lower Don River, 2013

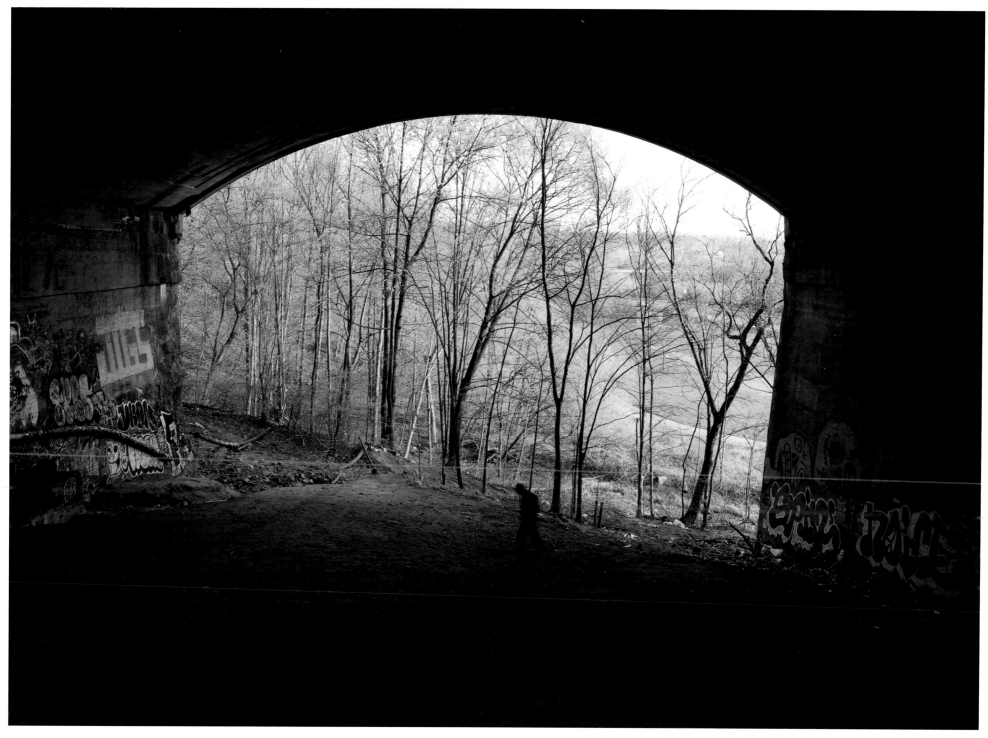

Homeless man beneath the Prince Edward Viaduct, 2013

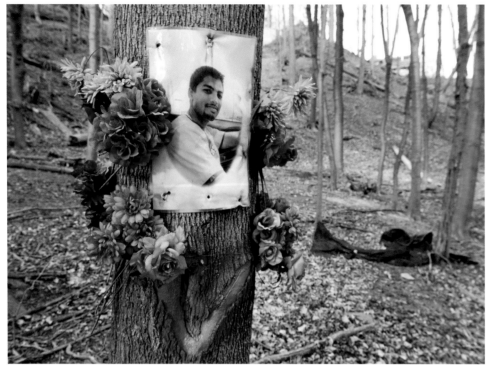

Memorial for Vijai Julmaladeen, Rosedale Valley, 2016

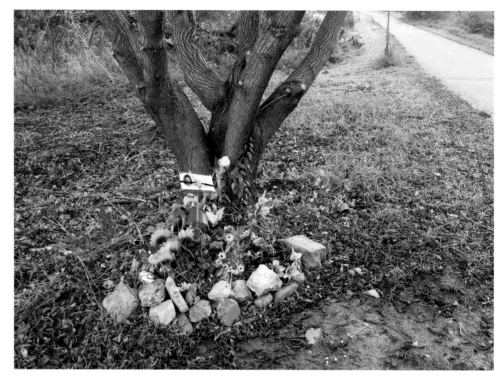

Memorial for Jason Singh, Lower Don Parklands, 2014

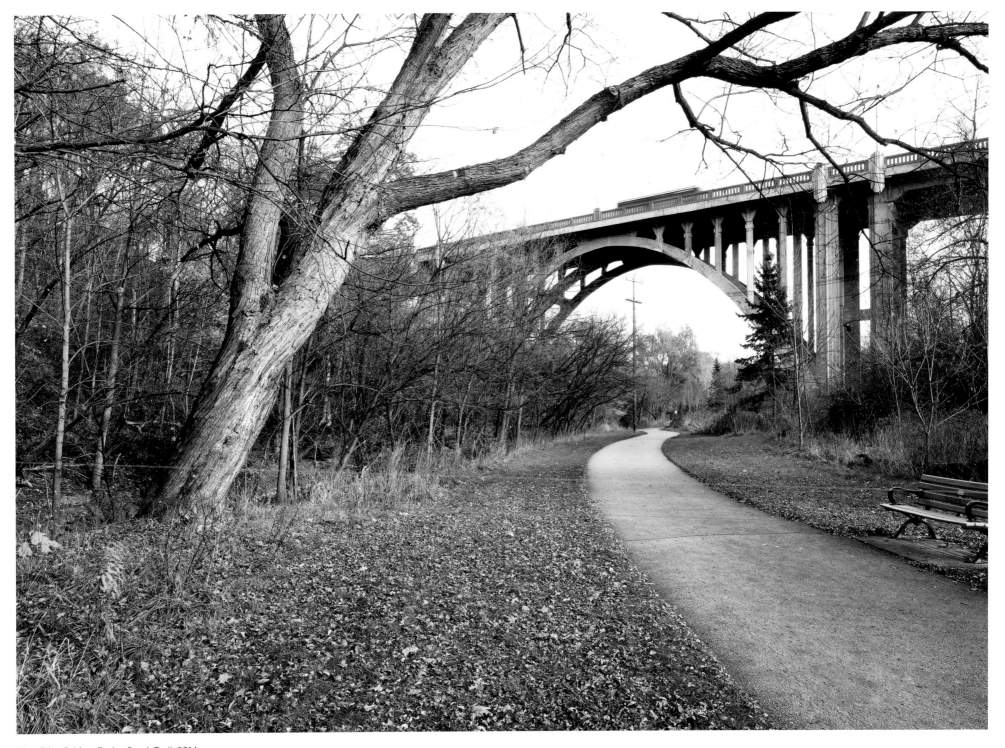

Woodbine Bridge, Taylor Creek Trail, 2014

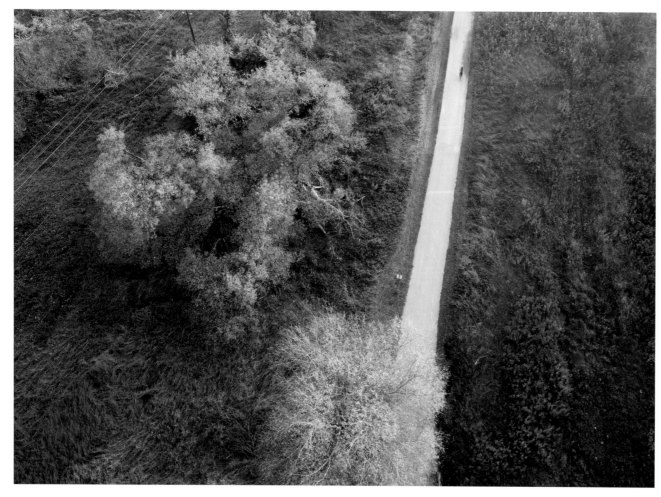

Lower Don Parklands Trail, 2014

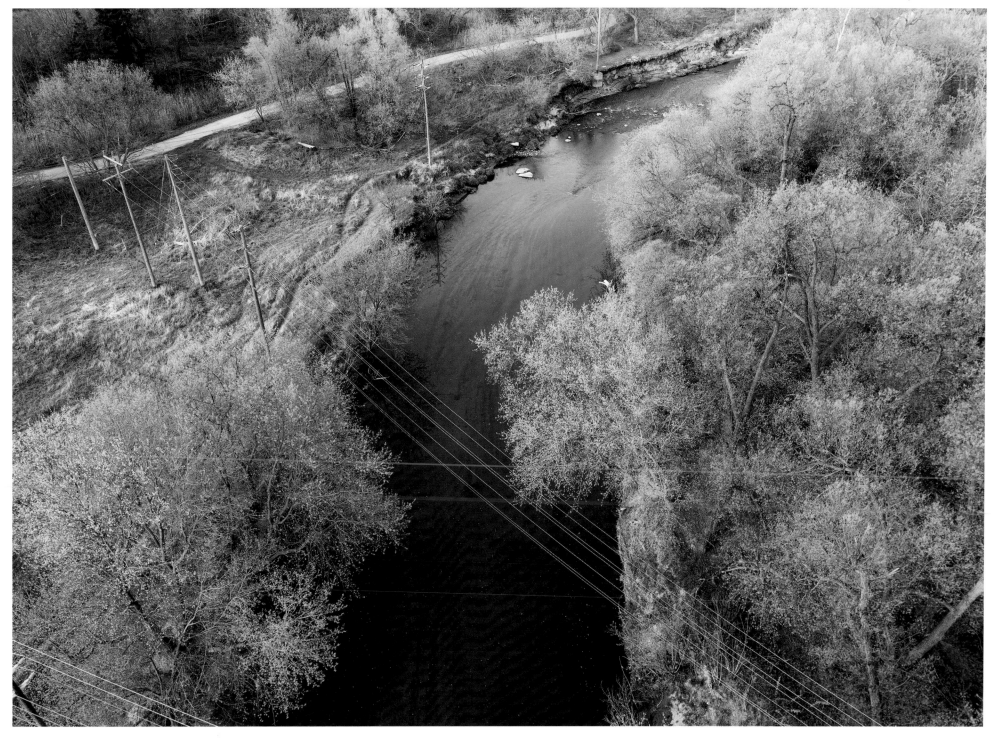

Don River, Lower Don Parklands, 2016

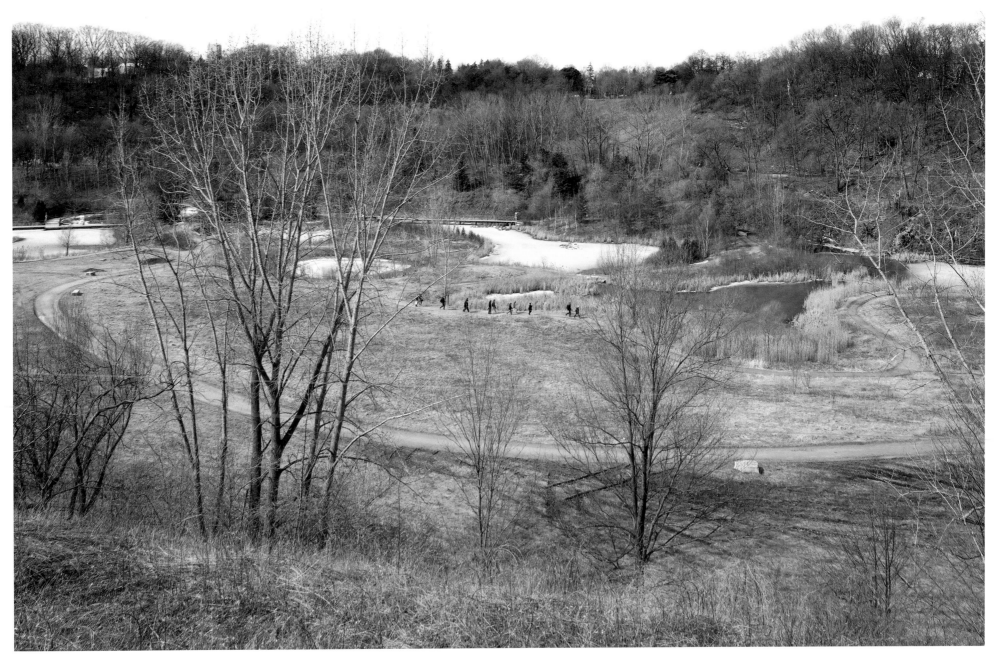

Don Valley Brick Works Park, 2014

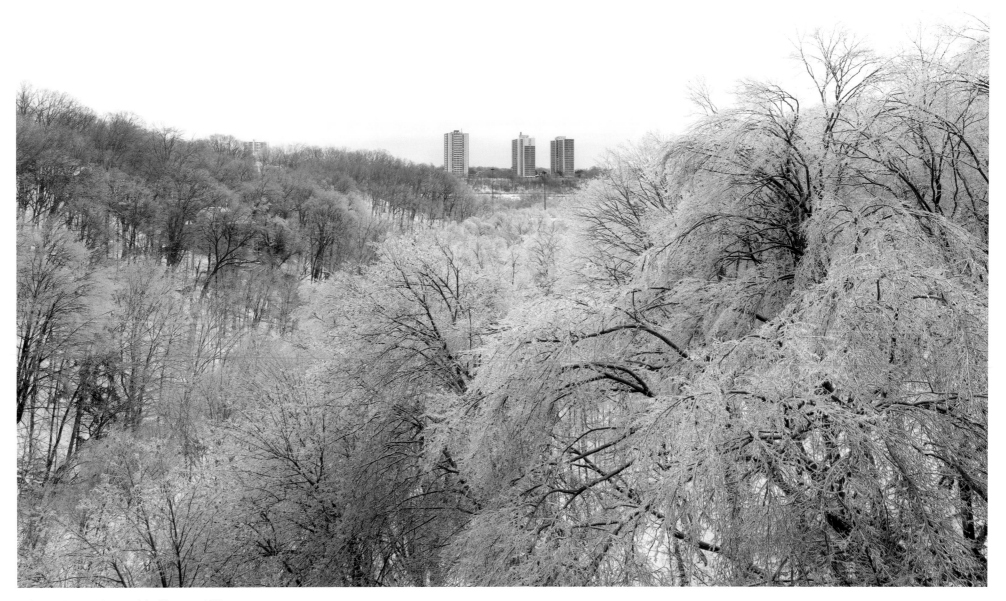

Park Drive Reservation Lands looking east, 2013

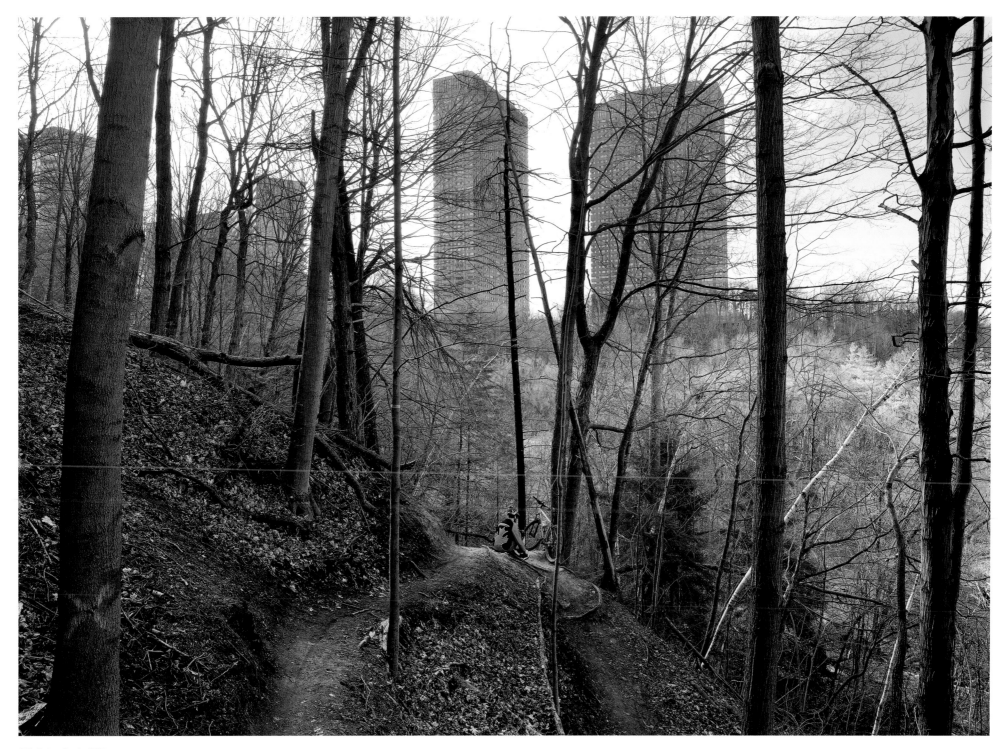

E.T. Seton Park, 2012

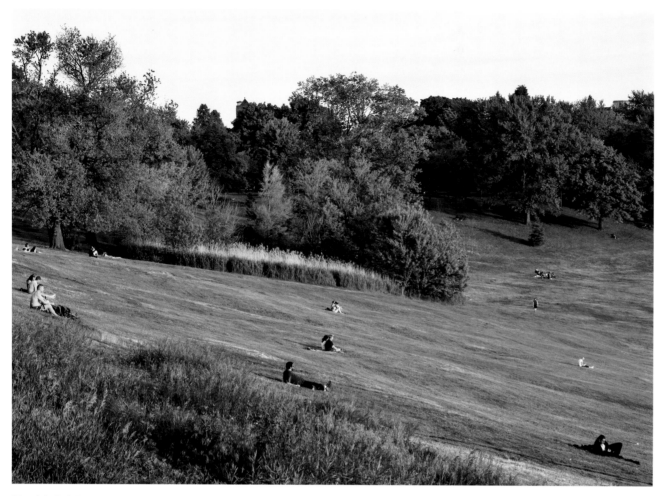

Riverdale Park East, 2014

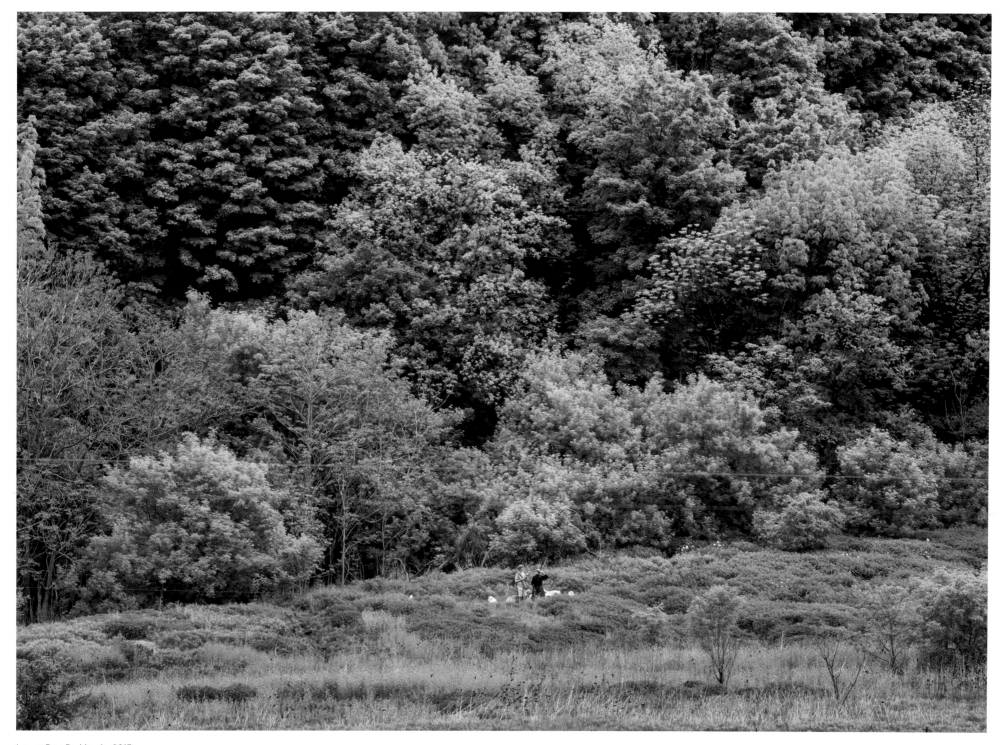

Lower Don Parklands, 2013

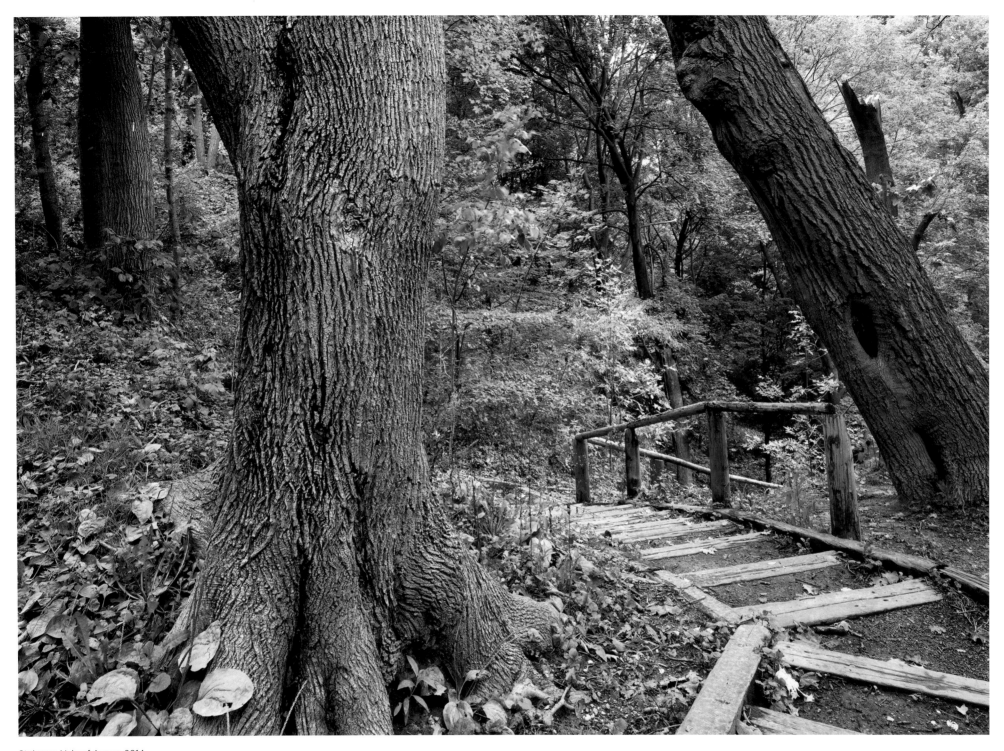

Stairway, Vale of Avoca, 2014

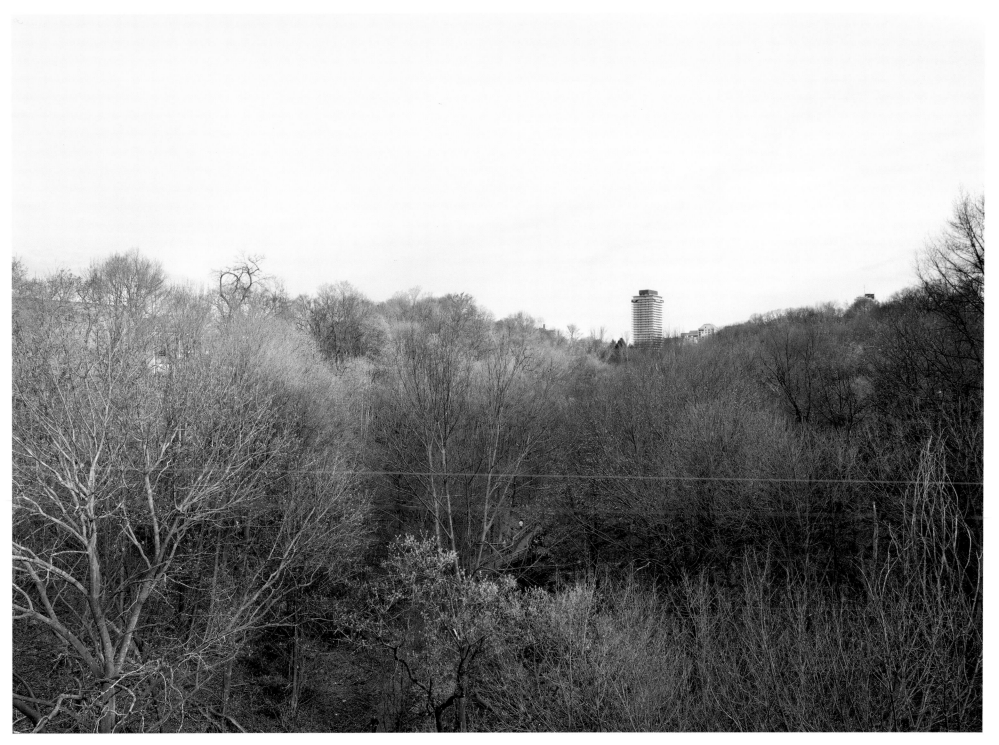

Vale of Avoca from St. Clair Avenue East bridge, 2014

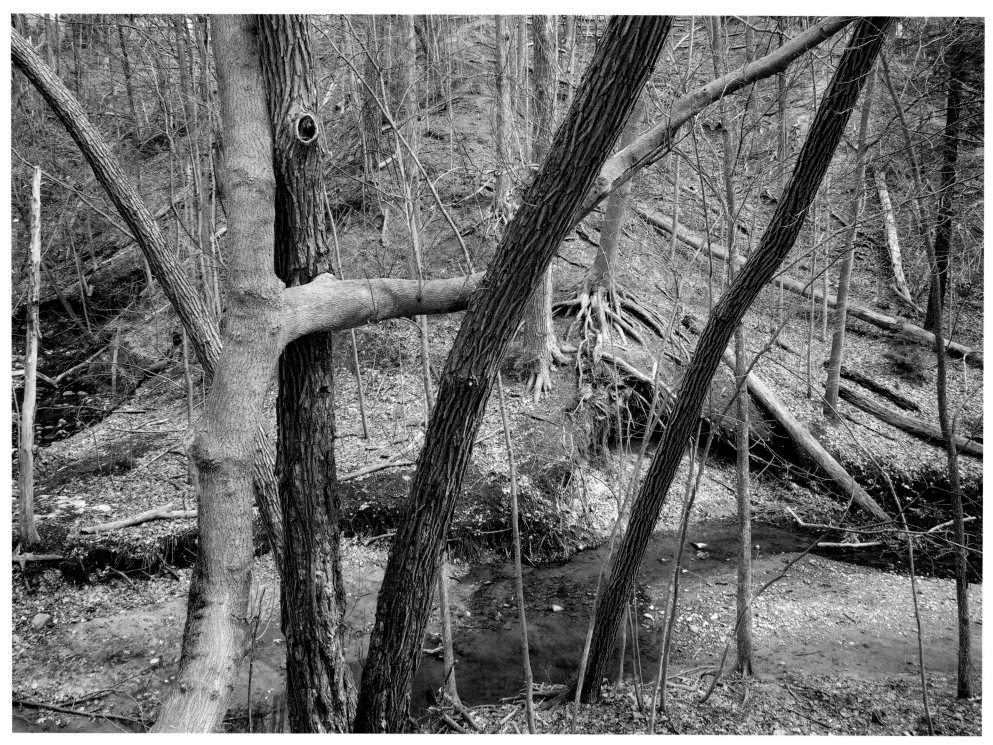

Mud Creek, Moore Park Ravine, 2014

Railway bridge, Moore Park Ravine, 2014

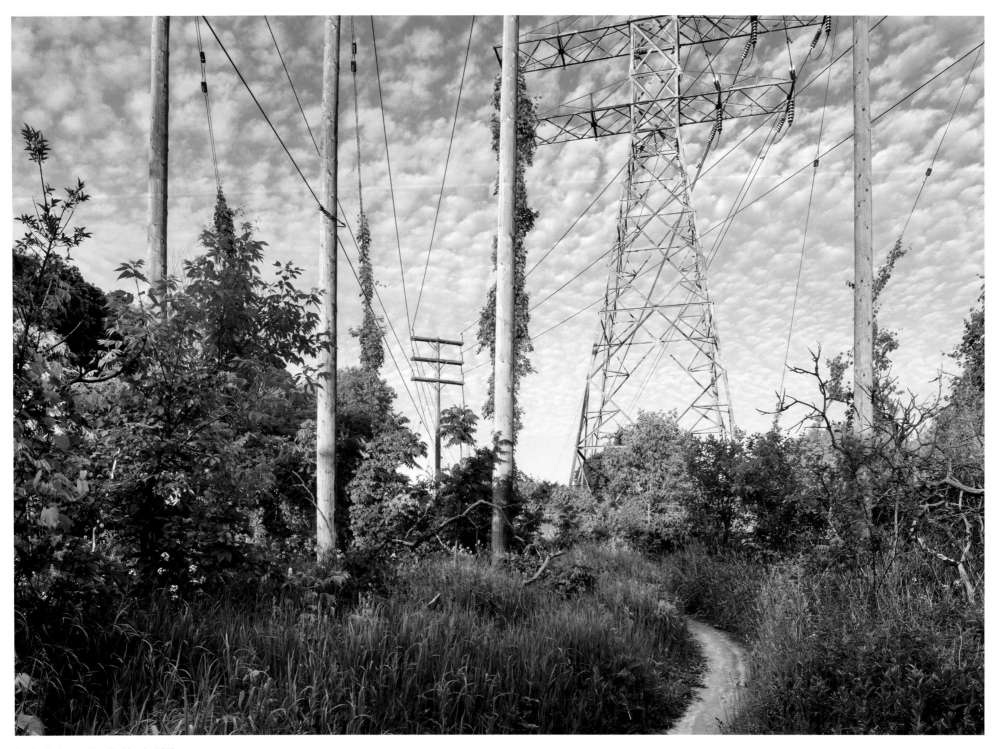

Footpath, Lower Don Parklands, 2016

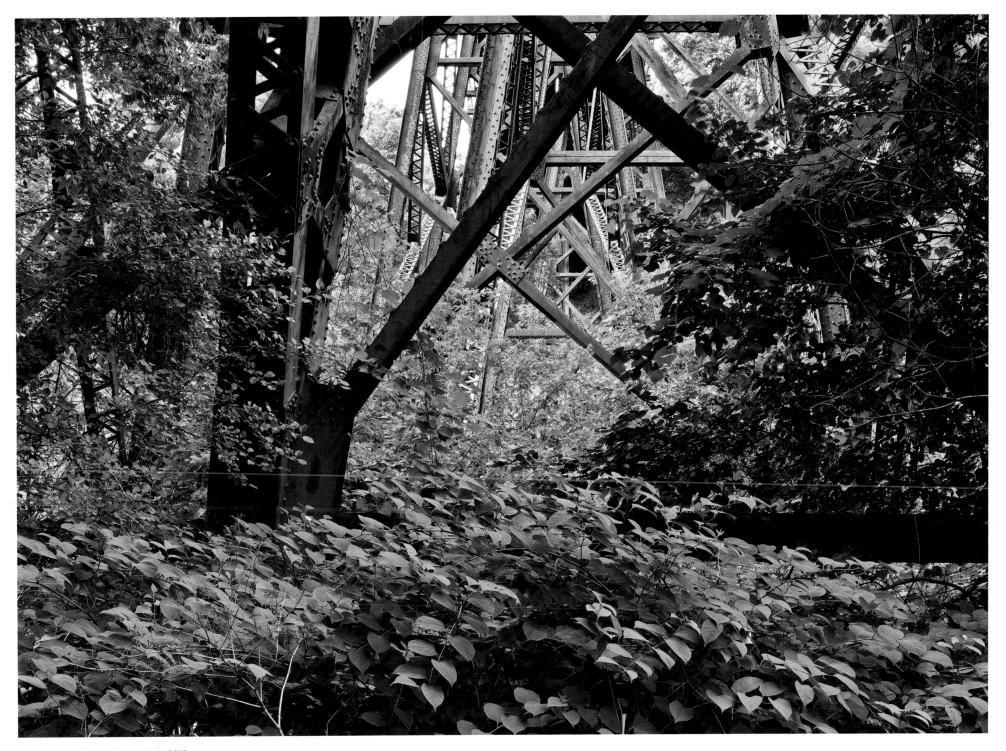

CP railway bridge, E.T. Seton Park, 2012

Catalpa tree, Sunnydene Park, 2016

East Don River, Charles Sauriol Conservation Area, 2016

Wilket Creek Park, 2013

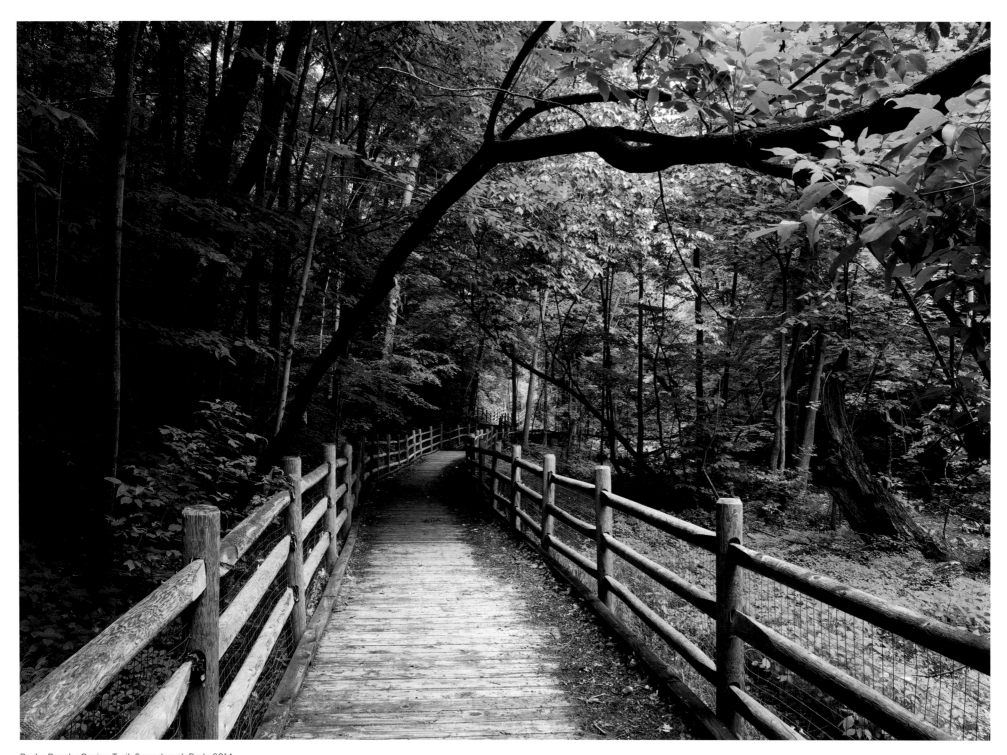

Burke Brooke Ravine Trail, Sunnybrook Park, 2014

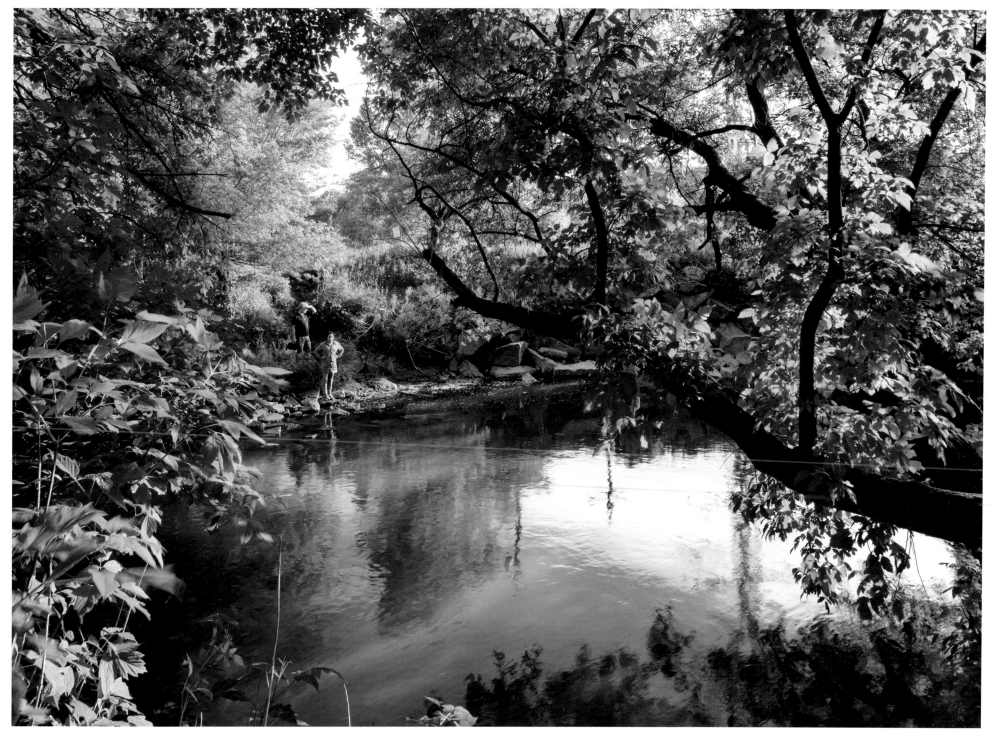

Don River, Crothers Woods, 2016

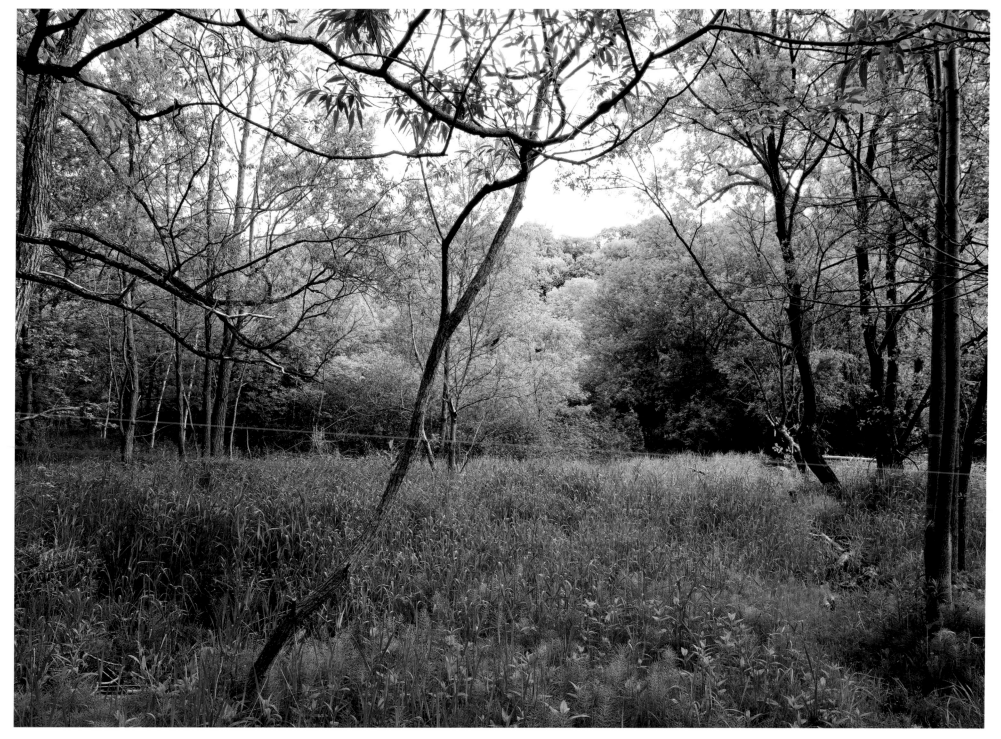

Glendon Forest, 2013

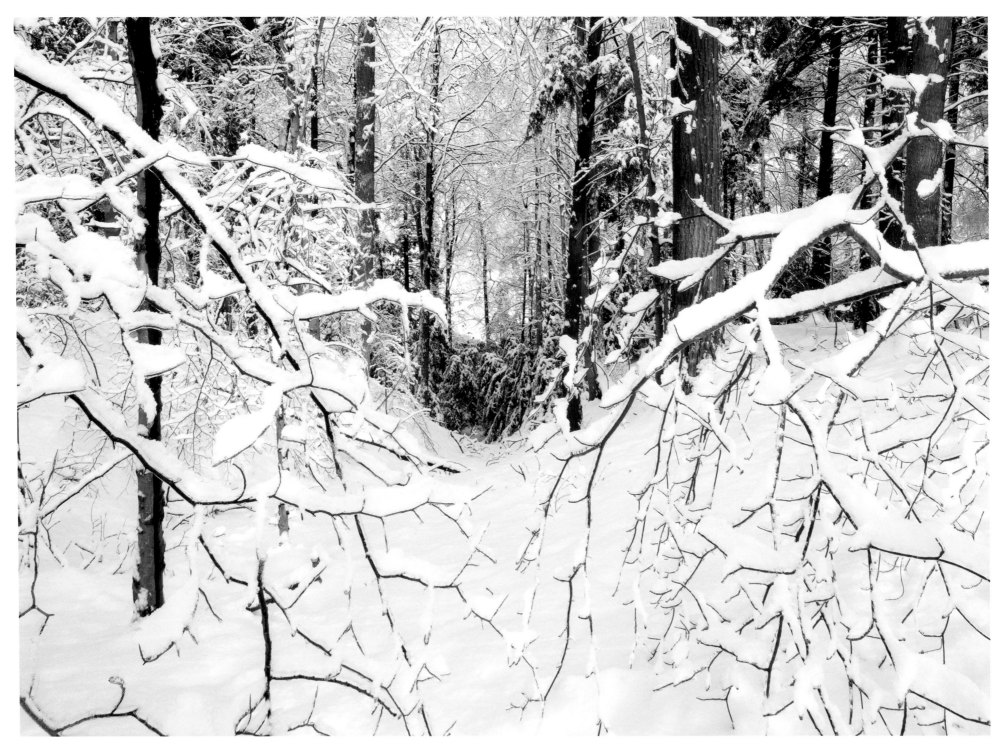

Wilket Creek Park, 2013

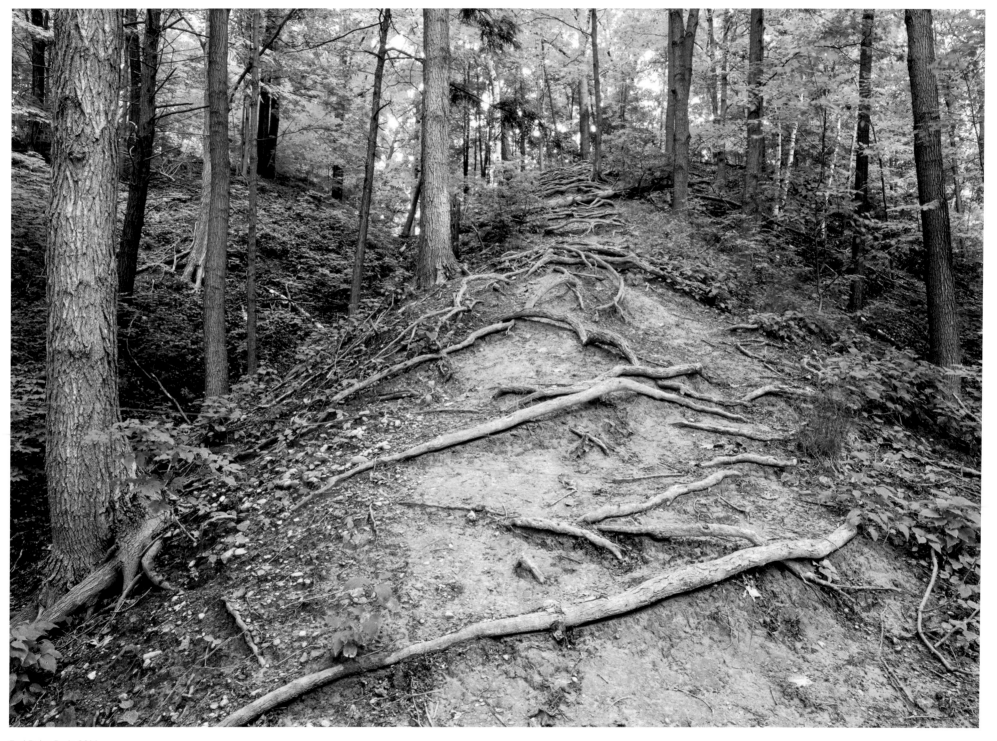

Earl Bales Park, 2014

Colonel Danforth Park

Highland Creek Community Park

Lower Highland Creek Park

Morningside Park

Rouge Beach Park & Rouge Marsh

Rouge Park
(Finch Meander Area, Vista Trail Area)

Forest

THE ROUGE RIVER VALLEY & HIGHLAND CREEK

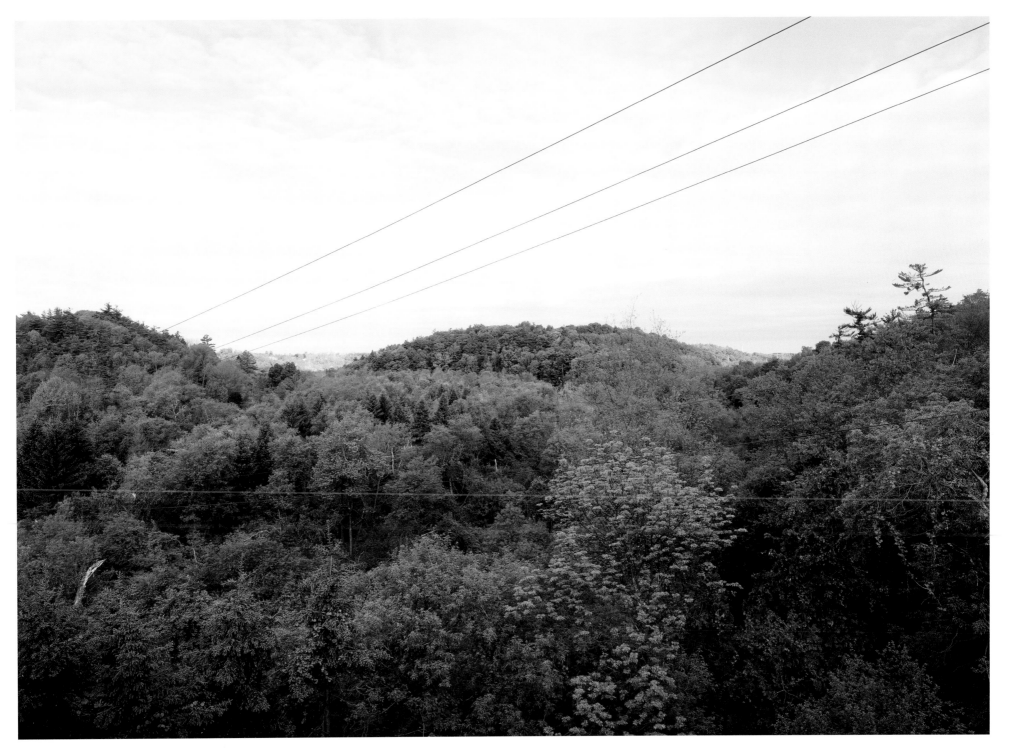

Rouge Park, 2014

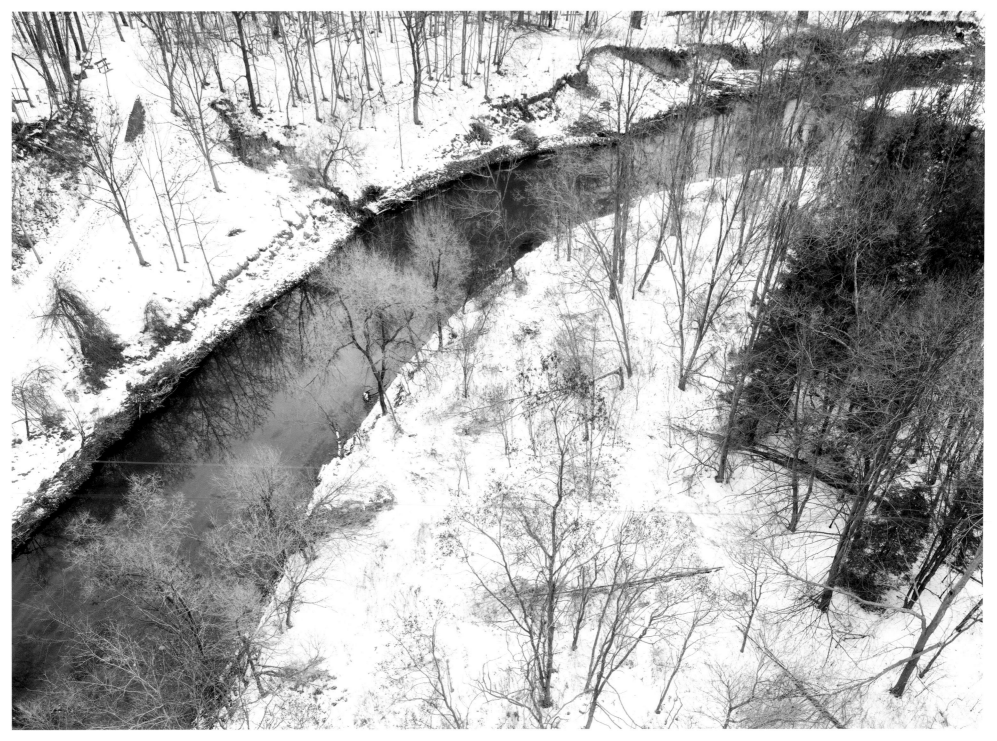

Colonel Danforth Park, 2016

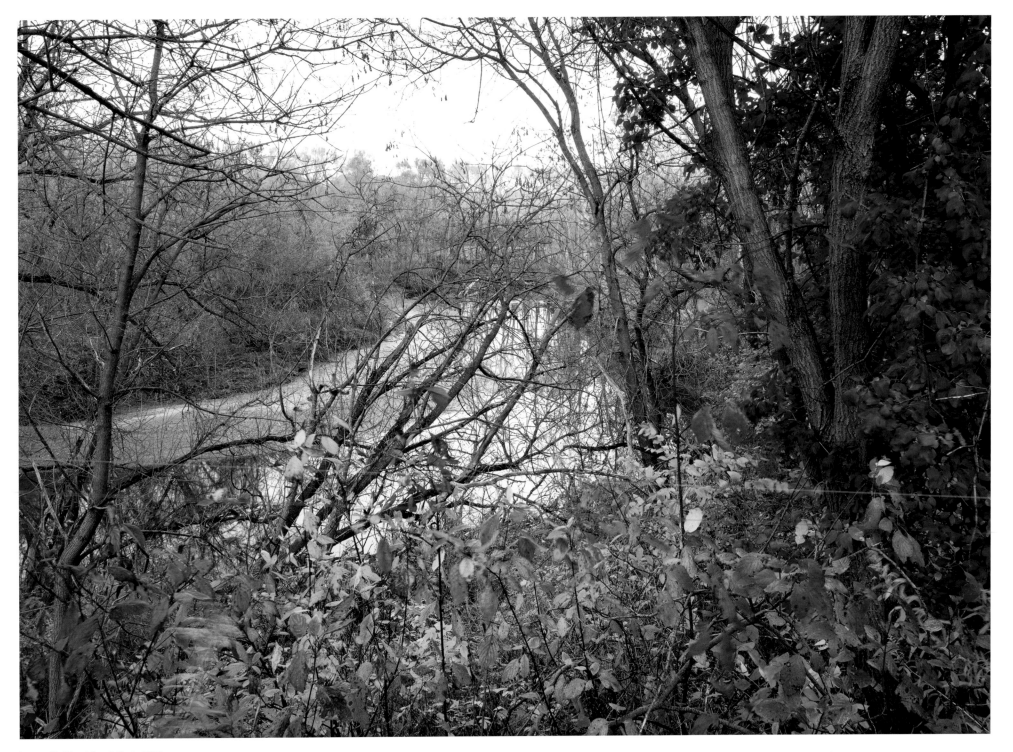

Lower Highland Creek Park, 2016

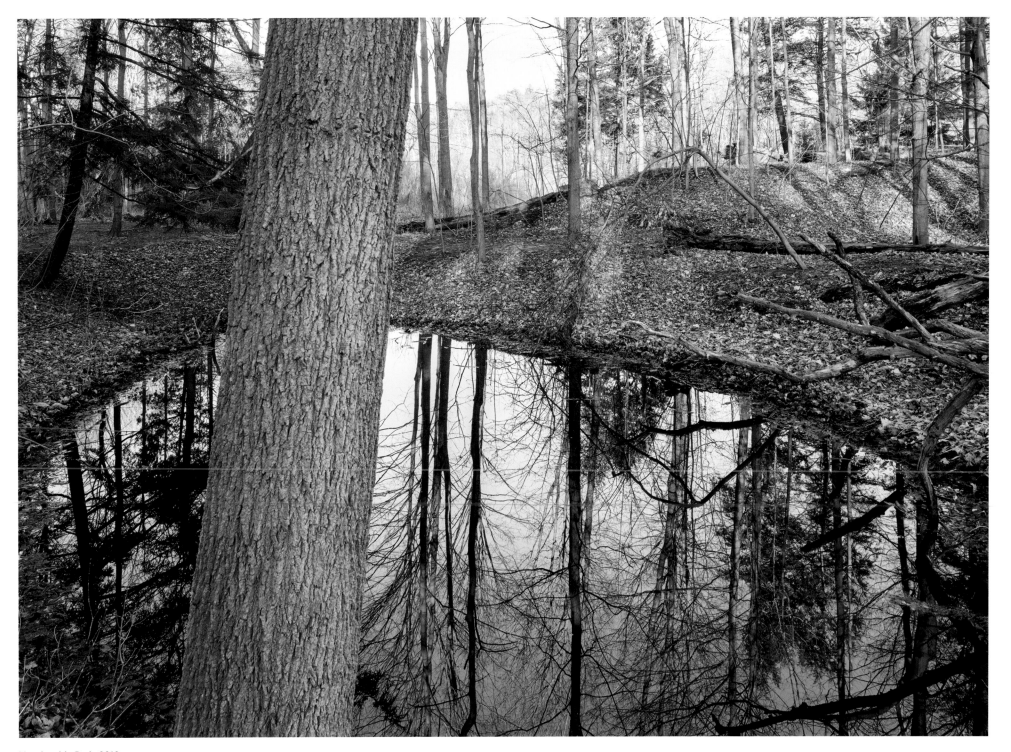

Morningside Park, 2016

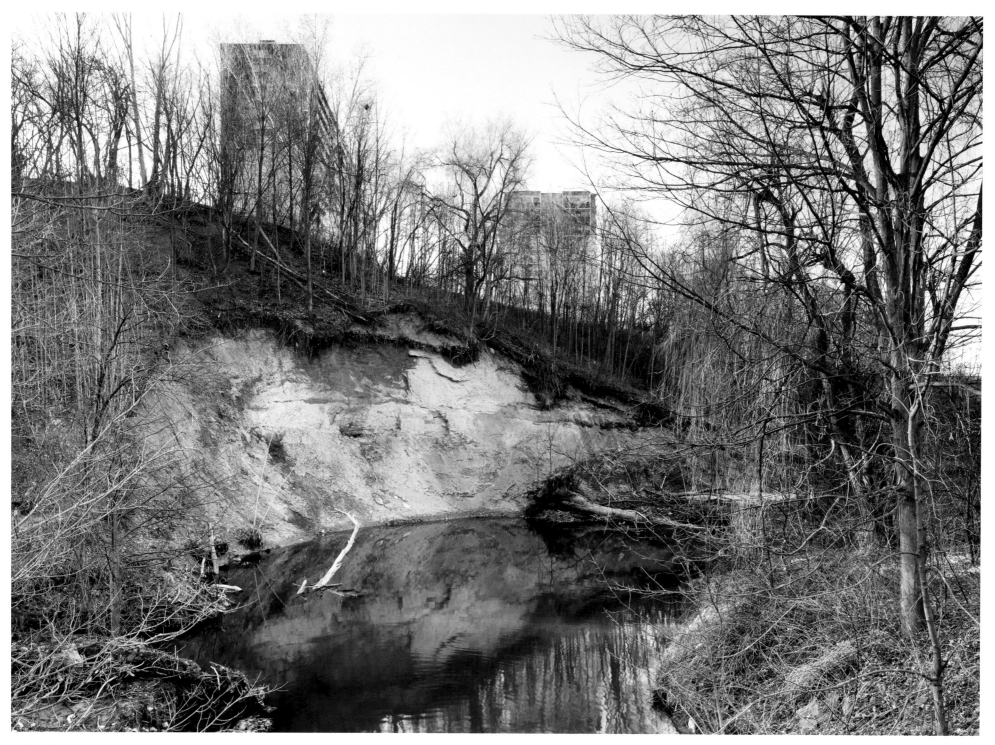

Highland Creek Park, 2016

Highland Creek Park, 2016

Morningside Park, 2016

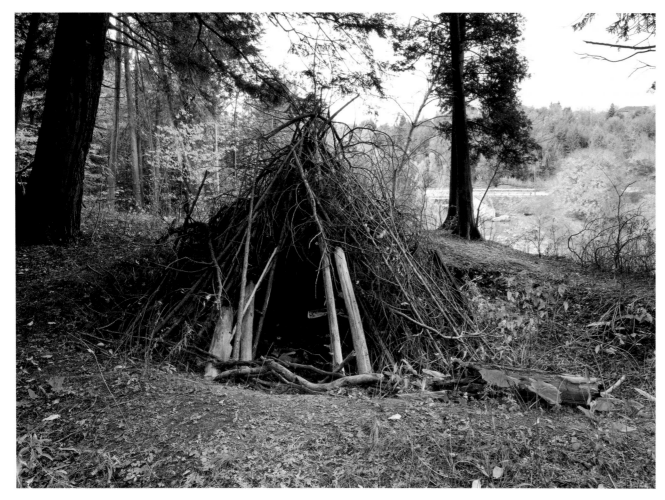

Lean-to shelter, Morningside Park, 2014

Sideways cedar, Morningside Park, 2014

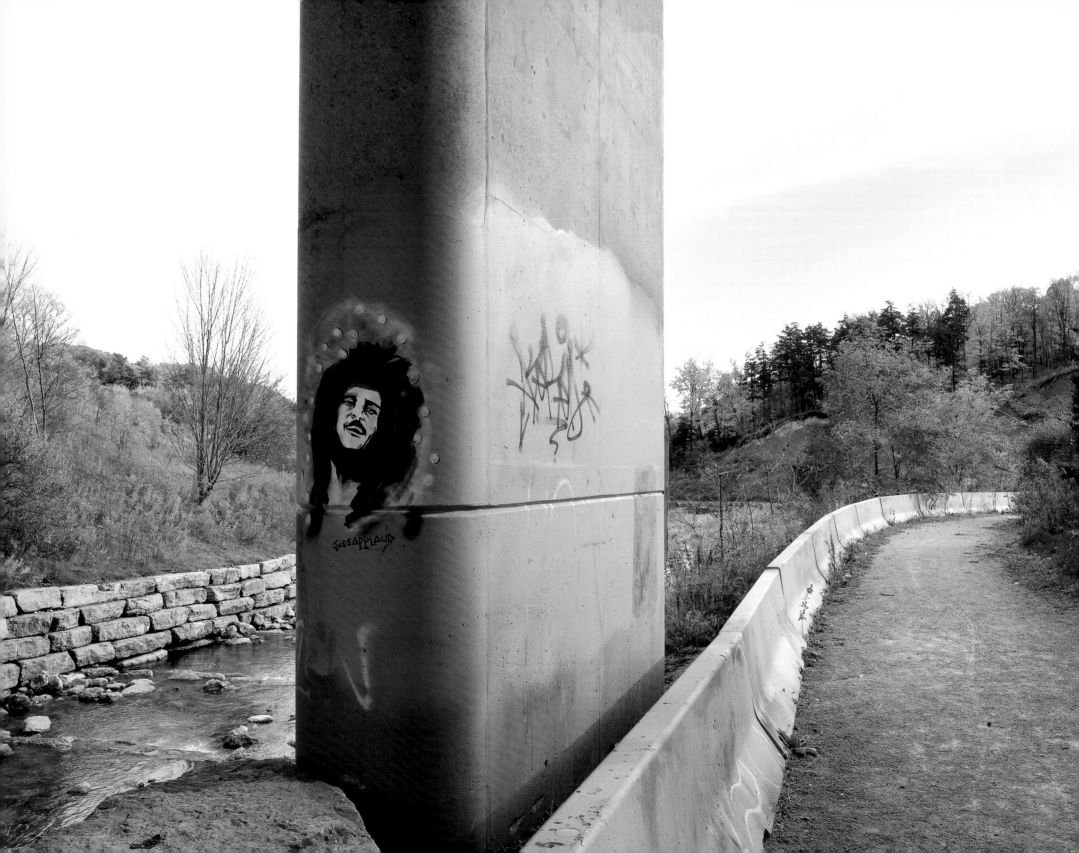

by George Elliott Clarke

Navigating the Rouge (Park[s])

I.

The visitation involves multiple —
if chaotically kaleidoscopic — pleasures.

Yes, I have an Impressionist memory of moors —
English, New Scottish —
Cape Breton's Cabot Trail miraculously displaced . . .

Madonna dei gigli
and me, circulator of word-pollen —
we step over mud puddles thick as jelly.
Green detonates even amid the dirt parking lot.

Two butterflies — Adam and Eve —
chase each other,
insect seraphs.
Trees brush or comb the wind.

The proper vowel unveils the sun:
Behold
brusque *Luminosity!*

Now, see cinnamon-complexioned Canucks pluck
crabs out the creek —
glimmering, shimmering, black and white, wet wool —
plunk em in plastic buckets,
out the Little Rouge —
the watershed twinkling,
wrinkling, among subdivisions . . .

If the marine critters are soon
"dead for a ducat" (as sayeth Hamlet),

still the occasion prompts opportune *Camaraderie* —
a whole clan wading in —
standing, Huck-Finn-poses,
mid-creek, pants rolled up,
while some Heinz 57 mutt yelps, yaps, cavorts,
excited as a crab bites down
on unwary fingers,
or gets exultantly lifted up,
and shifted into the grimy ooze
of a *de facto* honeypot . . .

The brown-green, olive-tint, rushing element,
never tidal, but rippling
wherever the creek cripples
over rocks,
or wherever the cerulean sky encounters
burnt-grass-coloured shadows,
foams up white wine, Champagne,
the frothing churn,
when rocks rupture flow:
Irritation prompts self-irrigation . . .

Beneath surface bubbling, gurgling, burbling —
the garrulous apocalypse —
one eyes silt like moon dust
velvetizing submarine igneous —
not sedimentary —
stone.
Nope, it's all volcanic rock plagued by grit.

Minnows arrow,
motoring through the accumulated smokiness,
the leopard-spot, mottled look of stone roof-slime,

Ellesmere Ravine, 2014

where a collapsed pine branch
drowned,
brings to mind a crone's head —
or Ophelia's —
but face-down, her hair all weeds —
or submerged, Queen Anne's lace —
reflecting the witchery of light,
them abracadabra shifts of shade . . .

Anyway, near us, several trees have caved in,
have crashed down into the creek;
their branches straggle and drag water
and soil and pebbles.

One tree, bent low,
bowed like a fishing rod,
gleams stark white,
save for a fringe of dark-green leaves.

Where we wend,
Ital gal and ebony I
(both Canuck too),
we endorse a *why-not* Romanticism,
with her thigh a-slant,
cambered gainst mine,
while we savour the sizzling light, august —
the sequins of sun,
the sequential sparkles on the winking fluid —
all the green density
and olive immensity
about us,
on the cricket'd banks,
plus the gilt-marmalade marguerites

magnetic to bees,
where we perch and lounge and picnic,
and observe white butterflies
flirting with their shadows mirrored
in the creek's clear murk . . .

We note the verdant backbone of a ridge;
forget driftwood —
lightning-splintered tree debris —
and wormwood,
pocked due to woodpeckers knocking out grubs;
watch a poplar shimmer silver as tambourine music.
(The spindly tree —
fragile as a decayed leaf —
arrows up into sapphire space.)

The black-capped chickadee —
chapel of *Vitality* —
warbles among mostly maple,
a little yellow birch,
in chime-chafed, chirp-strafed air.

Now a papa and his *fille* tread by,
and we say, "Hello, hello,"
while cattails —
those stunning, copper cylinders atop lime stalks
confronting a pebble strand —
wave to-and-fro across from us,
beckoning on
Hunger reckonings
and *Thirst* reconciliations . . .

Anyway, no deer saunter across our path,
while our lips feed on each other
like plants,
sucking, slurping, distilling . . .

The rug of green grass yields
luscious luminosity to fielded skin,
silvery and mahogany.

Across the way, junipers resolve to be cedars —
frondy, lacy;
goldenrod clarifies itself as ragweed.
Yellow flowers comet over groundling grass.
Where *Day-Glo* mauve flourishes,
gentian and vetch advertise *Beauty*.

Aye, all's bucolic here,
but the year is MMXVI,
and car engines intrude their murmurs
and car tires swish, swish, swish,
and a chord-organ train horn
throbs through our idyll,
and the droning passage
of a propeller plane
skews eyes skyward to view
a *Sci-Fi* crucifix,
its invisible messiah sighing,
"Don't Think Twice, It's Alright."

We're secreted — she and I —
somewhat,
from stretching, voyeuristic skyscrapers,
from howling sirens, moaning bullhorns, screeching brakes,

from all the ways that Greater Toronto imposes
its presence.
Here, bees resemble somersaulting agates,
gilded coal,
and glittering dragonflies hook to branch tips
to snatch at dullard mosquitoes,
whose whining is finale,
and grasshoppers,
their fuselages resembling knife handles,
crinkle legs into air.

In the swirl of our sloppy vortex
of kisses freshly accrued —
tireless lightning —
we drowse, we thoke
(bask)
like wildflowers pendant on ponds.

I feel the soft arch of her foot
cupping my shin,
as wind jangles silver leaves;
but they're not coins,
they're more like dollar bills —
green that means silver —
rustling —
echoing capitalists-in-a-hurry —
hustling, bustling —
that bunch of *Inadequates*,
seeking viable lives.

On the creek bank, we lovers lie,
peeping at galaxies of leaves,
the ceiling —

the sky-limit —
of our Joy.

(Later, moonlight silvers the page.
It's stable silver, this light —
never tarnished.)

II.

August segues into October —
août gives way to *octobre*
and we venture to Botany Hill
(a "natural regeneration area")
and marvel instantly at a green-furred pine,
basically a woolly mammoth,
lumbering, stooping,
near where red maples take on an anarchist black;
and now a bird caws;
its brogue burrs past our ears,
while car tires shirr in the dewy street adjacent.

Where we step, rain-dusted grass
darkens shoes,
passing the off-leash park,
where a sign intones,
"Dog people, obey:
Do your duty after your pet does theirs.

"Appreciate that pit bulls and female dogs in heat
ain't permitted to run free,
and all dogs must be under voice command —
like school kids."

(There's an empty playground at the park's entrance.
Clearly, the patrons are in classrooms: Imprisoned.)

"Holes dug by dogs must be filled in by owners —
who must play shallow gravediggers —
immediately.

"Remember: An average-sized dog yields
124 kg of poo —
shoe-sole coating —
per annum."

Moral: Free-range citizens —
like canine, feline, or feral clerics —
are dangerous, uncollared,
unleashed . . .

(Note the jostling of poets as maps open —
or governments set up shop —
thus factioning the citizens.)

Abandoning these Aesop commandments,
we are curtly informed,
we're way too late for The Salmon Festival
at Highland Creek . . .
Tarnation!
We can't catch anything now but a cold . . .

Amid barking, we stray
toward a tree flagrantly scarlet,
outshining flora all rust and withered,
or dull yellow, dark purple, dingy orange.
Here is sylvicultural *Communism*,

The Great Proletarian Cultural Revolution,
wherein *Red* redefines *Green* . . .

Passing elephant ears,
we sight a bushy-tailed rodent
squirrel itself away from sight,
as if we were predators.
No, we're no hunters,
even if "tis the season" . . .

G. breaks off a piece of juniper berry,
whose scent restores to me
the long-lost eucalyptus pip of Rodos,
where *Love* gave scents
freshly pungent sense.

(There was there, lavender among olives,
lavender among lemon and orange.)

Into Morningside Park —
"the largest remaining forest stand
in the Highland Creek watershed,"
we ramble among bush-brandished, blue berries
that'll succour birds when bugs disappear,
come blear, withering November,
when snowflakes —
wet lace —
hang white Victorian curtains.

(You need snow to keep the insects down.)

For now, bees pollinate purple cornflowers
or zigzag through goldenrod,

the latter sometimes yellow still,
but here-and-there browning,
turning dry, dour, and dun —
like Tennyson after Browning.

Apartment buildings, townhouses, a hospital —
plus electricity-threading, spindly towers —
all overlook the ravine,
and spy out lovers,
or stare at, peer at, interlopers —
or buzz about eccentrics
(nudists in snow, when snow there is,
or summer prey to mosquitoes
twirling, swirling
to make moon landings on buttocks) . . .

Right now, we witness florid depressions, burrows,
hollows —
lemon-lime, orange-rust, cherry-red
(cough-drop colours) —
and approach, peer into,
but don't enter
a tree-branch-formed, external cave,
carbuncling the hillside.

Close-up, butterflies seem to breach
the grid of the power tower wires,
but one has to be observant
and imaginative
to snare the illusion —
this idea of *Liberty*.

G. hands me seedpods, opened:
The innards are glossy,
shimmering like the souls
drafted for Dante's *Paradiso*.

We absorb, glancingly, a dead tree
springing red-leaf vines,
wild grapes busily cultivating the cadaver.

Rosehip bushes bob flagrantly crimson —
like the Maple-Leaf Flag,
defying sneak attacks on our Peacekeepers.

A chipmunk, all Dizzy Gillespie-cheeks,
soundless as mist,
slips behind a log
as G. *et* me reconnoitre a sloped path,
a youth-trod shortcut branching to a six-lane street —
a highway in suburban disguise —
where speedsters rush so pedestrians risk all,
even if they stick law-abidingly to sidewalks
and crosswalks . . .

Mushrooms have sprouted, harmonizing
with the fecal, acrid scent of *Decay*.

We descend now to the creek, where it flits
neath an overpass,
whose support columns picture Picasso graffiti —
pastel splotches of cream, pink, and sapphire.
Here we observe sudsy stuff,
tumbling the terraced waterway,

the liquid therein so low,
it's practically groundwater made visible.

Each petite waterfall avalanches bubbling snow —
as if glacier-kinky,
or loose, sodden, ash-tint squalls.

True: The creek butters pancake flats,
steppes;
its banks are man-cut granite slabs —
like butter pats —
sandwiched atop each other to forestall
Collapse,
of weak earth into stronger water . . .

Hear the crush, crash, of the creek,
a liquid quaking
that quickens the heart.
The current drowns itself in foam.

Most astonishing here be skull-sized boulders —
all uncatalogueable shapes and shades —
tumbling from the bottom of the overpass,
downslope, to the creek-side path,
but all frozen — fixed — in their gown-like sprawl
by concrete that still looks like cement —
fluid —
but solid now so as to deter erosion.

The half-lava-look of the cascade,
the Chinese-fan-style rockfall,
is like Lego blocks melted down,
gone half-plastic and half-pebble.

Streetlamps bend low over the overpass's lanes
while electrical transformer towers —
ugly, skeletal pylons —
step like colossi across the ravine,
as if it were a landed, Nordic version of Rodos,
the isle metapmorphosed here into a *cañada*,
with sumachs outrageously red and green —
Christmasy in colour —
but flailing black or dark-grey limbs . . .

Those skinny messengers of thoughts and of *Power*
keep an eye on us,
and inspect our conversations,
eavesdropping on keystroke and whispers,
unless, like Julia and Winston in *1984*,
we can hide away, for an hour or two,
out of sight and out of earshot,
in these woods,
our locale of organic *Freedom*,
what *Love* demands . . .

Shortly, we make our way back up the BH18 trail,
where poplar trees are coded as "Issued Out to Job."

I touch a tree trunk:
Leaves splash down,
aubergine or sunflower in tint.

We are inching toward the high-pitched chill
of blizzards,
the unalterable *Alteration*
that each reborn season brings.

As vagabond as drifting leaves,
we leave for a "Roissy *soirée*"
(a Beardsley-illuminated,
Glassco-translated
Histoire d'O),
in pale, purple dusk,
the peaceful burning —
Arson —
of streetlamps versus night,
to treasure the *Pleasure*
of *Civium Libertati*
("To citizens, Freedom!"),
to savour the forest's true taste,
to imbibe intact *Nature* —
the blue of grapes,
the red of wine —
while our twined flesh becomes
embroidered foliage —
gold and ivory, alabaster and copper —
and this ink, these words —
poesia della terra —
stream
into the cavern that's *Eternity*,

where all us one day must park.

Macdonald-Cartier Freeway, Rouge Park, 2014

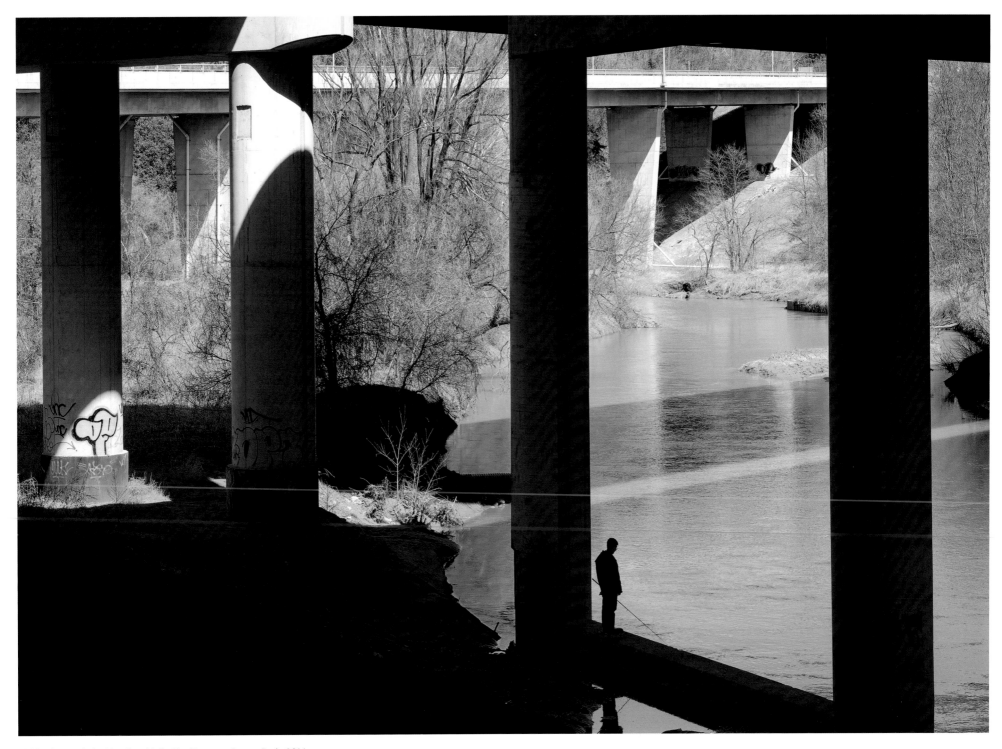

Fishing beneath the Macdonald-Cartier Freeway, Rouge Park, 2014

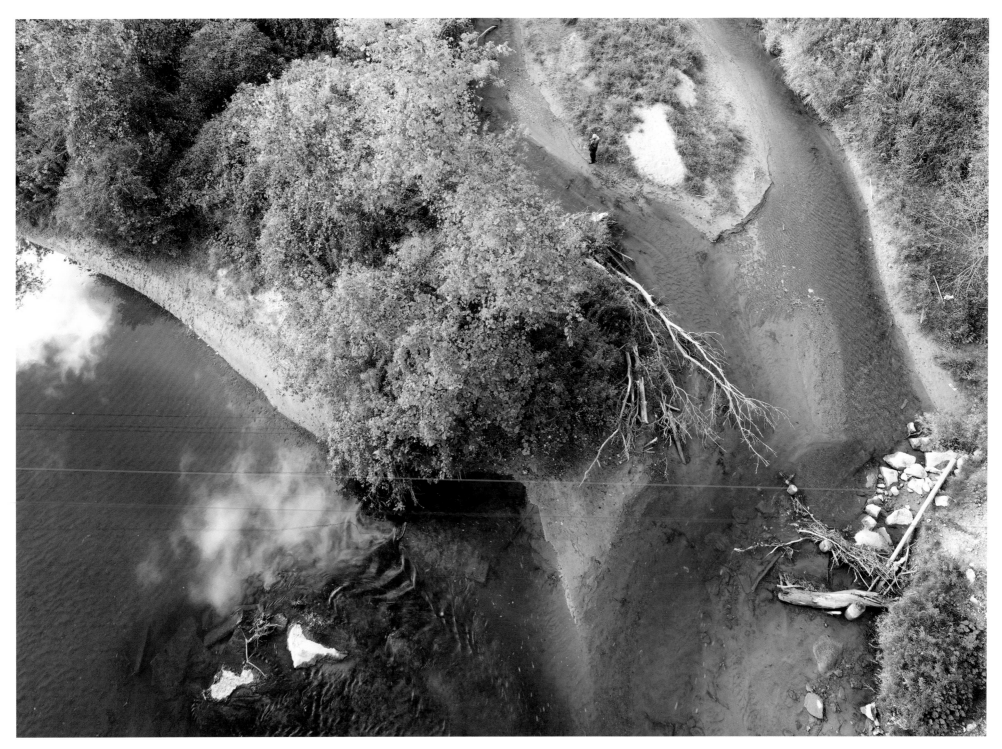

Forks of Rouge River and Little Rouge Creek, Rouge Park, 2015

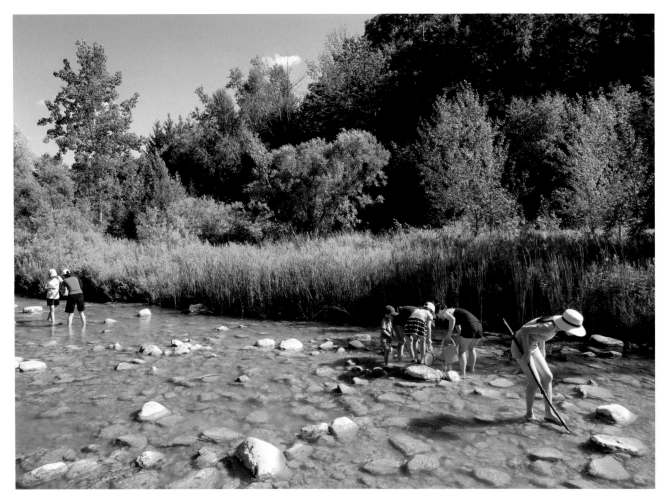

Searching for crayfish, Little Rouge Creek, Rouge Park, 2016

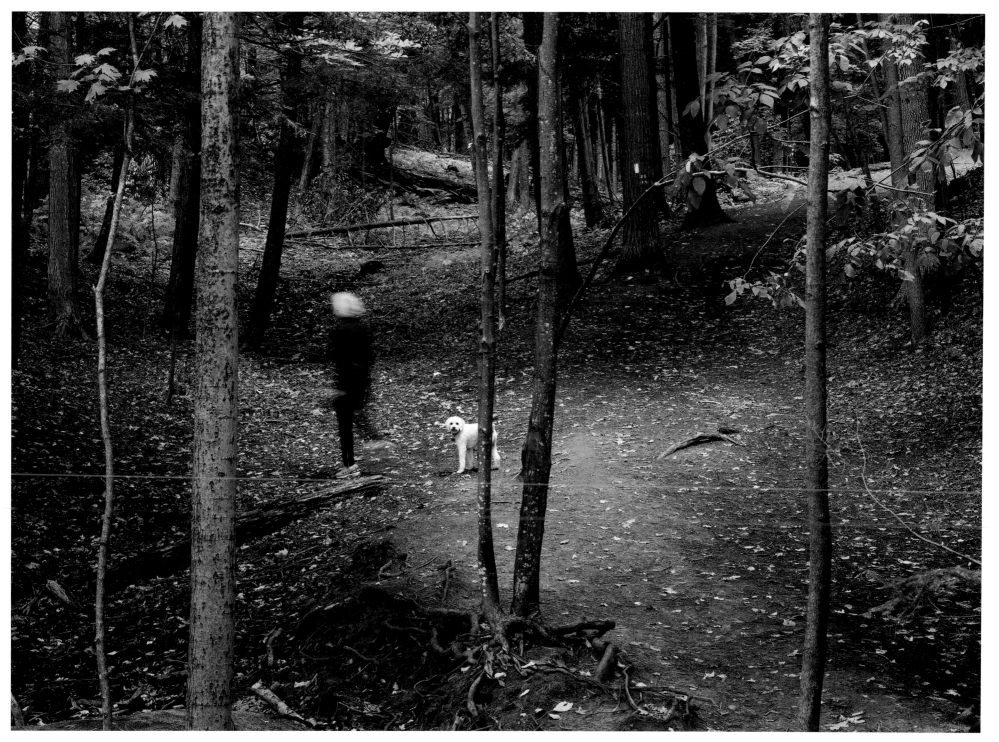

Glen Rouge Trail, Rouge Park, 2016

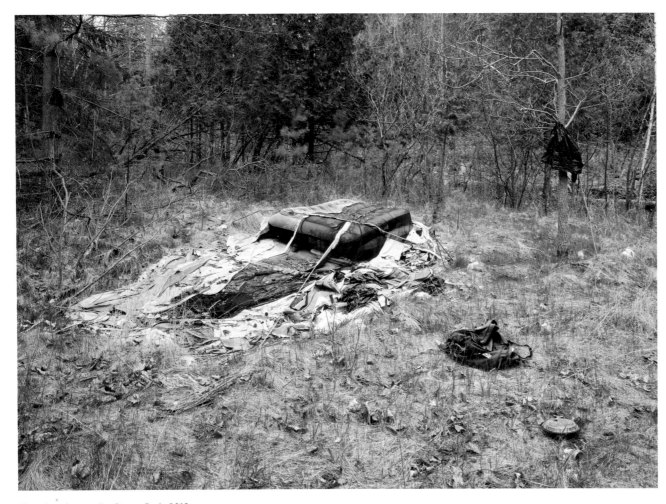

Abandoned campsite, Rouge Park, 2016

Wildflowers, Rouge Park, 2014

Woodland Trail, Rouge Park, 2016

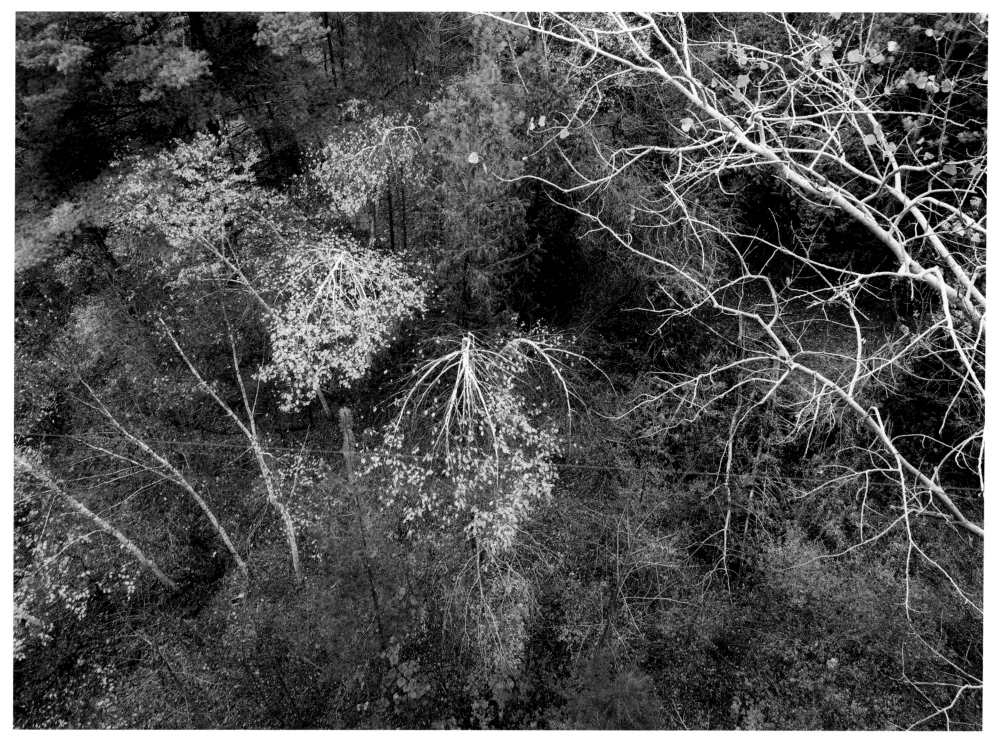

Rouge Park from Meadowvale Road, 2014

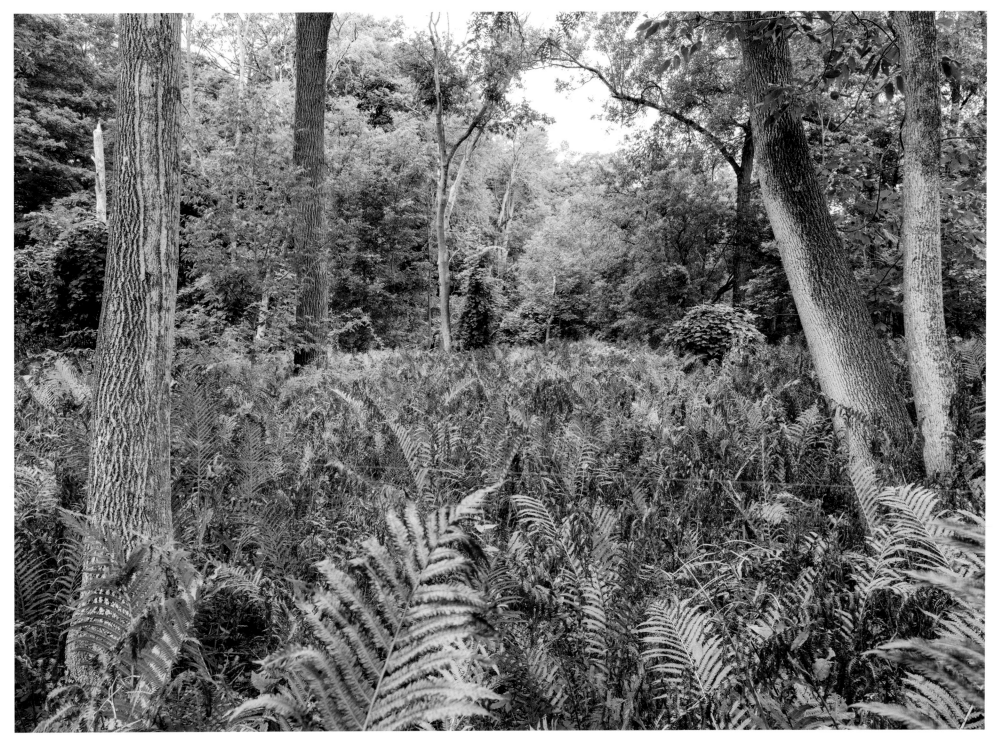

Rouge Park, 2014

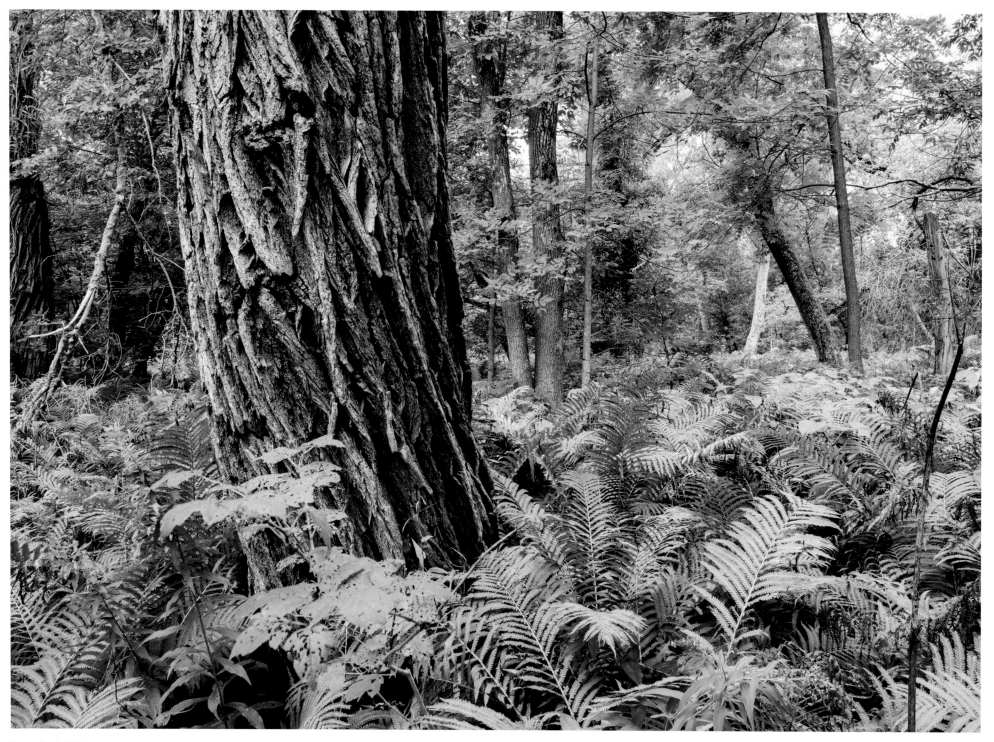

Rouge Park, 2016

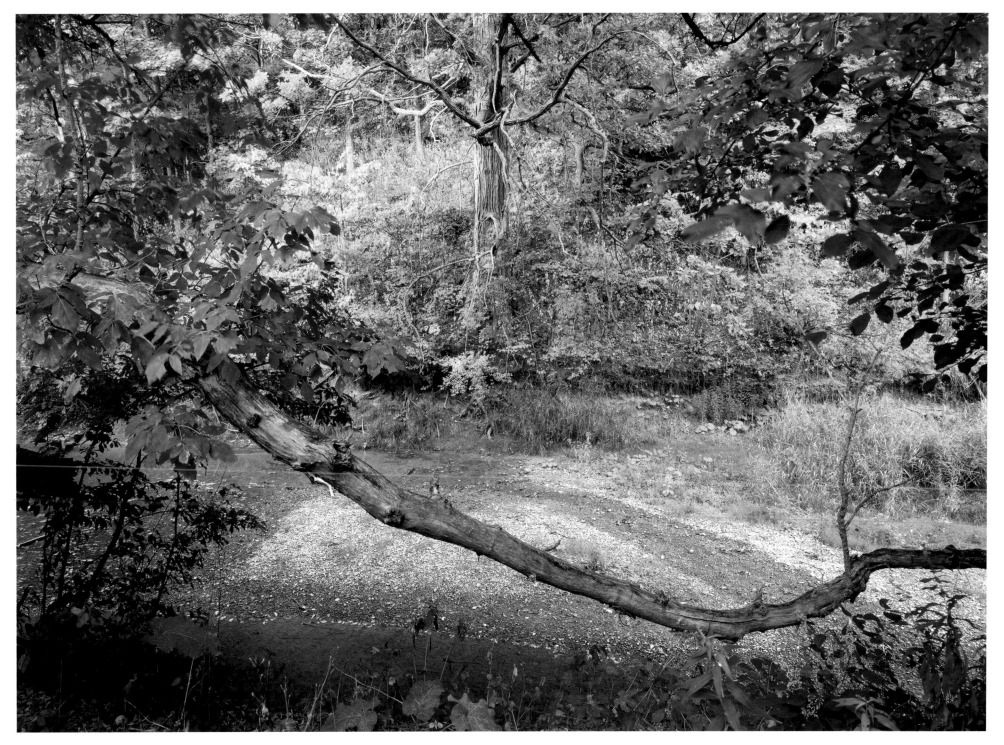

Mast Trail, Rouge Park, 2016

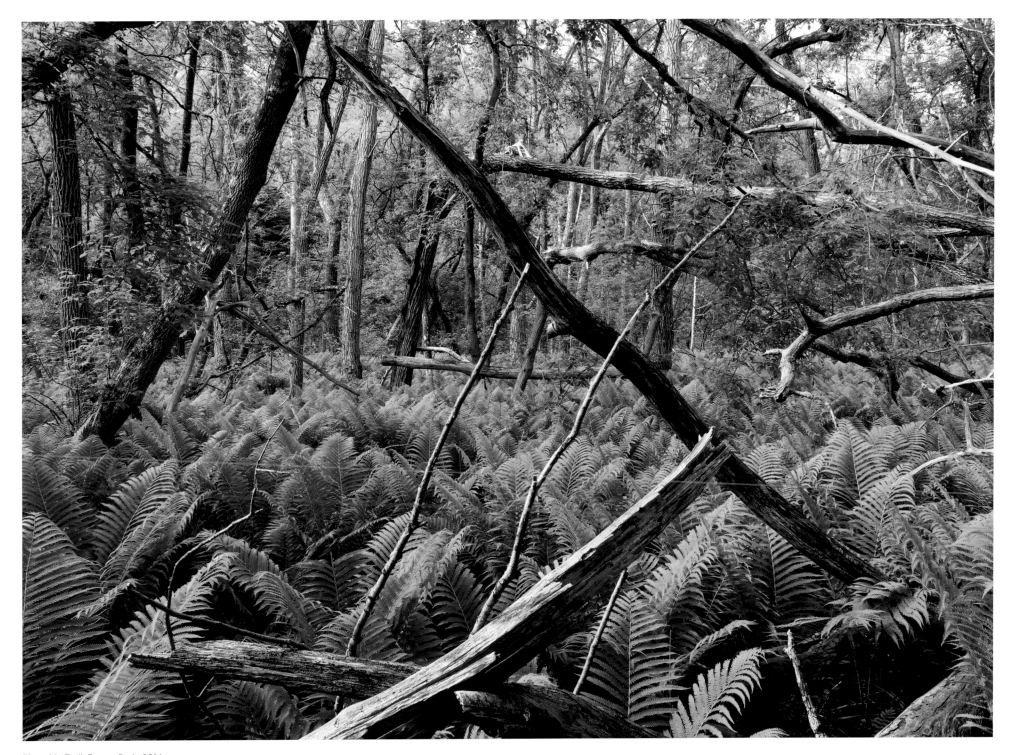

Riverside Trail, Rouge Park, 2014

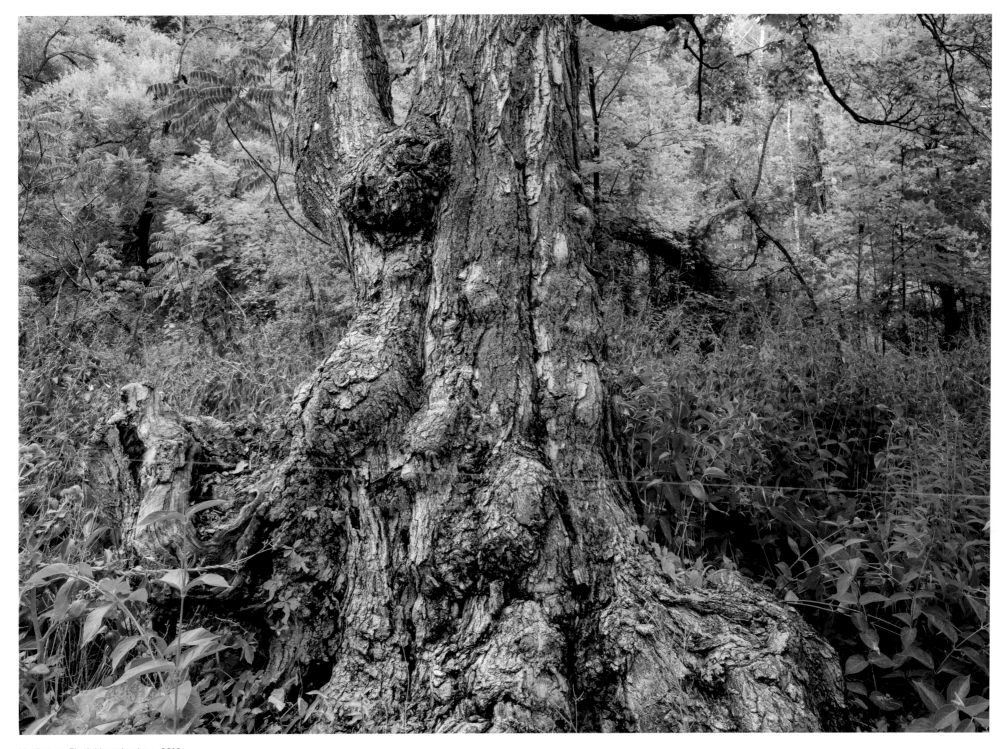

Maple tree, Finch Meander Area, 2016

Felled trees, Rouge Park, 2016

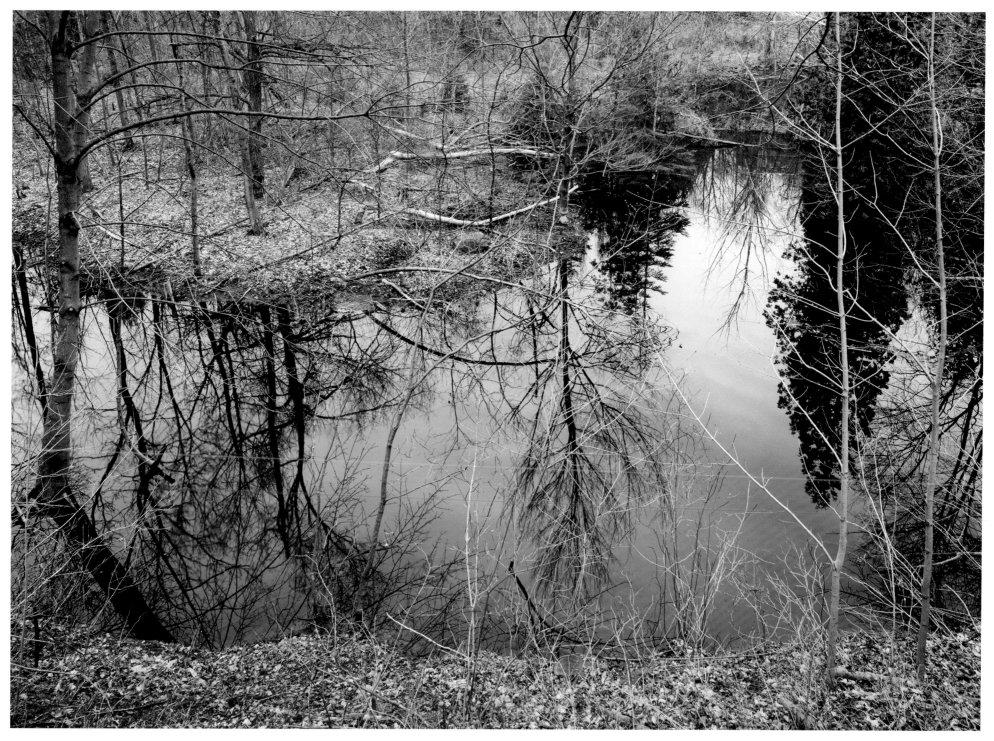

Beaver dam, Rouge Park, 2016

Rouge Marsh, Woodgrange Avenue, 2014

Rouge Marsh, Woodgrange Avenue, 2014

Rouge Marsh Area at Rouge Beach Park, 2014

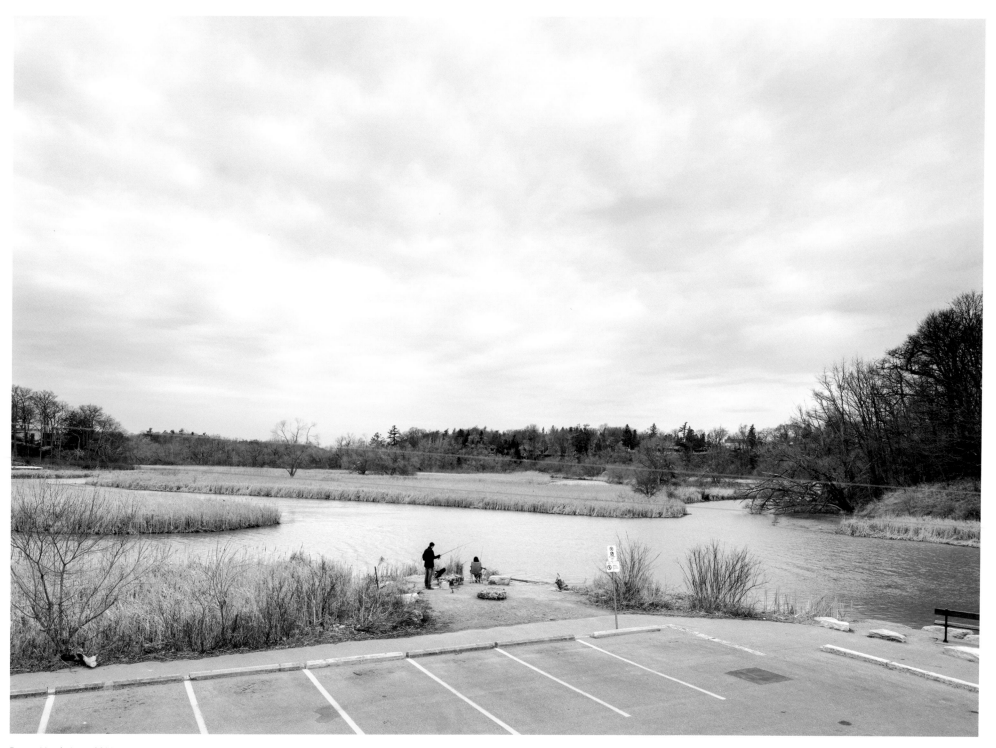

Rouge Marsh Area, 2014

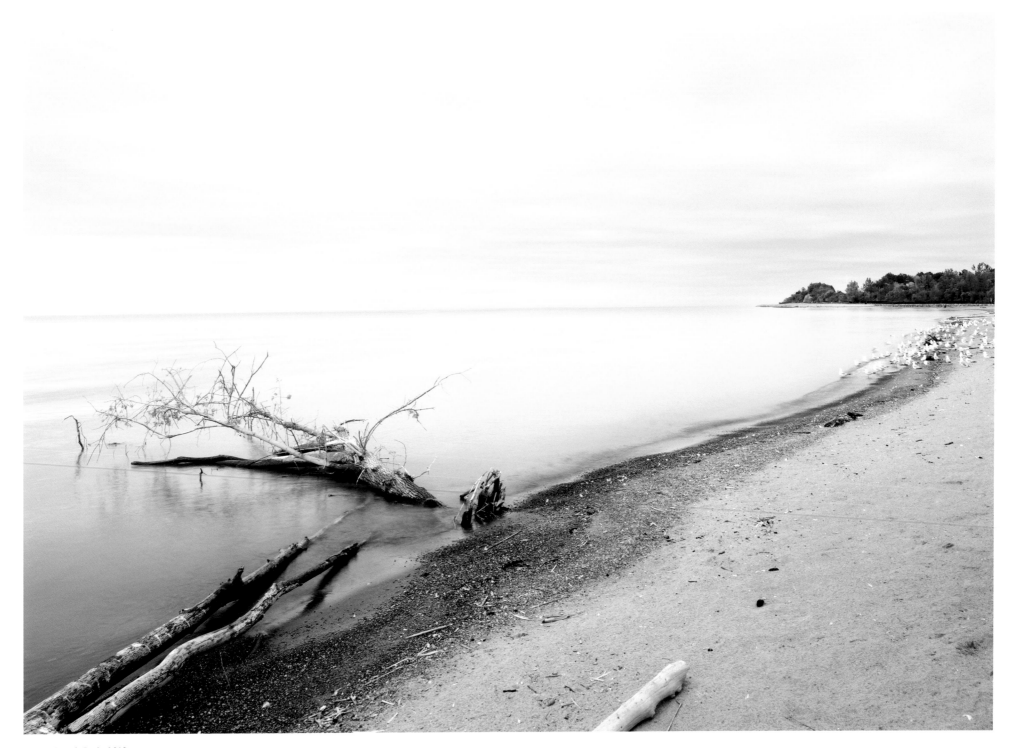

Rouge Beach Park, 2016

History & Appendix

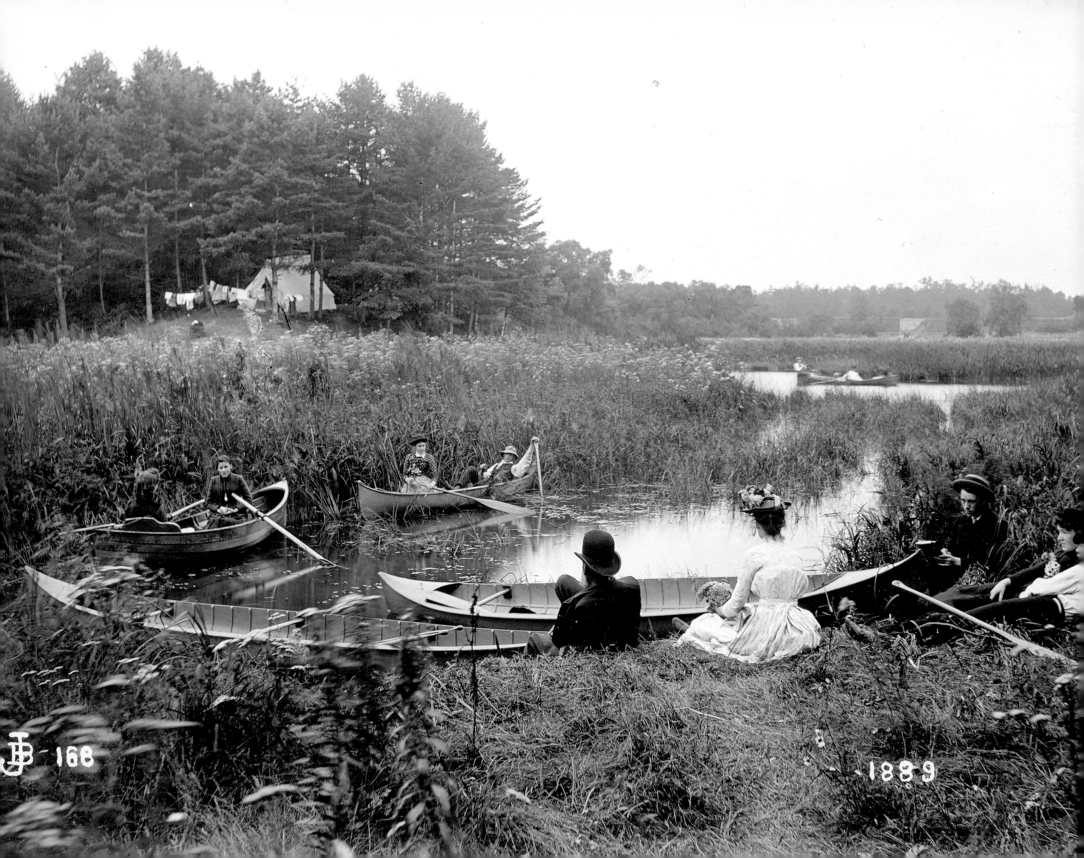

by Wayne Reeves

Imagining, Creating, and Sustaining Toronto's Natural Parklands: A Short History

Looking west along the Lake Ontario shoreline with newly erected tents at the York garrison and ships offshore in Humber Bay, 1793. [Elizabeth Simcoe, Archives of Ontario]

Human engagement with the Toronto landscape dates back some 12,000 years. Indigenous peoples lived lightly along the local waterways and found spiritual respite on what is now Toronto Island. Long after contact with Europeans, and despite the presence of Indigenous villages, campsites, and agricultural fields, most of what became Toronto would have looked like "natural parkland" to modern eyes.

Mere days after the Town of York took root two centuries ago, the European settlers began to record Toronto's natural beauty. This awareness and, more importantly, appreciation were the vital first steps to nature protection by settlers in Toronto. Elizabeth Simcoe — wife of John Graves Simcoe, first Lieutenant Governor of Upper Canada and York's founder in 1793 — was the first to document Toronto's natural world. She explored the Don and Humber Valleys and the lakeshore, including the Scarborough Bluffs (which she named after similar features in Yorkshire, England) and the Peninsula (later Toronto Island). Her adeptness with both brush and pen surfaced when her diaries were published in Toronto in 1911.

Starting with surveyor Alexander Aitken in 1793, technical perspectives on the land and its natural features provided a glimpse of a time when nature dwarfed the settled scene. Toronto's nature became a focus of scientific interest in the 1850s. With the founding of the (now Royal) Canadian Institute by the city's engineers, architects, and surveyors, including Sandford Fleming, in 1849. Fleming was the first to posit an eons-old interaction between the eroding Scarborough Bluffs and the discharge

of the Don River that created Toronto Harbour. George Jennings Hinde's paper on the Scarborough Bluffs in 1877 first recognized an interglacial formation in North America. The earliest watershed mapping of the Toronto region dates from the late 1880s, thanks to an engineering quest to find a new source of drinking water for the city. In 1913, A.P. Coleman authored the first comprehensive geological map of Toronto for the Ontario Bureau of Mines.

For some property developers Toronto's natural features were an obstacle, but others capitalized on the topography. Grand estates lined the brow of the Davenport Ridge, named after a house built there for John McGill in 1797. (Davenport is gone, but later mansions like Spadina and Casa Loma survive.) In 1854, Rosedale was designed as a community of curving streets — said to be the first of its type in Canada — in response to the local ravines.

Toronto's scenic features became a selling point of the city in the 19th and early 20th centuries. While urban streetscapes and key buildings were predictably featured on souvenir publications, lithographic wall-hangings, and stereographic and picture postcards, the Rosedale ravines, the Don and Humber Valleys, Toronto Island, and the Scarborough Bluffs captured a different spirit of the emerging city.

Long before public parkland existed, Torontonians turned to Toronto Bay, the Don, and the Humber for bathing, rowing, sailing, and canoeing in the summer, and skating, curling, sleighing, and iceboating in the winter. On the Island, riding and shooting gave way to picnicking

Boating at the confluence of Mimico and Bonar creeks at Lake Ontario, 1889. [Josiah Bruce, Archives of Ontario]

Bird's-eye view of Toronto, 1893, by Barclay, Clark, & Co. Humber Bay and High Park are on the far left; the Don River and Ashbridges Bay are on the right. The Oak Ridges Moraine is on the far horizon; closer to the city is the rolling till plain above the Davenport Ridge, the shorecliff of Glacial Lake Iroquois. [Toronto Public Library]

Spring Breezes, High Park, 1912
[J.E.H. MacDonald
oil on canvas, 71.1 x 92.2 cm
National Gallery of Canada]

and swimming, and the ravines offered perfect strolling places. With the emergence of ferries, steam railways, safety bicycles, and electric radial railways during the 19th century, it became easier to escape into nature, although the establishment of taverns, hotels, boat liveries, and amusement parks meant wilderness was becoming a little less wild.

Despite widespread forest clearances that began with settlement, many woodlots persisted in Metro Toronto's outlying areas into the 1950s. These woodlots formed an essential part of farm life, surviving not just where unfavourable topography and drainage existed, but because they could produce firewood, sawlogs, poles, and maple syrup sap. Tableland woodlots and the adjoining farm fields would be especially susceptible to urban development, concentrating the remnant forests in ravine settings.

Early Acquisitions and Advocacy, 1873–1942

After the railways arrived in the 1850s, Toronto became a booming regional hub for transportation, manufacturing, and financial services. But this decade of smokestacks and steam engines also brought the city's first permanent public parks: Riverdale, Stanley, and Queen's, along with the Horticultural (now Allan) Gardens. Straddling the Don Valley, Riverdale Park was the earliest (1856) and the largest (covering 44 hectares by 1883), hosting Toronto's main zoo and playing fields by 1900.

Riverdale lost its park supremacy with John G. Howard's

67-hectare gift of High Park in 1873. City council was reluctant to accept it, as Howard's estate lay outside the city's official boundaries and was inaccessible to most Torontonians. Perhaps inspired by New York's Central Park, the City purchased another 71 hectares for High Park in 1876, and a last 29 hectares in 1930. Howard envisioned High Park as a primarily natural area, and the city's thriftiness meant it was only minimally developed until the mid-1950s.

A fragment of Toronto Island, granted to the city by the Dominion government in 1867, was set aside as a public park in 1880. To construct Island Park, marshes, lagoons, and sandy areas were filled with garbage, street sweepings, and dredged material to make way for lawns, flower beds, and new trees. Though the parks commissioner described the island in 1887 as Toronto's "most beautiful natural feature," it was a highly artificial landscape by the Second World War.

Calls for a broadly conceived park system gained traction in the first decade of the 20th century. In a plan published in 1909, the Toronto Guild of Civic Art, a citizens' group, was the first body to link an understanding of Toronto's most distinctive assets with a plea for their protection:

Toronto has a character which in spite of the absence of imposing natural features is definite and pleasing. It is a place that has many attractions and that can be made very delightful to live in, if its attractive points are recognized

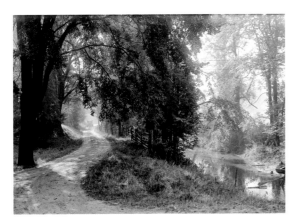

Sunnybrook Park, 1928, shortly after being officially opened. [Arthur Goss, Toronto Archives]

and developed . . . The lake shore, the Island, the rivers Don and Humber, the [Davenport] ridge, the numerous ravines, the facilities for outings both by land and water which make the city such a pleasant abode in summer, all these features can easily be spoiled for want of timely recognition and incorporation in an inviolable plan . . .

We have kept in view as far as possible, in drawing this plan, the characteristic features of the place, and have endeavoured to incorporate them in the plan, so as to preserve and indeed develop them, and thus to develop the natural character we have and make of Toronto not just a beautiful city, beautiful in a conventional way, after the model of some other city, but to bring out its own beauty. It is character in a town that makes the dwellers in it love it.

The guild's call for more parks and connecting driveways recognized that the region's intrinsic character would be lost without deliberate planning. Their vision of Toronto was shaped by features outside the city limits (like the Scarborough Bluffs and the Humber Valley), yet city council had few powers to regulate development in those areas unless they could be convinced to acquire them. And despite the guild's stirring call, no definite plan emerged. The City continued to focus on acquiring and developing small parks and playgrounds, though some of these parks included ravines feeding into the Don Valley.

Progress on securing large natural areas came in fits and starts. Mixing self-interest with civic spirit, real estate baron and Guild of Civic Art member Robert Home Smith struck a deal with the City in 1912 to protect the lower Humber Valley. Home Smith turned over 52 hectares of valley-bottom land and dedicated a boulevard allowance; in return, the City spent $125,000 on building Riverside Drive and Humber Boulevard and making park improvements. In 1923, Susan Marie Denton donated most of the lands making up Dentonia Park, a 30-hectare parcel straddling Massey Creek. Five years later, Alice Kilgour donated Sunnybrook Park to the City. In 1930, the Toronto Field Naturalists' Club opened Canada's first urban nature trail through this 74-hectare North York property — part of which would become a veterans' hospital in the next decade.

The idea of protecting natural areas for nature's sake remained latent, however. Recreational development was the goal for many advocates — as in using the ravines and river valleys for an encircling network of parkways and boulevards. Some strove to maintain Toronto's visual identity, but only those elements of Toronto's natural heritage that satisfied certain aesthetic norms, like the deep tree-clad ravines, were slated for preservation. Elements that were neither scenic nor picturesque were turned to productive ends. This was the fate of Ashbridges Bay, some 520 hectares of publicly owned marsh, sand, and shallow water that was reclaimed for port and industrial uses. This eliminated nearly all of the largest wetland in eastern Canada by 1940.

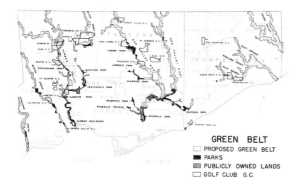

GREEN BELT
☐ PROPOSED GREEN BELT
■ PARKS
▨ PUBLICLY OWNED LANDS
☐ GOLF CLUB G.C.

The proposed plan for green belts and regional parks in Metro Toronto, 1954. The lower Rouge Valley (then part of the Town of Pickering, and not shown here) would be annexed by Scarborough and added to Metro in 1974. [Private collection]

A Regional Green Space System Takes Shape, 1943–1975

As the Second World War entered its third year, Canadian politicians turned their minds to conservation and regional planning in postwar reconstruction. The green space ideas sketched out for the Toronto region in the 1940s provided the conceptual basis for a regional parks system that developed rapidly after 1953, thanks to legislative and fiscal support from the Ontario government.

The fundamentals were laid out in the Toronto City Planning Board's *Master Plan for the City of Toronto and Environs* (1943). An inner green belt, shaped like an inverted U, protected the Don and Humber Valleys and their tributary ravines from "encroachment and vandalism." A low-speed recreational driveway linked these "metropolitan park reserves."

In the master plan, regional geographer D.F. Putnam also drew attention to conserving the Niagara Escarpment and the Oak Ridges Moraine, and to reforesting marginal agricultural lands. His proposed "conservancy district" included parks at Mount Nemo, the Credit Forks, and other sites, and a "peripheral driveway" linking Oshawa and Hamilton. Parks at Heart Lake and in the Rouge Valley were among those suggested within the agricultural zone, which would enjoy "protective planning" that stabilized stream flows and soil erosion. Reserving the lakeshore for public use was also a top priority.

Intermunicipal cooperation to achieve conservation goals became possible under the Conservation Authorities Act of 1946. Amid pressing needs for flood control and reforestation, Ontario's first conservation authority was organized in the Etobicoke Valley in 1946. Authorities for the Don and Humber Valleys (1948) and the Rouge-Duffins-Highland-Petticoat watersheds (1956) followed.

Creating a system of large urban green spaces became possible with the formation of the Municipality of Metropolitan Toronto in 1953, led by Frederick G. Gardiner. While Gardiner's role in developing hard infrastructure is well known, his support for conservation and regional parks has been overlooked.

Prompted by Gardiner, Metro Council adopted recommendations made by the Metropolitan Toronto Planning Board in 1954 to establish a 2,700-hectare park system based on the major river valleys. With over 40 percent of the system vulnerable to urban development, council authorized the creation of a green belt acquisition fund and directed the Metro Planning Board to prepare an official plan that addressed the river valleys, Toronto Island, and other parks.

The Metro Toronto Parks Department was formed in 1955. A year later, Parks Commissioner Tommy Thompson outlined the basic philosophy and future scope of the regional parks system:

Recreationally they will provide those things that the neighbourhood park seldom offers, but which people increasingly demand. The tempo of modern living and

the density of our population make it essential that nature be preserved in those areas where it still exists. Metropolitan parks should offer opportunities for an outdoor experience — a basic need of people — in a manner which they can enjoy. But in addition to the day camps, council rings, extensive picnic facilities, bridle paths, nature trails and wilderness areas, they will serve as the laboratories for outdoor education and conservation. Indeed, the whole concept of Metropolitan parks should be consistent with the highest ideals of conservation itself.

The fact that the natural features of the Toronto region were largely unprotected meant that land acquisition, not development, became Metro's highest priority in the short term.

In Metro's parks, extensive development typically involved access roads, parking lots, and paved trails, and some areas also featured picnic areas, fire pits, drinking fountains, water taps, and washrooms. Natural conditions prevailed. But while the parks "retain[ed] as much as possible their primitive character," turf was maintained in the valley bottoms and some low-lying areas were filled with industrial waste.

Metro quickly assembled an impressive amount of green space in the central and west Don, the Rouge, Highland Creek, the south and north Humber, Black Creek, and on the waterfront. In 1954, Metro's parkland comprised one 67-hectare parcel; by 1974, holdings totalled 3,161 hectares. By 1976, major new or expanded parks were in place along the lakeshore and in all valleys except Etobicoke and Mimico Creeks.

A major factor in park planning came roaring in with Hurricane Hazel in 1954. After taking 81 lives and causing $1 billion (current dollars) in damage in the Toronto region, Hazel convinced Gardiner that parkland serving regional needs was the proper function of low-lying areas like Toronto Island. Hazel was also directly responsible for Metro's creation of Marie Curtis Park in flood-ravaged Long Branch, and for the acquisition of floodplains in the name of public safety.

The Metropolitan Toronto and Region Conservation Authority (MTRCA), taking in 23 municipalities and over 2,400 square kilometres, was formed in 1957 through the amalgamation of four authorities. A close working relationship developed between Metro and the MTRCA. The two organizations' priorities differed slightly, with the authority emphasizing conservation and flood protection, and Metro wanting more developed land. (As the MTRCA put it, "Conservation may include parks, but parks are not necessarily conservation.") Despite these frictions, their mutual objectives brought much new land into the park system.

Front cover of Toronto the Green, 1976, which marked the entry of the Toronto Field Naturalists Club into environmental advocacy. [Private collection]

Naturalization and Restoration, 1976–1997

Having expanded rapidly for two decades, in the mid-1970s Metro concluded that its next priority should be developing major recreation facilities. This view was not shared by all. In 1976, the Toronto Field Naturalists Club issued *Toronto the Green*, which included recommendations for the conservation and management of natural areas in and around the city. The Field Naturalists demanded that all municipal official plans "explicitly recognize the conservation of natural areas as an important aspect of planning," requested that all municipalities adopt ravine protection bylaws, identified eight natural areas that should receive maximum protection, called on the province to initiate a watershed planning program for the Rouge River, and proposed guidelines for managing natural areas that included letting grass grow unmowed, leaving underbrush and fallen trees undisturbed, and planting native shrubs on slopes.

The issue of assigning significance to natural areas was taken up at various levels. Most of the core survey work began in the 1970s. In 1982, the Field Naturalists issued a list of 28 significant natural areas in Toronto, and the MTRCA released its Environmentally Significant Areas Study. By 1995, a total of 13 areas of natural and scientific interest, 7 provincially significant wetlands, 48 environmentally significant areas, and 42 other significant natural areas had been identified within Metro Toronto.

Much community effort centred on specific natural areas. For example, the Friends of the Spit formed in 1977 to advocate on behalf the Outer Harbour Eastern Headland. The 5-kilometre-long Headland — better

known as the Leslie (Street) Spit or Tommy Thompson Park — arose through lakefilling that began in 1959 in an abortive attempt to create new port facilities. When the spit was labelled an aquatic park in 1972, debate erupted over what level of recreational development should occur. The Friends of the Spit lobbied for ongoing naturalization, passive human use, minimal facilities, and a car-free environment in what was one of the MTRCA's largest environmentally significant areas.

The master plan for Tommy Thompson Park approved by the province in 1995 reflected the influence of the Friends of the Spit and, more generally, a new management ethos for Toronto's natural areas focusing on natural succession and minimal intervention. Unassisted natural regeneration would continue in some areas; in others, natural succession would be guided by park managers who created the base conditions and initial species mix.

The exploration of alternative naturalization techniques — what Michael Hough called "restoring identity to the regional landscape" — began in Metro Toronto's local park systems. Prompted partly by budget pressures, the City of North York began experimenting with park naturalization in 1982. Mowing was abandoned in selected areas, allowing the slow process of community succession to begin. The City of Scarborough followed suit. In High Park, concern over the decline of rare plant communities prompted a master plan that included controlled burns.

As for watershed-based conservation planning, the Toronto Field Naturalists' call for a provincial program for the Rouge was ultimately successful. Recognized as

early as 1956 as the "choicest block of natural unspoiled wilderness" in Metro, the Rouge was announced in 1990 as the largest urban wilderness park in North America, spanning about 4,250 hectares from Lake Ontario to the Oak Ridges Moraine. Undertaking restoration projects and implementing the rest of the plan fell to the Rouge Park Alliance, a multi-jurisdictional body with community input. The province formally created Rouge Park in 1995.

New large-scale planning frameworks for the Toronto region accompanied the rising interest in watershed consciousness, significant natural areas, and restoration ecology. The federal and provincial governments cooperated on two fronts in the 1980s, establishing the Royal Commission on the Future of the Toronto Waterfront (1988–1992) and the Metro Toronto and Region Remedial Action Plan (initiated 1987).

Municipally, progress was slow on regulating private development in and around significant natural areas. "There has never been and there is not at present a City policy on the preservation and use of natural parkland," lamented the City Planning Board in 1960, noting that 44 percent of the original 770 hectares of ravine land had been built over. City council quickly adopted the board's recommendations to tighten development controls in principle, but specific legal measures followed at a more leisurely pace. Toronto did not adopt an implementing ravine control bylaw until 1981. By then, Metro's Official Plan had rigorous conservation policies in place for the major river valleys and the waterfront.

Yet Toronto has made great strides since the mid-1970s. Metro's park system, MTRCA programs, and area municipal land use policies have generally protected the valleys from incompatible development and preserved their natural environment and flood-control functions. The regional park system alone grew from 3,194 hectares in 1976 to 4,680 hectares in 1996. This included large gains in the west Humber and the east Don — and the creation of the Don Valley Brick Works Park (1997), preserving a key element of Toronto's geological and industrial heritage.

Most (58 percent) of the growth in the regional park system, however, took place along the lakeshore. There, an extra 869 hectares nearly tripled the area of public waterfront green space. But most of the parkland was new lakefill, including parks at Bluffer's, Ashbridges Bay and Humber Bay, which offered little in terms of new habitat. The MTRCA's extensive erosion-control works at the Scarborough Bluffs were similarly found wanting, and attracted the wrath of earth scientists. To address these issues, in 1992 the MTRCA began focusing on "wilding" the shoreline to restore or create wetlands and fish habitat.

This remedial work — taking place on sites not two decades old — was a sea change in park management philosophy, from recreational usage to conservation of natural areas. A new sense of balance was evident at Colonel Samuel Smith Park in Etobicoke (1996), where natural features were designed into a lakefill setting that also accommodated a yacht club.

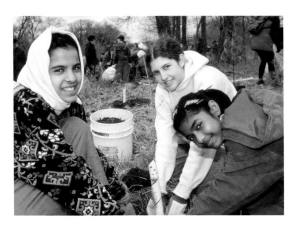

A community tree-planting event on the central Don River, 1995 [Stephanie Lake, Metro Parks & Culture]. In 1990, Metro began a naturalization program with the establishment of a wildflower meadow adjacent to a new paved path in the west Humber. This program relied heavily on community volunteers and saw more than 400,000 native trees, shrubs, and wildflowers planted on sites throughout Metro Toronto by 1996.

The natural heritage system outlined in the City of Toronto's Official Plan, 2002 [City of Toronto Planning]. A review of the Official Plan later produced a new study of environmentally significant areas (2012) and a revised set of ESAs and natural heritage policies (2015), reflecting council's vision of "a connected system of natural features and ecological functions that support biodiversity and contribute to civic life."

Natural Heritage Policy-Making and Management, 1998 to the Present

A storm of controversy greeted the Province's announcement in late 1996 that Metro Toronto's seven municipal governments would become a single City of Toronto in 1998. One clear benefit was a unified environmental perspective, which meant enhanced protection for natural areas across Toronto.

Soon after amalgamation, Toronto city council established an environmental task force with a mandate to create a green strategy for the new city. The result was *Clean, Green and Healthy: A Plan for an Environmentally Sustainable Toronto*, adopted by council in 2000. The plan called for an increase in parks and natural areas, development of a natural heritage strategy, planting of more trees, and protection of significant landforms.

The uneven treatment of ravines in pre-amalgamation Toronto was addressed through a harmonized bylaw adopted in 2002. The aim was to regulate alterations to topography, water flow, or natural plant communities that would affect ravine ecology and functions. In 2008, this regulation was amended to include tableland forests and forested portions of the Lake Iroquois shorecliff, and became known as the Ravine and Natural Feature Protection Bylaw. A broadened definition of heritage trees was added to the bylaw in 2013.

The push to more strongly integrate Toronto with the provincial Greenbelt Area began in 2009 through the lobbying efforts of Environmental Defence. In 2015, city staff proposed amendments to bring Toronto's Official Plan into conformity with the Greenbelt Plan, including adding Greenbelt Protected Countryside and Greenbelt River Valley Connections as mapped elements of the urban structure.

The massive Rouge Park represented a new milestone for natural-area management. Legislation establishing Rouge National Urban Park was passed in 2015, and Prime Minister Harper announced the park's boundaries would be increased by 36 percent, to 79.5 square kilometres. The park now stretches far beyond the City of Toronto.

Volunteers continue to be essential to nurturing Toronto's natural parklands. The Parkland Naturalization Community Planting Program worked with 5,000 volunteers in 2016 to establish native trees, shrubs, and wildflowers at naturalization sites. The Community Stewardship Program involves volunteers in ongoing maintenance and monitoring at selected sites. Participants are trained in basic ecology, plant identification, and monitoring, and work in teams assigned to specific sites. In 2016, over 100 volunteers were regularly active at seven sites.

The challenge of unmanaged recreational use of natural parklands is being been tackled by engaging trail users rather than by simply fencing them out. City staff began working with users in 2002 to address the environmental impacts of informal natural surface trails in Crothers Woods, a 52-hectare environmentally significant forest.

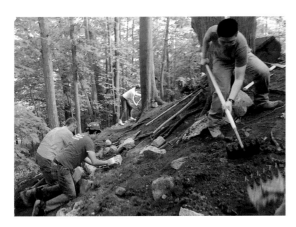

Volunteers build a natural environment trail in Crothers Woods, c. 2008. [Toronto Parks, Forestry, & Recreation]

The City has constructed 2 kilometres of new multi-use natural-surface trails, closed and restored over 1.5 kilometres of eroded and unsustainable trails, and built several trailheads. Many goals and objectives have been achieved by working closely with trail users and by collaborating with groups such as the International Mountain Bike Association.

The lessons of Crothers Woods for integrating recreational uses with natural parklands were put to use in the city's Natural Environment Trails Strategy (2013). In addition to 300 kilometres of formal paved and granular multi-use park trails, park staff discovered another 227 kilometres of informal dirt trails, which damaged the urban forest through erosion, compaction, and trampling of the understory. The solution was to build better, more sustainable trails with a light footprint to minimize environmental impact.

This approach gained official sanction as part of the *Toronto Parks Plan 2013–2017*, adopted by council in 2013. The plan included recommendations such as implementing a program to strengthen the management of sensitive natural areas, determining thresholds to prevent excessive use, and increasing staff knowledge and skills to better manage environmentally sensitive lands.

Effective stewardship of Toronto's natural parklands will require a mix of enlarged civic resources and expanded citizen engagement to meet the many threats to nature's integrity, such as rising recreational pressures from an increasing population, insufficient infrastructure to direct users away from sensitive sites, the impacts of climate change, the spread of invasive species, encroachment by private landowners, and limited public awareness of the value of natural areas.

All this might seem to augur poorly for the future, but Toronto has made remarkable strides in just six decades. Opportunities exist to convert turf into meadow, forest, or wetland, and, just as importantly, this is a shared goal. The Ravine Strategy initiated in 2015 offers a way of pulling various policies, programs, and regulations together. The challenge will be finding the means to sustain the vision that has nurtured Toronto's natural sanctuaries and will preserve them for generations to come.

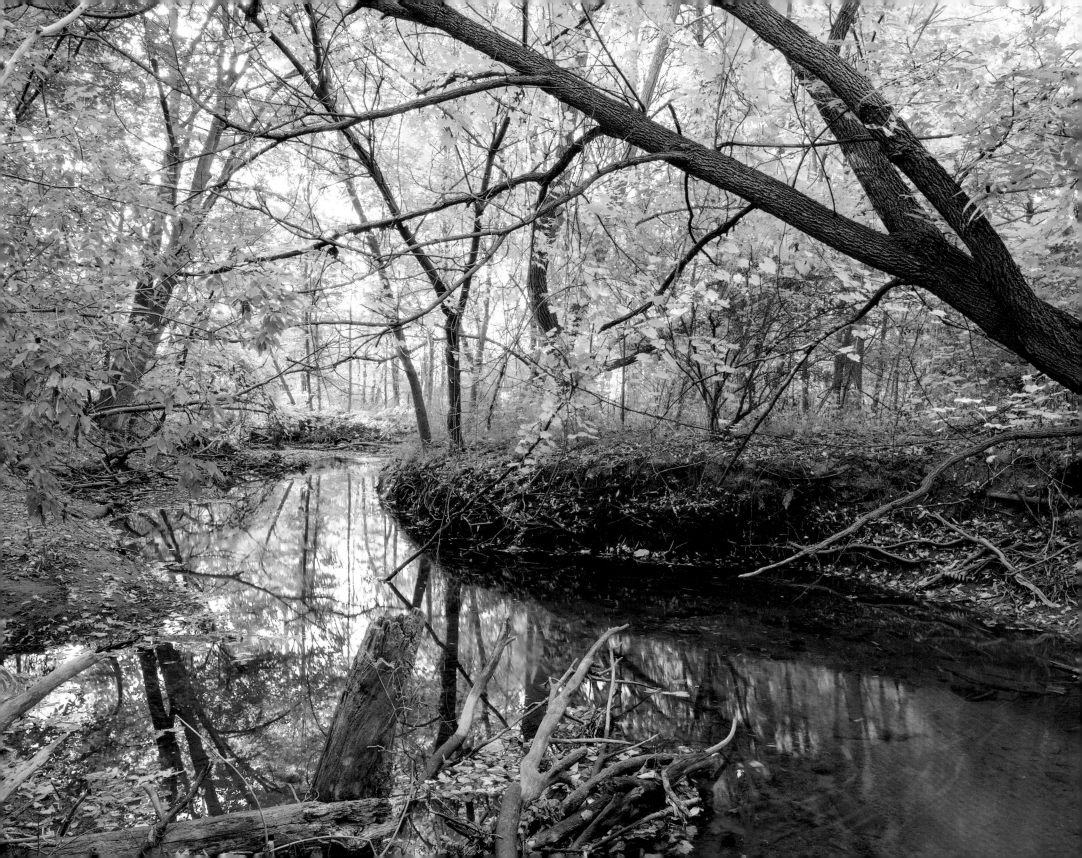

Nested within Toronto's natural parklands are places that support an extraordinary variety of plant and animal life and provide unique opportunities for people to enjoy, experience, and connect with nature. From a constructed Spit where migratory birds first land after crossing Lake Ontario, to remnants of prairie and black oak savannah that once flourished on sandy soils, to secluded floodplain swamps where amphibians breed, to the great forests of the Rouge — biodiversity hot spots persist within our urban fabric.

Over the past 10 years, research commissioned by the City of Toronto has identified and documented over 86 of these biodiversity hot spots — officially referred to as environmentally significant areas or ESAs — mostly within river valleys, ravines and along the waterfront. ESAs contribute disproportionately to biodiversity in Toronto. They contain habitats of unusually large size or high diversity, rare plant and animal species, and unique landforms. They also contribute to the ecosystem beyond the city's boundaries by serving as stopover locations for migratory wildlife and colonial bird breeding habitat. A total of 2,698 ha, approximately 4 percent of the city's land area (64,100 ha), is ESA (equivalent to almost eight Central Parks). Most of these areas are located on City parkland and are managed by the City of Toronto and the Toronto and Region Conservation Authority. Some ESAs extend onto privately owned land. Collectively, ESAs contain over 1049 species of plants (including 369 significant plant species), at least 175 species of birds (including 128 species confirmed to be breeding), many species of insects including migrating monarchs and many other species of butterflies, as well as a variety of reptiles and amphibians and numerous mammals. Several of these areas are provincially significant and a number are located on lands which are part of the Ontario Greenbelt and soon to be included in the Rouge National Urban Park. ESAs and the lands that surround them are protected by a framework of policies, regulations and programs that support nature in the City and the surrounding bioregion.

Many of the photographs in this book were taken in ESAs. The photographs, together with the natural parkland descriptions that follow in this Appendix, provide a glimpse into the rich biodiversity of these special places. Each of these places supports unique and sensitive species that need to be protected — you can help by doing the following: stay on designated trails, keep dogs on leash, refrain from collecting plants or seeds, do not disturb wildlife, and avoid littering. Enjoy your visit, and come back often.

SELECTED TORONTO NATURAL PARKLANDS

Key natural features, habitats, and species found in the parks identified on this map are described in the pages that follow.

Lake Ontario Waterfront
1 Cherry Beach — Clarke Beach Park
2 Colonel Samuel Smith Park
3 Cudia Park / Cathedral Bluffs Park / Bluffer's Park / Scarborough Bluffs Park
4 East Point Park
5 High Park
6 Sylvan Park — Gates Gully
7 Tommy Thompson Park (Leslie Street Spit)
8 Toronto Islands Park

Humber River Valley
9 Chapman Valley Park
10 Home Smith Park
11 Humber Arboretum
12 Humber Marshes
13 Lambton Park
14 Lambton Woods
15 West Humber Parkland and Summerlea Park
16 Rowntree Mills Park
17 South Humber Park

Creeks and Lost Rivers
18 Black Creek
19 Cedarvale Ravine
20 Centennial Park
21 Etobicoke Creek
22 Glen Stewart Park
23 Mimico Creek
24 Nordheimer Ravine and Roycroft Parklands
25 Williamson Park Ravine

Don River Valley
26 Betty Sutherland Trail Park
27 Brookbanks Park
28 Charles Sauriol Conservation Area
29 Crothers Woods
30 David A. Balfour Park and Vale of Avoca
31 Earl Bales Park
32 East Don Parkland
33 E.T. Seton Park
34 Lower Don Parklands
35 Moore Park Ravine
36 Rosedale Ravine Lands
37 Sunnybrook Park Complex
38 Taylor Creek
39 Todmorden Mills

Rouge River Valley & Highland Creek
40 Colonel Danforth Park
41 Lower Highland Creek Parkland
42 Morningside Park
43 Rouge Park (City of Toronto portion)
44 Rouge Marsh Area
45 Finch Meander Area
46 Vista Trail Area

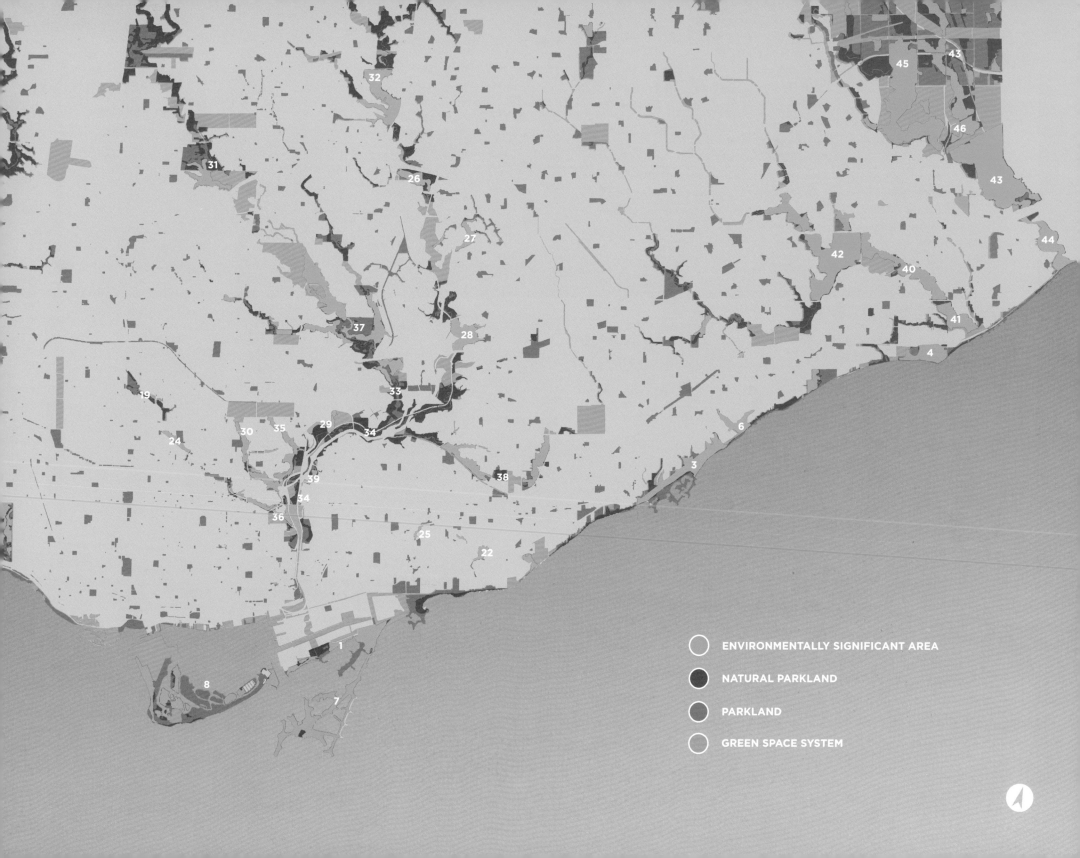

ENVIRONMENTALLY SIGNIFICANT AREA

NATURAL PARKLAND

PARKLAND

GREEN SPACE SYSTEM

LAKE ONTARIO WATERFRONT

The Lake Ontario waterfront stretches 43 km across the city (138 km following the shorelines of bays and islands). The shoreline is a bioregional corridor, similar to the Oak Ridges Moraine or the Niagara Escarpment, and provides habitat and migration routes for wildlife. Species travel along the shoreline and some also use it as a resting area before or after travelling across the lake north to breeding areas in the boreal forest or south to overwintering areas. Many rare plant species thrive on the dynamic habitat provided by shifting sand, waves and wind. The cottonwood coastal forests provide nest sites for colonial birds and birds of prey. Small fish that breed in the shallows help support the food webs of the Great Lakes fishery, and provide prey for mammals and birds that hunt along the shoreline.

CHERRY BEACH — CLARKE BEACH PARK

Location:
at the foot of Cherry Street, south of Unwin Avenue, extending along the north shore of the outer harbour from Tommy Thompson Park to the Eastern Gap

Area: 36.4 ha

Key Natural Features:
- an area of fill in various stages of succession
- an abundance and variety of breeding birds likely due to diverse habitat and proximity to Lake Ontario
- well known area to see migrating songbirds
- the eastern and western flanks of the park are part of the Cherry Beach ESA
- multi-use trail

Key Habitats:
- predominantly beach and sand dune with non-native successional communities but also some rare shrubby wetlands dominated by sandbar willow and red osier dogwood
- cottonwood forest, which is a rare plant community in the Greater Toronto Area
- provides cover for hundreds of migrating birds in the spring

Key Species:
- birds of thicket and open wooded habitat such as yellow warblers, gray catbird, blue-gray gnatcatcher, warbling vireo, and occasional wetland-dependent species such as common yellowthroat
- migrating songbirds abundant in spring
- dunes and beaches support rare species that thrive in the unstable shoreline habitat, such as Baltic rush, Nelson's horsetail, sand dropseed, smooth aster, and sea-rocket

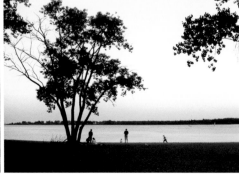

COLONEL SAMUEL SMITH PARK

Location:
on fill placed to create a marina and park at the foot of Kipling Avenue at Lake Shore Boulevard West

Area: 47 ha

Key Natural Features:
- mature trees of the former hospital grounds together with the bays, marshes, and meadows create a diverse range of habitat for migrating songbirds
- well-known stopover area for migrating land birds, waterfowl, and shorebirds
- considered to be the best place in Toronto to observe large numbers of whimbrel, a large curlew-like shorebird, during spring as they migrate between their South American wintering grounds and their breeding grounds on the tundra coast of the Hudson Bay Lowlands
- views of the lake and favourite site for viewing winter waterfowl due to sheltered bays
- southern portions of the park are part of the Colonel Samuel Smith Park ESA
- multi-use trails

Key Habitats:
- predominantly meadow, successional forest, and thicket
- small wetland areas of marsh and thicket swamp, as well as a large pond
- hibernation areas for snakes where they can get below the frost line to survive the winter

Key Species:
- 268 species of birds have been recorded in the park
- breeding birds including song sparrow, yellow warbler, and gray catbird
- whimbrel concentrate along shoreline in spring and fall
- wintering and migrating waterfowl concentrate just offshore, including lesser scaup, red-breasted merganser, bufflehead, and long-tailed duck
- red-necked grebes have nested in the yacht club basin

CUDIA PARK/CATHEDRAL BLUFFS PARK/BLUFFER'S PARK/SCARBOROUGH BLUFFS PARK

Location:
a series of parks extending along the Scarborough Bluffs south of Kingston Road from Meadowcliffe Drive west to the base of Scarboro Crescent

Area: 110.6 ha including Cudia Park (16.1 ha), Cathedral Bluffs Park (8.9 ha), Bluffer's Park (76.7 ha), and Scarborough Bluffs Park (8.9 ha)

Key Natural Features:
- the Scarborough Bluffs are a geological feature that formed from the accumulation of sedimentary deposits over 12,000 years ago and subsequent stream and wave erosion
- the bluffs are said to contain the most complete record of Pleistocene geology in North America, providing glimpses of shoreline changes spanning two glaciations (late Illinoian and Wisconsinan), one interglacial period (Sangamonian), as well as the most recent Holocene period
- the tallest points along the bluffs are the tall spires of the eroded sandstone cliffs in Cathedral Bluffs Park, which rise more than 90 m above Lake Ontario; these form some of the most aesthetic and dramatic landscapes in Toronto
- Bluffer's Park, one of the few locations with vehicular access to the waterfront, provides views of the face of the bluffs
- varied aspects, slopes, and substrate types support high diversity of vegetation
- this section of the bluffs is part of the Scarborough Bluffs Sequence ESA and the Scarborough Bluffs Provincial Life Science and Earth Science Area of Natural and Scientific Interest

Key Habitats:
- habitats range from mature slope forests to open and successional bluff communities
- some remnant species of savannah can be found in south-facing openings within the forest at the top of the bluffs
- open beach and dune communities along with small wetland communities, which are created by groundwater seepage from the bluff face, are found at the base of the bluffs
- pockets of forest interior habitat (100 m or more from forest edge), which is rare in Toronto

Key Species:
- bird species such as warbling vireo, spotted sandpiper, and red-winged blackbird are drawn to wetland and riparian areas
- bank swallows nest in the bluffs
- American toad and tree frogs have been heard singing
- savannah species such as yellow pimpernel, field thistle, and thin-leaved sunflower hint at savannah that occurred previously along the edge of the bluffs
- dunes and beaches support rare plants such as sea-rocket, Baltic rush, and American beachgrass

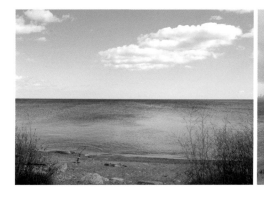 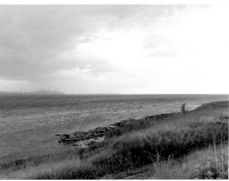 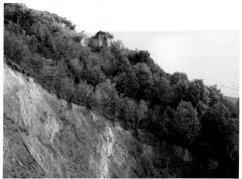 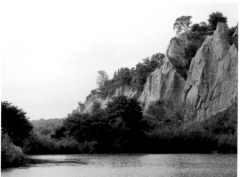

EAST POINT PARK

Location:
point of land overlooking Lake Ontario west of Highland Creek, south of Copperfield Road and west of Beechgrove Drive

Area: 54.8 ha

Key Natural Features:
- one of Toronto's largest waterfront parks, offering scenic views of Scarborough Bluffs and the Lake Ontario waterfront
- bluffs rise in height from 10 m on the east side to 25 m on the west; the highest point is over 33 m
- best place in Toronto to observe active bluff formation, due to erosion at toe of slope, and bluff habitats
- identified as a Toronto Bird Sanctuary due to the large numbers of birds that use the park as a migratory stopover site
- portions of the park are part of East Point ESA

Key Habitats:
- one of the best places to observe forest succession from open meadows, to dogwood and staghorn sumac thickets to poplar woodlands
- bluff habitats with species such as buffalo berry and shrub willows
- abundant patches of moist calcium-rich soils and small wetlands support a high diversity of sedges and rare Toronto flora such as gentians
- remnants of prairie still occur within openings, and planted prairie species thrive

Key Species:
- one of the few areas with habitat for grassland birds such as eastern meadowlark, savannah sparrow, and bobolink
- birds of later shrubby vegetation stages are abundant, such as yellow warbler, gray catbird, and willow flycatcher, along with some area-sensitive birds that breed in larger forest patches such as black-and-white warbler and mourning warbler
- small wetlands provide breeding habitat for American toad
- staging area for migrating monarch butterflies
- bank swallows can be found nesting in large colonies on the bluffs

HIGH PARK

Location:
stretching from Bloor Street south to The Queensway, just north of Lake Ontario, between Parkside Drive and Ellis Avenue

Area: 141.7 ha

Key Natural Features:
- significant natural area in Toronto due to its large size, rare plants, habitat types, and associated wildlife species
- High Park has been known since the 1800s as an important site for rare plants in North America
- known for globally rare black oak savannah forest; the City carries out regular prescribed burns to restore the savannah; wild lupines blanket the savannah in late spring
- a high topographic diversity, including warm, sandy, south-facing slopes and tablelands, deep, cool, moist ravines, and wetland habitat in Grenadier Pond and Duck Pond
- plant communities from three different life zones: Carolinian forest from the south; tall grass prairie, or savannah, from the west; and boreal mixed forest from the north
- excellent location to observe migrating birds and the fall migration of diurnal raptors over the hill north of the Grenadier Restaurant
- old growth forest (over 140 years old) has been noted in some areas
- Grenadier Pond and Duck Pond are remnants of Toronto's once-extensive coastal marshes
- High Park ESA and High Park Oak Woodlands Provincial Life Science Area of Natural and Scientific Interest
- multi-use and natural environment trails

Key Habitats:
- wide variety of habitat types, including mature upland forest, successional forest, cultural communities, bottomland forest, and wetland communities
- dry black oak savannah with a tallgrass prairie understory

Key Species:
- black oak, black cherry, red maple, hemlock, white birch, beech, white ash, and white pine
- prairie grasses, including big bluestem and little bluestem
- prairie flowers such as pale-leaved sunflower and showy tick trefoil
- over 250 species of birds have been sighted, well over 150 species are seen regularly, and more than 50 species breed in the park, including wood duck, gadwall, Cooper's hawk, eastern screech-owl, warbling vireo, blue-gray gnatcatcher, and orchard oriole
- more than 69 species of butterflies, of which at least 40 are known to breed in the park
- at least 52 species of dragonflies and damselflies
- about 18 species of mammals, including bats
- amphibians and reptiles, including eastern red-backed salamander; garter and brown snake; and snapping, Midland painted, and rare northern map turtle

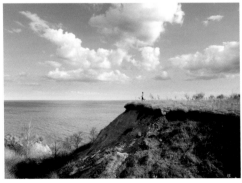 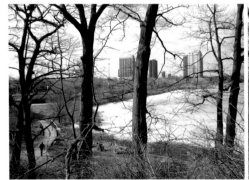 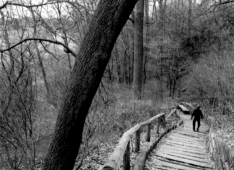

SYLVAN PARK — GATES GULLY (BELLAMY RAVINE)

Location:
a steep, forested ravine beginning below Kingston Road at Bellamy Road South and extending down to Lake Ontario

Area: 20.2 ha

Key Natural Features:
- this deep ravine (also known as Gates Gully) formed where Bellamy Creek cuts thorough the Scarborough Bluffs as it flows to Lake Ontario
- creek now flows within an engineered channel
- one of the few places with access to the lake from the Scarborough Bluffs
- trail, named for Canadian artist Doris McCarthy, drops about 90 m from the plateau at the top of the Scarborough Bluffs to the shoreline of Lake Ontario
- scenic views of the Scarborough Bluffs geological sequence and ancient Lake Iroquois shoreline from the beach at the base of the bluffs
- high-quality deciduous forest on steep slopes of a ravine
- park and adjacent slopes are part of the Bellamy Ravine/Sylvan Park ESA
- walking trail

Key Habitats:
- predominantly deciduous and mixed forests, with a rich understory of spring-flowering species in some areas
- the top of the ravine supports some open-grown oaks with a few species characteristic of savannah habitats in the understory, indicating there were likely savannah remnants in openings on south-facing slopes

Key Species:
- forest species include white pine, eastern hemlock, sugar maple, American beech, and white birch, with an understory of spring ephemerals
- forest-dependent bird species such as great crested flycatcher and hairy woodpecker, as well as species dependent on successional habitats such as gray catbird, orchard oriole (a Carolinian species), blue-gray gnatcatcher, and warbling vireo
- bluffs east of the ravine support a bank swallow colony of over 300 nests; thousands of bank swallows can be seen foraging over the lake and bluffs in the summer

TOMMY THOMPSON PARK (LESLIE STREET SPIT)

Location:
Tommy Thompson Park is part of the Leslie Street Spit, a man-made peninsula extending 5 km into Lake Ontario from the intersection of Leslie Street and Unwin Avenue

Area: the entire peninsula is over 500 ha; Tommy Thompson Park is 181.8 ha

Key Natural Features:
- one of the largest natural areas on the Toronto waterfront and an area of high ecological value due to its location on the lakeshore and mosaic of habitats
- exceptional location to see large numbers of migrating birds during spring and fall
- one of the best places in the city to see owls during fall and winter
- designated as a globally significant Important Bird Area (IBA) by Birdlife International for its importance to populations of nesting water birds and migratory species
- bird research station used for bird studies and education
- excellent location to view butterflies
- registered monarch waystation and staging area for monarch butterflies during fall migration
- includes three ESAs (Base of Spit ESA, Leslie Street Spit ESA, Tommy Thompson Park ESA)
- multi-use trails

Key Habitats:
- diverse habitats created by natural succession as well as through habitat creation and enhancement, including cottonwood forests, willow thickets and meadows, and aquatic habitat
- common terns nest on manmade reef-rafts and engineered islands in wetlands and embayments
- meadows provide habitat for aerial insect foragers and display areas for American woodcock
- seasonal pools and permanent bays are important breeding areas for amphibians
- complex shoreline and nearshore areas provide habitat for warm- and cool-water fish
- rubble along the shoreline provides hibernation sites for hundreds of snakes

Key Species:
- large concentrations of songbirds during migration (316 species of birds have been recorded)
- local and regionally rare bird species such as Virginia rail, sora, and American woodcock
- many species of breeding colonial water birds, including double-crested cormorant, great egret, great blue heron, black-crowned night-heron, ring-billed gull, herring gull, and Caspian tern
- red-necked grebes migrate just offshore in hundreds, and some breed in the park
- over 50 species of butterflies, including ringlet, blue, sulphur, and red admiral
- amphibians such as American toad and northern leopard frog
- coyotes have denning sites within the park
- melanistic garter snakes emerging from hibernation can be seen in the hundreds in early spring
- aquatic mammals such as beaver, American mink, and muskrat

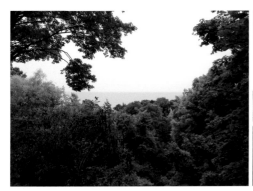
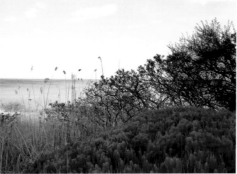
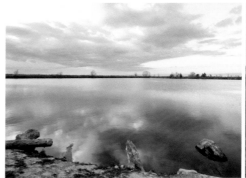
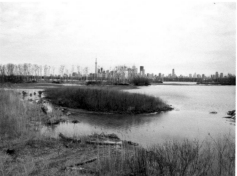

TORONTO ISLANDS PARK

Location:
just offshore of the city centre at the foot of Queens Quay bounded by the Eastern and Western Channel, Lake Ontario to the south, and the Inner Harbour to the north

Area: 225.4 ha

Key Natural Features:
- an archipelago of 14 islands connected by a network of shallow channels and lagoons formed from one of Lake Ontario's largest sand spits
- pastoral setting with a variety of landscapes and unparalleled vistas of the city and Lake Ontario
- an abundance of breeding birds
- winter refuge for waterfowl
- excellent location to see large numbers of migrating birds in spring and fall
- exceptional butterfly viewing location, especially for monarchs during fall migration
- eastern cottonwood, a tall fast growing and relatively short-lived pioneer tree species commonly found on the Islands, releases fluffy white seeds in June that blanket the ground like snow
- six ESAs: Centre Island Meadow/Wildlife Sanctuary, Hanlan's Beach, Muggs Island, Ward's Island, Snake Island, and West Algonquin Island
- Toronto Islands Provincially Significant Coastal Wetland Complex and Area of Natural and Scientific Interest
- some portions of the islands have been designated a nature reserve by the TRCA
- multi-use paths and boardwalk

Key Habitats:
- unique, rare freshwater coastal sand dunes, beach strands, and sand barrens
- stopover habitat that facilitates movement of migratory species through one of the most urbanized areas in North America
- sheltered aquatic marsh habitats between the smaller islands support a diversity of aquatic plant species that provide food for migrating waterfowl
- fallen trees along sheltered shorelines provide basking sites for turtles and cover for fish

Key Species:
- marram grass, which covers open sand dunes and helps stabilize shifting sand; their extensive underground root system helps them thrive under harsh, dry, and windy conditions
- as many as 60 breeding bird species, including blue-gray gnatcatcher, least flycatcher, willow flycatcher, yellow warbler, and eastern kingbird
- during migration it is not unusual to see hundreds of warblers, kinglets, thrushes, and sparrows
- black-crowned night-heron, great blue heron, great egret, and osprey can be seen foraging
- rare canvasback duck and, more recently, piping plover are known to breed on the Islands
- winter visitors include the tiny northern saw-whet owl
- snapping turtle as well as the rare Blanding's turtle and northern map turtle

 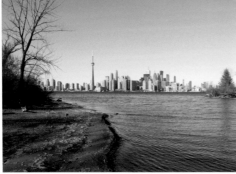

HUMBER RIVER VALLEY

The Humber River drains the largest watershed in the Toronto area with headwaters on the Niagara Escarpment and the Oak Ridges Moraine. The Humber has a long history of human settlement along its banks. It was used by indigenous peoples, early explorers, traders, and missionaries as a passageway from Lake Ontario to Lake Simcoe and Georgian Bay. Unlike the Don River to the east, the Humber remained relatively free from industrialization as Toronto grew. Much of the valley floor and sides has been protected as parkland, with many large natural areas, including some remnant native vegetation. Below Bloor Street, wetlands provide important habitat for breeding and migratory birds.

CHAPMAN VALLEY PARK

Location:
along lower Humber Creek, a tributary of the Humber, west of Scarlett Road

Area: 5.3 ha

Key Natural Features:
- deep, secluded well-wooded ravine with remarkably diverse flora due to varying microclimates found on the cool north-facing slope and warmer south-facing slope and seepage areas
- Chapman Valley ESA includes the park and adjacent ravine from Scarlett Road almost to Royal York Road

Key Habitats:
- predominantly mixed and deciduous forest with small areas of marsh

Key Species:
- forest tree species include sugar maple, American beech, black cherry, red oak, and eastern hemlock
- along the creek banks vegetation includes wetland species such as marsh marigold, spotted water hemlock, water horsetail, fringed loosestrife, and narrow-leaved cattail
- birds of small forested habitats such as downy woodpecker, great crested flycatcher, red-eyed vireo, and eastern wood-pewee (a provincial species of special concern) as well as forest sensitive species such as pine warbler, hairy woodpecker, and Cooper's hawk

 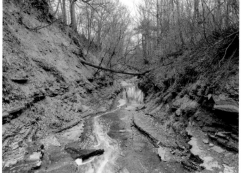

HOME SMITH PARK

Location:
on west side of Humber River, south of Dundas Street West and north of Old Mill Road

Area: 15.1 ha

Key Natural Features:
- mature forests on slopes
- wildlife viewing opportunities, with plenty of waterfowl and songbirds
- swallows nesting in bluffs
- great spot to view salmon swimming up the Humber River to spawn each fall
- mature sugar maple stand on slopes in northern portion of park
- forested slopes are part of Home Smith Area ESA
- multi-use trails

Key Habitats:
- deciduous and mixed forest

Key Species:
- predominantly sugar maple, with some white pine, black cherry, basswood, and eastern white cedar
- bird species include green heron (along the river) and white-breasted nuthatch as well as forest-dependent species such as great crested flycatcher and eastern wood-pewee, considered a species of special concern
- northern rough-winged swallow has been noted here

HUMBER ARBORETUM

Location:
northwest corner of Toronto next to the Humber College North Campus, west of Highway 27 and north of Rexdale Avenue

Area: 98.2 ha

Key Natural Features:
- botanical gardens and natural areas surrounding the Humber River
- extensive collection of native and horticultural trees including species characteristic of the Carolinian zone
- naturalized meadow with over 5,000 plants, typical of species found in this environment
- extensive variety of spring ephemerals, including white and yellow trout lily
- giant bur oak over 30 m tall with a circumference of almost 4 m
- Humber College Arboretum ESA
- visitor centre
- walking trails

Key Habitats:
- high-quality deciduous swamp and forest communities
- botanical garden

Key Species:
- Carolinian hardwood forest containing maple, beech, and ironwood
- floodplain adjacent to river includes lowland bur oak and black maple
- horticultural species have been planted that are native to the United States but not native to Toronto, such as sweetgum and pawpaw
- the song of wood thrush, a provincial species of special concern, can be heard in early summer, a sign of possible breeding

 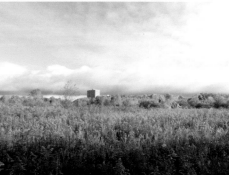

HUMBER MARSHES

Location:
lower Humber River south of Bloor Street to just north of The Queensway, primarily on the east side of the main river channel

Area: 31.2 ha

Key Natural Features:
- one of the few remaining shoreline marshes in Toronto
- extensive marshes provide important breeding and foraging habitat for birds, turtles, and amphibians
- abundant wildlife and birdwatching opportunities, including abundance of migrating birds
- important habitat for fish, with over 50 species recorded
- Humber Valley ESA
- Lower Humber Provincially Significant Wetland Complex
- multi-use trails through King's Mill Park on the west side of the Humber River

Key Habitats:
- marsh and swamp bordered by steep wooded slopes
- significant amphibian breeding habitat and important link between lake and river corridor that contributes to connection between foraging and breeding habitat for frogs and turtles
- small vernal pools fed by seepage support breeding salamanders and other amphibians that need multiple habitats
- large open water marshes support brood-rearing habitat for wood ducks, mergansers, herons, and egrets
- abundant standing dead trees provide habitat for woodpeckers as well as cavity-nesting ducks such as wood duck and hooded merganser; fallen trees at the edges of open water provide basking habitat for several turtle species
- part of a contiguous greenspace corridor with high topographic diversity that supports a very high diversity of wildlife and plant species

Key Species:
- wetlands are dominated by cattails, purple loosestrife (an invasive species), and reed canary grass
- breeding bird species include double-crested cormorant, wood duck, hooded merganser, green heron, great horned owl, eastern screech-owl, belted kingfisher, wood thrush, and two species of cuckoo
- one of the last reliable locations to find red-headed woodpeckers breeding within the city
- reptile species include snapping turtle, northern map turtle, Blanding's turtle, and abundant Midland painted turtles

LAMBTON PARK

Location:
on the east side of Humber River across from Lambton Woods north of Dundas Street West

Area: 13.5 ha

Key Natural Features:
- together, Lambton Woods and Lambton Park Prairie provide an excellent representation of the lower to middle Humber River valley in the City of Toronto
- remnants of the provincially and globally rare black-oak savannah, characterized by widely spaced trees with an understory of tallgrass prairie species growing in sandy well-drained soils, with smaller openings of tallgrass prairie (similar to High Park)
- great spot to find wandering butterflies due to its location near the intersection of the Humber River Valley, a rail line, and a hydro right-of-way (all butterfly highways)
- decomposing tree stumps and fallen logs and open, bare sandy ground provide good habitat for many bee species
- Lambton Park Prairie ESA
- multi-use trails

Key Habitats:
- predominantly savannah with some deciduous forest

Key Species:
- open-grown black oak, characteristic of savannahs in this region, plus other associated species such as New Jersey tea, little bluestem, big bluestem, and Canada wild rye
- bird species characteristic of successional habitats in urban areas such as gray catbird, cedar waxwing, black-billed cuckoo, house wren, and northern mockingbird, along with riparian species such as yellow warbler, willow flycatcher, and warbling vireo
- in recent years, 58 butterfly species have been identified, with an abundance of skippers, including the usually scarce crossline skipper

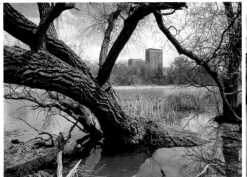
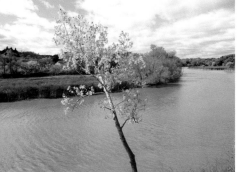
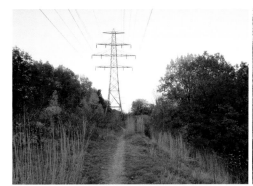
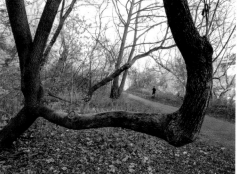

LAMBTON WOODS

Location:
along the west bank of the Humber River north of Dundas Street West and south of
James Gardens

Area: 9.4 ha

Key Natural Features:
- together, Lambton Woods and Lambton Park Prairie provide an excellent representation of the lower to middle Humber River valley in the City of Toronto; representation includes glacial Lake Iroquois shallow water sands visible in the northern portion of the park
- a portion of the terrace at Lambton Woods is bedrock-controlled as shown by outcrops along a small unnamed creek in the southern portion (one of the few places in Toronto where bedrock is exposed)
- exceptionally rich mixed woodland containing some tamarack and a remnant of a cedar bog
- exceptional bird viewing location
- parklands, valley slopes, and portions of adjacent James Gardens are part of Lambton Woods ESA
- multi-use trails

Key Habitats:
- predominantly mixed deciduous forest and swamp with small open wetlands and successional communities

Key Species:
- southern part of the park includes mixed upland forests of sugar maple, eastern hemlock, and white birch on steep slopes that grade into a large area of groundwater discharge dominated by balsam poplar, tamarack, yellow birch, and abundant skunk cabbage
- one of the best places to find eastern screech-owl and a variety of woodpecker species year-round; great horned owl, wood duck, wood thrush, rose-breasted grosbeak, and both species of cuckoo also breed here
- five area-sensitive bird species have been noted here in the breeding season: brown creeper, American redstart, hairy woodpecker, least flycatcher, and scarlet tanager
- sora rail, a reclusive bird found in wetland habitats, has been noted in marshy openings in the breeding season

ROWNTREE MILLS PARK

Location:
along the Humber River, between Islington Avenue and Kipling Avenue, north of
Finch Avenue West

Area: 92.1 ha

Key Natural Features:
- diversity of vegetation is fostered by varied topography: upper and middle slopes primarily support sugar maple and oak forests supplemented by plantations; lower slopes and the bottomlands are covered with lowland forests, deciduous swamps, and shallow marshes; standing water is present within the marsh area in spring
- pond, wetlands, and an old oxbow support plants characteristic of cool wetlands
- ideal location for birdwatching
- one of the most important breeding habitats for amphibians within Toronto
- Rowntree Mill Swamp ESA contains areas of forest interior (more than 100 m from edge), which is rare in Toronto
- multi-use trails

Key Habitats:
- deciduous forest together with high-quality swamp and marsh
- amphibian breeding habitat and important linkage between foraging and breeding habitat for frogs

Key Species:
- endangered butternut trees
- American toad, green frog, wood frog (and possibly northern leopard frog)
- wetland-dependent bird species include common yellowthroat and red-winged blackbird

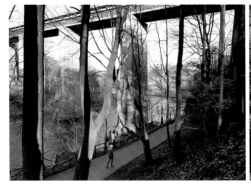
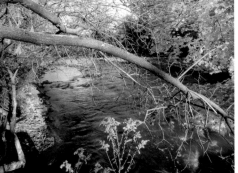
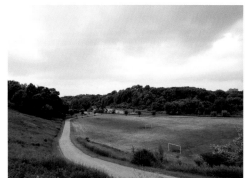
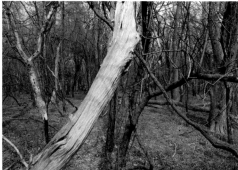

SOUTH HUMBER PARK

Location:
on west bank of the Humber River across from Humber Marshes, just north of the Humber Wastewater Treatment Plant

Area: 17.7 ha

Key Natural Features:
- remnant black-oak savannah, a provincially and globally rare vegetation community, with rare white sassafras in the northwest corner of the park
- scenic views of Humber Marshes
- savannah area is designated as Sassafras Site ESA
- multi-use trails

Key Habitats:
- deciduous forest

Key Species:
- open-grown black oak with large patches of white sassafras in the understory and openings dominated by little bluestem
- birds characteristic of successional habitats in urban settings such as gray catbird and American goldfinch, forest-sensitive species such as red-eyed vireo, and riparian species of young forest habitats such as blue-gray gnatcatcher

WEST HUMBER PARKLAND AND SUMMERLEA PARK

Location:
near the junction of the Humber River's east and west branches and Emery Creek, including Summerlea Park

Area: 83.6 ha

Key Natural Features:
- naturalized valley
- wildflower naturalization project
- includes Humberforks at Thistletown ESA, a large node of natural habitat at the junction of the east and west branches of the Humber River; Bluehaven Area ESA, which contains a colony of regionally rare Gray's sedge; and Thistletown Oxbow ESA, an unusual landform and important natural wetland on the Humber River's east branch
- high quality, unusual fluvial landforms/processes can be found at the Humberforks, including meanders, meander bars, a river mouth bar (at the junction of two rivers), sandbars with ripple marks, a well-developed sharp meander bend in process of being cut-off and by-passed, and an oxbow lake
- multi-use trails

Key Habitats:
- deciduous forest, successional forest, and marsh

Key Species:
- the areas of young riparian forest are notably large
- shrubby willows have stabilized the edge of the river
- riparian bird species such as warbling vireo, willow flycatcher, and yellow warbler; black- and yellow-billed cuckoo and rose-breasted grosbeak; cavity-nesting species such as hairy woodpecker and red-breasted nuthatch
- species generally restricted to the southern parts of the province take advantage of the warm microclimate here, including white trout lily, yellow-billed cuckoo, and Gray's sedge are
- oxbow supports breeding green frogs — one of the few natural breeding sites in the city

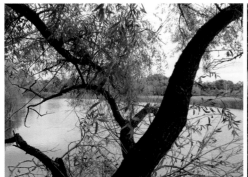
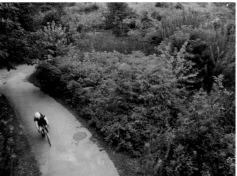
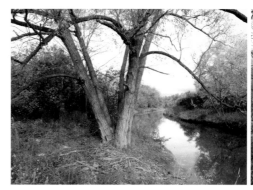
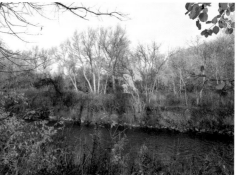

CREEKS AND LOST RIVERS

Toronto once had numerous creeks some of which have since been covered over or filled in. A notable example is where Queen's Park Crescent West makes a jog to avoid a watercourse no longer visible. Others, such as Etobicoke Creek, Mimico Creek and Black Creek have been altered or channelized and their entire drainage system has been changed by urbanization. While parkland is no longer continuous along these tributaries, the natural areas that still cling to their margins provide valuable park space and play an important role in facilitating the movement of both wildlife and people. Nordheimer and Cedarvale Ravines were originally linked to the Don River but have been separated by landfilling and urban development. Glen Stewart Park and Williamson Park Ravine were once part of little tree-filled valleys in which streams flowed south to the lake. These ravine remnants still provide an oasis of natural habitat, a much-loved place to walk, and an important stepping stone for migratory species moving north and south through the urban environment.

BLACK CREEK

Location:
a tributary of the Humber River flowing south from Steeles Avenue and intersecting the Humber River at the Lambton Golf and Country Club west of Scarlett Road

Length: 45 km (22 km within the City of Toronto)

Key Natural Features:
- vigorous successional growth has taken advantage of every potential area of soil. Even among rubble and other debris, there is a fairly continuous forest along the floodplain and adjacent slopes, which, though often dominated by non-native species, provides habitat for locally rare species of wetland and upland plants
- a few patches of native swamp with silver maple and slippery elm
- some upper slopes sustain oak and sugar maple forest
- portions of the creek provide aquatic habitat with riffles over cobbles and deeper pools
- Downsview Dells Park is a good example of an enduring natural area
- below Wilson Avenue most of the river is channelized. Channelized stretches, considered to be 'state of the art' in stream stabilization when installed, are now recognized to have negative effects such as loss of wetlands, decline of fish populations and increased flooding downstream
- multi-use trails in sections

Key Habitats:
- young forests of trembling aspen, Manitoba maple, willow, and cottonwood
- a few older forests of oak and sugar maple
- small fields at the top of slopes provide habitat for woodchuck

Key Species:
- feeding areas for great blue heron and black-crowned night-heron
- a few spring ephemeral flower species such as trout lily and Virginia waterleaf can be seen blooming in the spring
- swallows nesting under the bridges at Eglinton Avenue West feed on aerial insects along the creek

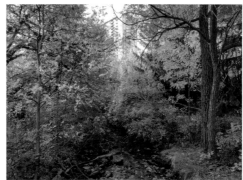
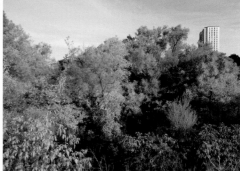

CEDARVALE RAVINE

Location:
straddling Bathurst Street between Vaughan Road and Spadina Road south of Eglinton Avenue West

Area: 7 ha

Key Natural Features:
- westernmost extension of the ravine that follows the course of Castle Frank Brook, a former tributary of the Don River
- deep, wooded ravine with oak-maple forests, coniferous forests composed of an unusual mixture of pine and hemlock, and small wetlands on soft, moist soils created by groundwater seepage trickling from the sides of the ravine
- sizable cattail marshes east of Bathurst Street
- northern section near Bathurst Street is relatively undisturbed
- multi-use trails

Key Habitats:
- varied topography has created diverse vegetation, with oak-maple forest on slopes and wetlands along the bottom of the ravine
- young trees and shrubby areas create habitat for thicket-nesting bird species such as house wren and yellow warbler
- small pools of water created by seepage persist into mid-summer and provide breeding habitat for American toads

Key Species:
- songbirds such as Baltimore oriole nest in slope forests, while wetland birds such as common yellowthroat, red-winged blackbird, and warbling vireo nest in cattail marshes and surrounding willows on the bottomlands
- American toads breed in small pools and spend the summer on sunny upper slopes before burying themselves in the sandy soils during the winter

CENTENNIAL PARK

Location:
at the northern limit of Etobicoke Creek in the City of Toronto between Rathburn Road and Eglinton Avenue West and west of Centennial Park Road

Area: 214.4 ha

Key Natural Features:
- largest park on Etobicoke Creek within the City of Toronto
- forested slopes along the narrow valley of Etobicoke Creek with a tableland component mainly consisting of recreational areas interspersed with small scrubby patches that have been allowed to naturalize, including a pond and a riparian area associated with a tributary of Etobicoke Creek (Elmcrest Creek)
- the hydro corridor between the Etobicoke Creek Valley and Mimico Creek Valley, although fragmented by roads, provides an important linkage and has resulted in a higher diversity of wildlife than is usually seen in small habitat patches
- a string of wetlands along Elmcrest Creek, as well as the edges of the pond, have recently been designated as Centennial Park Provincially Significant Wetland Complex
- known as a good spot for fishing
- multi-use trails

Key Habitats:
- deciduous forest and wetlands
- forests within the park still harbour southern flora species such as slippery elm, running strawberry bush, and narrow-leaved spring beauty
- the park formerly harboured some elements of tallgrass prairie and there are a few species reminiscent of prairie habitats such as prairie cordgrass and Virginia mountain mint; many other prairie species have been planted

Key Species:
- shagbark hickory forest and a patch of sugar maple–beech forest are unusual for the Etobicoke Creek valley
- scattered swamps featuring red ash and riparian forests with slippery elm and non-native crack willow on the valley bottom
- the pond supports reclusive wetland bird species unusual in Toronto such as green heron and Virginia rail

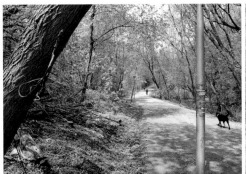
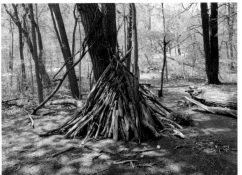

ETOBICOKE CREEK

Location:
flowing south of Eglinton Avenue West to Marie Curtis Park at Lake Ontario, forming part of the western boundary of the City of Toronto with the City of Mississauga

Length: 61 km (13 km within the City of Toronto)

Key Natural Features:
- sections of the valley north of Burnhamthorpe Road contain natural areas with mixed forest and are good places to observe birds during spring and fall migration
- Etobicoke Creek Ravine Park, west of the intersection of the West Mall and The Queensway, is one of the broadest habitat nodes along the creek south of Centennial Park and contains several regionally rare plants and plant communities, as well as gravel bars and an old oxbow that provides unusual habitat
- several of the broader areas of floodplain share space with Mississauga's natural areas; the size and quality of the creek valley are thus enhanced by having natural areas on both sides of the creek
- Marie Curtis Park at the creek mouth is a well-known spot for birding during spring and fall migration, with a high diversity of songbirds and waterfowl
- multi-use trails in Centennial Park and south of the Queen Elizabeth Way

Key Habitats:
- Manitoba maple, black walnut, and willow floodplains
- creek bed contains diverse aquatic habitats such as beaches, gravel bars, riffles, pools, oxbows, and shrubby flats
- slopes forested with oak and sugar maple, occasional hemlock in cooler microclimates
- scattered old fields and plantations

Key Species:
- some portions of the creek valley support unusual (in the context of Toronto) nesting bird species dependent on shrubby habitats, such as brown thrasher and blue-gray gnatcatcher
- the creek valley is a good feeding place for swallows — they can often be seen flying up and down the creek in search of flying insects — and its banks and bridges provide nesting habitat
- white-tailed deer make use of this corridor through Toronto and Mississauga and can be found almost all the way down to the mouth of the creek

GLEN STEWART PARK

Location:
starting at Kingston Road and extending south to the intersection of Glen Manor Drive East and Glen Manor Drive West

Area: 11 ha

Key Natural Features:
- small, deep, wooded ravine with wide diversity of plants and birds
- good location to observe migrating songbirds
- Ames Creek, a clean groundwater-fed stream, emerges just below Kingston Road in the wooded portion of the ravine and continues underground south of Glen Manor Drive East to Lake Ontario
- ravine slopes and valley lands are part of the Glen Stewart ESA
- walking trails

Key Habitats:
- predominantly deciduous forest with small areas of mixed forest
- sunny upper slopes support native dryland species such as oak and snowberry, while cool, moist lower slopes are colonized by maple and hemlock
- abundant seepage areas support wetland plants

Key Species:
- predominantly red oak and red maple with hemlock at the south end of ravine
- forest-dependent bird species such as wood thrush, great crested flycatcher, and red-eyed vireo
- Canada warbler has been noted singing from shrubby slopes late into the breeding season, even though it probably doesn't nest here
- cavity-nesting species such as downy woodpecker, northern flicker, white-breasted nuthatch, and hairy woodpecker

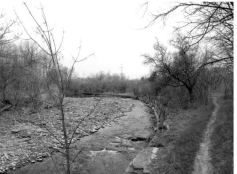
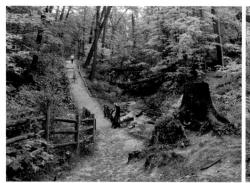
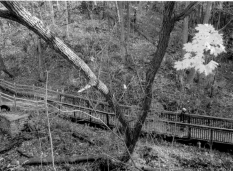

MIMICO CREEK

Location:
flowing south from near the intersections of highways 409 and 427 to Humber Bay Park at Lake Ontario

Length: 34 km (19 km within the City of Toronto)

Key Natural Features:
- a shallow creek flowing mostly over bedrock — one of the few places where limestone bedrock is exposed in the city
- the combination of riparian zone and exposed bedrock results in some landforms that are found almost nowhere else in the City of Toronto, including small areas of shrubby and treed cliff habitats, as well as river bars with sand, gravel, and cobble
- top of slopes supports some small patches of unusual oak forest
- bottomlands consist of a variety of lowland forests and swamps including both native and non-native species
- West Deane Park between Burnhamthorpe Road and Eglinton Avenue is still partially forested
- Humber Bay Butterfly Habitat, located in Humber Bay Park at the mouth of Mimico Creek, provides critical habitat for a variety of butterfly species and is an important staging area for migrating monarch butterflies
- Humber Bay Park is a good spot for fishing
- multi-use trails between Eglinton Avenue West and Burnhamthorpe Road and between Dundas Street West and Bloor Street West

Key Habitats:
- Humber Bay Butterfly Habitat incorporates diverse wildflowers, grasses, shrubs, and trees known to support a variety of butterfly species throughout their lifecycles
- McMillan Park and Humber Bay Park are stopovers for numerous migrating birds in spring and fall including diverse songbirds and waterfowl
- pockets of habitat remain in parks south of Bloor Street
- a few more sensitive fauna species are found between Bloor Street and The Queensway
- a hydro corridor links the Mimico Creek and Humber River corridors and adds diversity to these habitats

Key Species:
- monarch butterflies
- some more sensitive bird species such as eastern screech-owl, orchard oriole, and rose-breasted grosbeak breed along the creek south of Bloor Street West
- northern rough-winged swallows have been seen along the creek; this species uses holes in bluffs as nest sites
- mink have been seen along the creek south of Bloor Street West; these probably range throughout the creek in search of food
- white-tailed deer range along the creek, taking advantage of the cover the creek provides; they also take advantage of the linkage between Mimico Creek and the Humber River corridor

NORDHEIMER RAVINE AND ROYCROFT PARKLANDS

Location:
from St. Clair Avenue West south to Boulton Drive

Area: Nordheimer Ravine (3.2), Roycroft Parklands (1.1 ha)

Key Natural Features:
- a wooded ravine that follows the course of Castle Frank Brook, a former tributary of the Don River
- one of the finest stands of old oaks in the city
- good place to see spring ephemerals
- Glen Edyth and Roycroft wetlands are both TRCA wetland restoration projects
- forested ravine slopes are part of the Nordheimer Ravine ESA
- multi-use trails

Key Habitats:
- the deep ravine topography contributes to diversity, with mature deciduous forest along ravine slopes and lowland deciduous forest and swamp at the bottom of the ravine
- seepage areas along the ravine contribute to humid conditions at the bottom of the ravine
- a small woodland pond adds to habitat diversity

Key Species:
- dominant tree species include sugar maple with some Norway maple, white oak and red oak
- spring-flowering ephemeral plant species are abundant in some areas
- restored wetlands contain native plantings of species unusual in Toronto, including buttonbush, skullcap, lakebank sedge, and swamp milkweed
- forest-dependent birds such as eastern wood-pewee (a species of special concern in Ontario) and great crested flycatcher
- scarlet tanagers have been noted singing late into the spring, attempting to attract a mate, but they probably do not nest here
- signs of white-tailed deer have been observed in the ravine

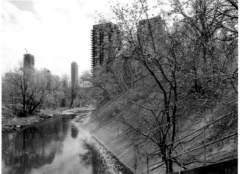

WILLIAMSON PARK RAVINE

Location:
running between the Canadian National rail line and Gerrard Street East

Area: 1.8 ha

Key Natural Features:
- one of four natural areas where it's still possible to see Small's Creek, a tributary that once ran through the east end of Toronto, originating near Danforth Avenue and Woodbine Avenue
- Small's Creek enters the ravine on the south side of the CN rail line and alternates between daylight and underground channels before disappearing again under Gerrard Street East
- deciduous forest on steep-banked ravine slopes
- park and ravine slopes are part of the Williamson Park ESA

Key Habitats:
- deep, sheltered ravine with oak forest on the drier, sunnier upper ravine slopes and non-native species such as Manitoba maple on the moist lower slopes
- dry, sunny openings provide habitat for native open meadow species such as arrow-leaved aster

Key Species:
- red oak on upper slopes support forest-dependent birds such as red-eyed vireo, white-breasted nuthatch, and Cooper's hawk
- wetland plant species such as touch-me-not and rice cutgrass occur on bottomlands
- numerous cavity-nesting bird species such as downy woodpecker and white-breasted nuthatch
- moist soils with abundant deadfall provide habitat for eastern red-backed salamanders, an indicator of higher quality forest
- white-tailed deer forage in the ravine — they may come into the area using the rail line at the north end, as the park is not big enough to support an isolated population

DON RIVER VALLEY

The Don River is one of Toronto's most distinctive physical features. Rising on the Oak Ridges Moraine, it flows south to the Keating Channel, which empties into Lake Ontario. Within the City of Toronto, the Don River watershed is mostly urbanized, while much of the flood-prone valley land of the main channels and remaining creeks is public parkland and transportation corridor. The Upper Don sustains some notable wetland habitats with many rare species and other significant features.

Below the Forks of the Don (the confluence of the East and West Don Rivers and Taylor Creek), the lower Don is a deep, wide valley — at the Bloor Street Viaduct, the valley is about 400 m wide while the river is only about 15 m wide. South of the Bloor Street Viaduct, the slow meandering river has been straightened and its banks reinforced — originally with wood piles, then steel, and now concrete. Efforts to renaturalize and restore the health of the river are reviving the lower Don's role as a natural greenspace corridor.

BETTY SUTHERLAND TRAIL PARK

Location:
south of Highway 401 along the east branch of the Don River west of Don Mills Road

Area: 30.1 ha

Key Natural Features:
- named after Betty Sutherland, a former member of city council and the TRCA, for her significant contribution to the development of regional parks systems
- contains the east side of the Black Grass Site ESA
- multi-use trail follows the meanders of the East Don River from Duncan Mill Road to Sheppard Avenue West

Key Habitats:
- deciduous forest with successional communities, marsh, and swamp
- open wetlands provide additional diversity for flora and fauna

Key Species:
- mature sugar maple
- riparian bird species such as red-winged blackbird, warbling vireo, and spotted sandpiper
- seepage areas provide habitat for rare wetland sedges

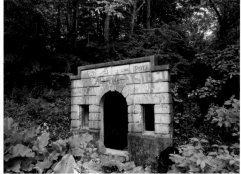

BROOKBANKS PARK

Location:
follows Deerlick Creek, south of York Mills Road and east of the Don Valley Parkway

Area: 26.6 ha

Key Natural Features:
- forested ravine along Deerlick Creek, a tributary to the East Don River
- abundant flowering spring plants
- most of the park is part of the Brookbanks Ravine ESA
- multi-use trails

Key Habitats:
- deciduous slope and bottomland forest

Key Species:
- sugar maple, yellow birch, American beech, and hemlock
- spring ephemerals such as yellow trout lily, trilliums, blue cohosh, and, occasionally, spring beauty, and hepatica
- cavity-nesting birds such as hairy woodpecker, white-breasted nuthatch, and red-breasted nuthatch
- large forest patches attract species such as American redstart
- eastern red-backed salamanders thrive in moist, rich soils with abundant woody debris

CHARLES SAURIOL CONSERVATION AREA

Location:
along the Don River East Branch from Lawrence Avenue East to the forks of the Don, between Victoria Park and the Don Valley Parkway

Area: 96.2 ha

Key Natural Features:
- named after Charles Sauriol, a passionate conservationist who worked to preserve the natural state of the Don River Valley
- large natural area with forested slopes surrounding the main river valley and several small tributaries
- this river section provides excellent examples of natural meandering in the Don River watershed within the City of Toronto, including a sharp, recurved meander bend
- good spot for viewing wildlife and interesting plants
- locally important refuge for wintering wildlife due to presence of conifers, such as eastern white cedar, and open water along creeks draining into the Don River
- includes the Wigmore Park Ravine ESA
- multi-use trails

Key Habitats:
- high-quality deciduous and mixed forest with small areas of bluff, swamp, and marsh, with a diverse, rich understory
- forest-interior habitat (100 m or more from the forest edge), which is rare in Toronto

Key Species:
- tree species include eastern white cedar, sugar maple, black cherry, eastern hemlock, red oak, and ironwood
- a wide variety of forest-dependent bird species including Cooper's hawk, great crested flycatcher, red-eyed vireo, rose-breasted grosbeak, wood thrush, and American redstart

CROTHERS WOODS

Location:
within the Lower Don Parklands on the west side of the Don Valley between Bayview Avenue and Millwood Road

Area: 52 ha

Key Natural Features:
- mature, relatively undisturbed forested slopes with habitat for birds and other wildlife
- many trees more than a century old, with parts of the forest in much the same condition as before European settlement
- provides a great example of the upper valley wall above the terrace of the Don River; this valley feature is cut into older waterborne deposits (deposited in a proto–Don River) overlain by Glacial Lake Iroquois sand
- a former landfill adjacent to the forest is being restored to provide diverse habitat
- wooded slopes are part of the Crothers Woods ESA
- natural environment trails

Key Habitats:
- mature and successional forests, wetlands, and meadows
- small areas of seepage along the bottom of the slopes

Key Species:
- high-quality sugar maple, American beech, red and white oak as well as beaked hazel, bitternut hickory, black walnut, and butternut (a provincially endangered tree species), with a rich understory
- herbaceous plants with a diversity that is unusual in Toronto region including bloodroot, jack-in-the-pulpit, mayapple, trillium, and trout lily
- forest-dependent birds such as eastern wood-pewee, great crested flycatcher, and red-tailed hawk
- eastern red-backed salamanders take advantage of fallen logs and moist soils

DAVID A. BALFOUR PARK AND VALE OF AVOCA

Location:
starting around St. Clair Avenue West, south of Mount Pleasant Cemetery, and running south to Mount Pleasant Road

Area: 21.3 ha

Key Natural Features:
- includes a forested ravine known as Vale of Avoca following the remnants of Yellow Creek, a former tributary of the Don River
- ravine areas are part of the Vale of Avoca ESA
- multi-use and natural environment trails

Key Habitats:
- predominantly deciduous forest with native species in the understory

Key Species:
- red oak, white oak, sugar maple, and black maple with an understory of witch hazel, a species with a southern distribution
- forest-dependent species such as red-eyed vireo, and cavity-nesting birds such as house wren, northern flicker, and downy woodpecker
- winter wren and American redstart can be heard in the early summer, indicating that these area-sensitive species are possibly breeding in the ravine
- eastern red-backed salamanders thrive in moist, rich soils with abundant woody debris

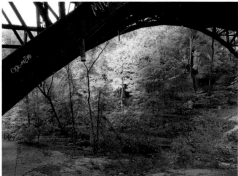
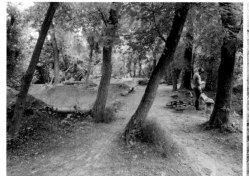
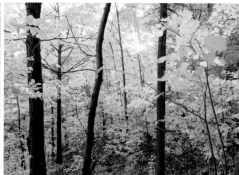

EARL BALES PARK

Location:
along the west branch of the Don River, south of Sheppard Avenue and east of Bathurst Street

Area: 51 ha

Key Natural Features:
• high-quality forested tablelands, slopes, and bottomlands
• mature black walnut stand in north end of park
• forested areas provide good habitat for birds and other wildlife
• southwest portion of the park is part of Earl Bales Woodlot ESA
• multi-use trails, including through the Woodlot ESA

Key Habitats:
• mature deciduous forest, lowland forest, and swamp
• rich, moist soils provide habitat for amphibians in the summer

Key Species:
• white pine, sugar maple, black maple (which has a Carolinian distribution), and American beech
• breeding forest birds such as eastern wood-pewee, rose-breasted grosbeak, great crested flycatcher, wood thrush (a species of special concern), pine warbler (a warbler that prefers mature conifers), and red-eyed vireo
• birds dependent on thickets and young woodlands, such as willow flycatcher and American redstart
• cavity-nesting birds such as pileated woodpecker, hairy woodpecker, downy woodpecker, red-breasted nuthatch, and white-breasted nuthatch
• eastern red-backed salamanders take advantage of fallen logs and moist soils

EAST DON PARKLAND

Location:
from Sheppard Avenue East to Steeles Avenue East between Leslie Street and Bayview Avenue along the East Don River and German Mills Creek

Area: 158.7 ha

Key Natural Features:
• a large, highly diverse natural area including wetlands, ponds, forested valley slopes, and successional and riparian areas
• excellent habitat for viewing wildlife and rare plant species, especially wetland species
• East Don Valley Swamp ESA, Williams ESA, and East Don Valley Provincially Significant Wetland Complex between Cummer Avenue and Sheppard Avenue East encompass a series of wetlands and old oxbows adjacent to the river
• multi-use trails

Key Habitats:
• wetlands including many types rare in Toronto such as cedar swamps, meadow and aquatic marsh, alder swale, yellow birch seepage slope, and cattail–bur-reed marsh
• much of the habitat is riparian, including poplars, willows, and dogwoods, with adjacent mature forested slopes

Key Species:
• wetland species such as narrow-leaved cattail, broad-leaved sedges, alder, and red osier dogwood
• forest species, with a rich understory, including sugar maple, eastern hemlock, and American beech, as well as white pine
• area-sensitive bird species such as belted kingfisher, hairy woodpecker, pileated woodpecker, Acadian flycatcher (considered endangered in Ontario and Canada), and yellow-billed cuckoo
• eastern red-backed salamanders thrive in the rich soils with abundant deadfall
• star-nosed moles dig tunnels along the wetland edges
• several frog and toad species have been seen here, and the area contains habitat for breeding, foraging, and overwintering
• green heron, great blue heron, and black-crowned night-heron forage in this swampy area and may occasionally breed here

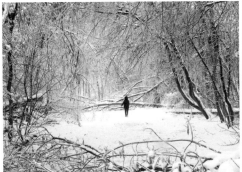
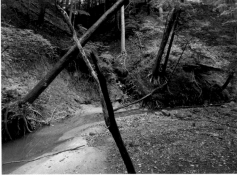
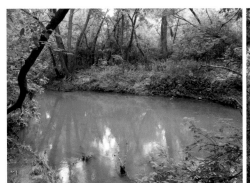

E.T. SETON PARK

Location:
along the west branch of the Don River, west of Don Mills Road stretching south from Eglinton Avenue East to the Forks of the Don at Don Mills Road

Area: 121.2 ha

Key Natural Features:
- named after Ernest Thompson Seton, a Scottish-Canadian author, wildlife artist, and founding member of Boy Scouts of America
- large natural area that is part of a chain of parks that forms a forested corridor extending from the Lower Don Parklands upstream through the Sunnybrook Park Complex
- high-quality forest and wetlands
- range of wildlife-viewing opportunities, including songbird meadow with bird boxes
- forest and wetlands areas are part of E.T. Seton Park ESA
- multi-use trail that connects to Taylor Creek Park and the Lower Don Trail

Key Habitats:
- forest, swamp, and marsh
- forest-interior habitat (100 m or more from the forest edge), which is rare in the city, may occur in the northern and southern portions of the park

Key Species:
- sugar maple, red oak, white pine, and red pine
- notable breeding bird species include great horned owl, wood thrush, area-sensitive species such as veery, scarlet tanager, American redstart, and two species of cuckoo

LOWER DON PARKLANDS

Location:
below the forks of the Don (at Don Mills Road) and extending along the Don River to the Keating Channel at Lake Shore Boulevard, including the Don Valley Brick Works and Crothers Woods

Area: 98.3 ha

Key Natural Features:
- a place of settlement, agriculture, industry, and now regeneration
- Ashbridge's Marsh, at the mouth of the Don, once one of the largest freshwater coastal wetlands in eastern Canada, was filled in and much of it was reshaped into an industrial and transportation corridor
- a catalyst for Bringing Back the Don, a subwatershed plan to reconnect the river and its surrounding natural environment
- includes Don Valley Brick Works Park, a former quarry and now refurbished industrial site adjacent to naturalized ponds surrounded by forested slopes; north face of the quarry contains Pleistocene glacial and fossil deposits and is designated as an ESA and a provincially significant Earth Science Area of Natural and Scientific Interest
- the Don Valley Brick Works Park is an internationally significant public park, operated by the City of Toronto with assistance from the TRCA and the Weston Foundation, located next to the Evergreen Brick Works complex, which is operated by the City of Toronto and the Evergreen Foundation and hosts environmental and community programming
- Chester Springs Marsh, designed to provide habitat for many native wildlife species, covers 3 ha and is divided into two parts separated by the Don River: the eastern side borders the Lower Don Trail and is open to the public, and the part west of the river, largely inaccessible, provides a protected habitat for wetland wildlife
- section of valley south from Prince Edward Viaduct to Riverdale Pedestrian Bridge is designated as Don Valley (Central Section) ESA
- multi-use trails

Key Habitats:
- deciduous forests, restored wetlands, successional areas, thickets, and meadows
- the river within this area contains diverse aquatic and shoreline habitats, with gravel bars, beaches, and sandy banks, and a variety of in-stream habitats, including riffles and pools

Key Species:
- dominated by maples, willows, and poplars, with many non-native species present
- significant flora restored within Chester Springs Marsh and the surrounding area
- breeding riparian birds and birds that nest in thickets and young woodlands, such as warbling vireo, cedar waxwing, indigo bunting, American goldfinch, and yellow warbler
- wood ducks nest in cavities in large willows and nest boxes and raise broods along the Don River
- tree swallows nest in tree cavities, and cliff swallows nest under bridges

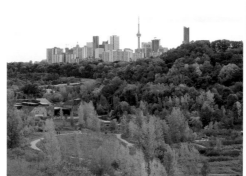
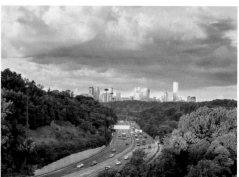

MOORE PARK RAVINE

Location:
running from Moore Avenue just south of Mount Pleasant Cemetery to the Don Valley Brick Works

Area: 6 ha

Key Natural Features:
- ravine following Mud Creek, a tributary of the Don River
- thickly wooded slopes and wetlands provide good opportunities for viewing wildlife
- ravine bottom supports moist forest communities
- exceptional bird viewing location due to funnelling effect of the Moore Park Ravine coupled with the wide variety of trees in nearby Mount Pleasant Cemetery
- high diversity of plants
- valley and adjacent slopes are part of the Moore Park Ravine ESA
- multi-use trails

Key Habitats:
- predominantly deciduous forest with a rich understory along with small areas of mixed forest, successional areas, marsh, and swamp
- a few prairie indicator species present on upper slopes such as New Jersey tea, yellow pimpernel, and showy tick trefoil

Key Species:
- red and white oak, and sugar maple
- a wide variety of migrating warblers and passerines in spring
- breeding birds include forest-dependent species such as red-eyed vireo, eastern wood-peewee (a species of special concern), great crested flycatcher, and white-breasted nuthatch
- wood thrush, a forest bird of special concern that prefers mature forests, can be heard in the ravine in early summer

ROSEDALE RAVINE LANDS

Location:
running along the north and south sides of Rosedale Valley Road between Mount Pleasant Road and Bayview Avenue

Area: 14.8 ha

Key Natural Features:
- ravine was an early barrier to northward development of the city and still clearly separates Rosedale neighbourhood from the development to the south
- popular for walking and cycling
- wooded ravine with habitat for birds and wildlife
- ravine follows the course of former Castle Frank Brook, a former tributary of the Don River
- parklands and adjacent slopes are part of the Rosedale Valley ESA
- multi-use trails

Key Habitats:
- predominantly deciduous forest on slopes with successional areas at bottom of ravine

Key Species:
- forest tree species include red oak, white oak, and sugar maple
- bird species such as northern cardinal, Baltimore oriole, wood thrush, gray catbird, house wren, northern flicker, and downy woodpecker
- wood thrush, a species that prefers mature forest habitat, can be heard here in the early summer
- a notable area for migrating songbirds
- non-native species are prevalent but some sensitive forest understory species are still present

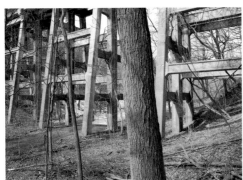 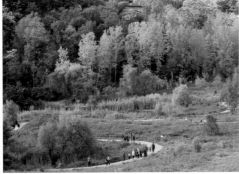 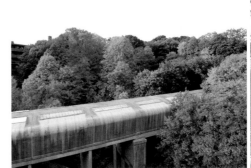 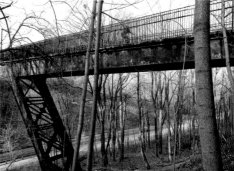

SUNNYBROOK PARK COMPLEX

Location:
at the confluence of Wilket Creek, the Don River, west branch, and Burke Brook, between Bayview Avenue and Leslie Street, north of Eglinton Avenue East

Area: Sunnybrook Park (90.3 ha), Wilket Creek Park (44.7 ha), Glendon Forest (20.2 ha), and Serena Gundy Park (15.4 ha)

Key Natural Features:
- intersection of three large forested areas that are designated as ESAs: Glendon Forest ESA to the northwest, Wilket Creek Forest ESA to the northeast, and Burke Brooke Forest ESA to the west
- together this complex of parks makes up one of the largest greenspaces in central Toronto and is part of a contiguous corridor that extends south through E.T. Seton Park to the Lower Don Parklands
- like many of Toronto's ravines, much of the land in Sunnybrook Park and its neighbouring parks was farmland with just a few large trees less than a century ago; since that time, large areas of the park have regenerated or been restored to natural forest, especially the valley slopes and along the West Don River and its tributaries
- stopover area for migrating songbirds
- stately old white pines dot the treeline of Glendon Forest
- soon after snow melts, forest floors are carpeted with spring wildflowers, such as trilliums and trout lilies, especially along Wilket Creek
- Wilket Creek is an unusual and high-quality example of a high-gradient stream, dissecting surficial soil materials
- north-facing slopes of Burke Brook retain some old hemlock trees mixed with sugar maples and oaks
- multi-use trails

Key Habitats:
- diverse mixture of forest, bluff, swamp, and marsh communities
- a rich forest understory provides habitat for a highly diverse woodland plant assemblage

Key Species:
- forest tree species include sugar maple, red and bur oak, white pine, American beech, and eastern hemlock
- notable breeding bird species include great horned owl, wood thrush, and birds that can only breed in larger forests such as veery, scarlet tanager, American redstart and two species of cuckoo
- hairy-tailed mole tunnels can be seen in the sandy soils in some areas

TAYLOR CREEK

Location:
arising near Sheppard Avenue East and Victoria Park Avenue and flowing to the forks of the Don at Don Mills Road

Length: 16 km

Key Natural Features:
- a major tributary of the Don River, which is mostly channelized in upper reaches
- largest natural areas are Warden Woods (37.5 ha) and Taylor Creek Park (67.6 ha)
- Warden Woods ESA, between Warden Avenue and Victoria Park Avenue, contains a steep valley along the creek with deciduous slope forests and bottomland Manitoba maple lowland forest
- Taylor Creek Park ESA, between Dawes Roads and O'Connor Drive, contains oak and sugar maple on slopes with a variety of wetlands and lowland forests along the creek
- multi-use trails

Key Habitats:
- mature deciduous forest on slopes with successional areas in bottomlands

Key Species:
- sugar maple together with red oak, American beech, white ash, and ironwood
- a high diversity of wetland plants, including bur-reeds, horsetails, cotton-grass, and rushes
- wetland and riparian birds such as yellow warbler, red-winged blackbird, mallard, belted kingfisher, rough-winged swallow, and eastern kingbird; forest-dependent species such as eastern wood-pewee and great crested flycatcher; area-sensitive species such as Cooper's hawk, pileated woodpecker, and yellow-billed cuckoo

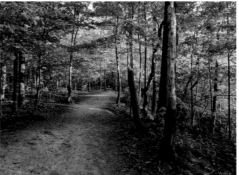

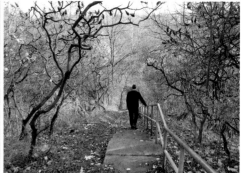

TODMORDEN MILLS

Location:
east side of the lower Don River with access from Pottery Road

Area: 9.2 ha

Key Natural Features:
- restored natural area and wetlands are part of the Todmorden Mills Wildflower Preserve
- the preserve is a nature park that was started by Charles Sauriol and horticulturist Dave Money
- diverse plants, including abundant spring ephemerals
- forest and wetland areas are part of the Todmorden Mills ESA
- interpretive nature trail that passes by wetlands and former oxbow of the Don River

Key Habitats:
- deciduous and successional forest and wetlands
- the steep, wet slope adjacent to Chester Hill Road is the least disturbed and sustains the greatest number of native trees; at least three seepage areas have been noted at the base of the slopes
- small ponds are present within the site; the bottomlands along the oxbow and the lower slopes support several significant flora species

Key Species:
- upland forest species include white ash, white pine, and sugar maple
- forested wetland species include white cedar, black ash, ferns, and dogwood
- wetland plants include sedges, blue flag iris, and marsh marigold
- spring ephemerals such as bloodroot and trilliums
- birds of successional and riparian areas such as yellow warbler, warbling vireo, and song sparrow
- rare birds such as black-crowned night-heron forage along the edges of the pond and oxbow

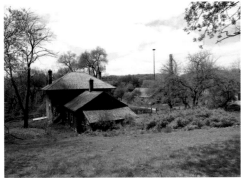 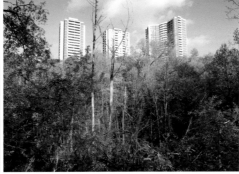

ROUGE RIVER VALLEY AND HIGHLAND CREEK

The Rouge Valley Area is an exceptional forested ravine complex along the Rouge and Little Rouge Rivers. It forms part of a contiguous green space corridor that extends from Lake Ontario to the headwaters of the Rouge in the Oak Ridges Moraine and facilitates species movement through one of the most urbanized areas in North America. Over 79 km² of land in the Rouge Valley, including 1,448 ha in the City of Toronto, will be included in Canada's first national park within an urban area.

Just west of the Rouge, the Highland Creek watershed is almost entirely contained within the City of Toronto. Although the watershed is heavily urbanized, large remnant forests, wetlands and meadows remain, mostly below Highway 401.

COLONEL DANFORTH PARK

Location:
extending south from University of Toronto (Scarborough Campus) to Lawrence Avenue East and Meadowvale Road

Area: 55 ha

Key Natural Features:
- extensive mature forest and wetlands
- part of a large contiguous natural area in the Highland Creek corridor
- high abundance of native species, especially south of old Kingston Road
- good place to watch fall salmon run and spring rainbow trout run
- Highland Forest/Morningside Park Forest and Highland Creek West ESA
- multi-use trails

Key Habitats:
- primarily deciduous forest, with small areas of coniferous forest, marsh, and swamp

Key Species:
- forested slopes dominated by hemlock on cool east-facing slopes and deciduous forest on warmer west-facing slopes; floodplain swamps dominated by Manitoba maple and tamarack
- amphibians such as salamanders

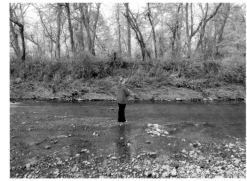

LOWER HIGHLAND CREEK PARKLAND

Location:
south of Lawrence Avenue East to Lake Ontario east of Beechgrove Drive
and west of Bridgeport Drive

Area: 34.5 ha

Key Natural Features:
- wetlands framed by forested ravine slopes
- part of a large contiguous natural area in the Highland Creek corridor
- varied topography and vegetation gives rise to rich diversity of wildlife
- high diversity of breeding birds, including forest-dependent, wetland-dependent, and Carolinian species
- good place to watch fall salmon run and spring rainbow trout run
- much of the floodplain below Lawrence Avenue East, known as Stephenson's Swamp, is designated as an ESA
- Highland Creek Provincially Significant Wetland Complex
- multi-use trails

Key Habitats:
- deciduous and coniferous forest, marsh, and swamp
- interior forest habitat (100 m or more from the forest edge), which is rare in the city
- vernal pooling

Key Species:
- red oak, eastern hemlock, white pine, and sugar maple dominate the hillsides
- crack willow and pockets of cattail marshes grow in the moist soils of the floodplain
- forest dependent, area-sensitive birds include veery, winter wren, brown creeper, hairy woodpecker, white-breasted nuthatch
- extensive cattail marshes provide habitat for wetland dependent species such as swamp sparrow and green heron
- Carolinian species include orchard oriole and Carolina wren
- wetland mammals, such as beaver and muskrat, thrive here
- vernal pools support breeding woodland salamanders that then migrate to woodlands, where they depend on burrows of small mammals to descend underground

MORNINGSIDE PARK

Location:
west of Morningside Avenue between Ellesmere Road and Lawrence Avenue East, surrounding the forks of East and West Highland Creek

Area: 217.5 ha

Key Natural Features:
- largest contiguous forested area in the Highland Creek watershed
- relatively undisturbed tracts of coniferous and mixed forest
- varied topography supports a broad range of forest habitats in a small area
- white cedar swamp with one of the few stands of tamarack in the city
- steep bluffs up to 30 m in height along Highland Creek
- wide diversity of birds
- pollinator garden and sandy soil beside river are good places to observe bee species
- good place to watch fall salmon run and spring rainbow trout run
- Highland Forest/Morningside Park Forest and Highland Creek West ESA
- Highland Creek Swamp Provincial Candidate Life Science Area of Natural and Scientific Interest
- multi-use trails
- cross-country skiing in winter

Key Habitats:
- eastern and southern slopes grade from sugar maple and American beech forest with some black cherry, white birch, white pine, and hop-hornbeam to upper slopes with open-grown red oak and white cedar with some chokecherry
- north-facing slopes are cloaked in pure stands of eastern hemlock
- west-facing slopes are erosion slopes where Manitoba maple and several species of willow grow well in the disturbed soils
- areas of cold groundwater seepage on bottomlands and on lower slopes support black peaty soils with undisturbed wetlands dominated by skunk cabbage, as well as moist forests, with many rare, sensitive wetland species of cool northern habitats
- important amphibian breeding habitat

Key Species:
- forest tree species include sugar maple, American beech, eastern white cedar, and balsam fir
- forest-dependent bird species such as winter wren, scarlet tanager, eastern screech-owl, American redstart, magnolia warbler, and ovenbird
- bank swallows and belted kingfisher nest in holes in the bluffs along the river

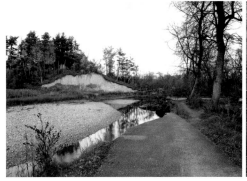

ROUGE PARK (CITY OF TORONTO PORTION)

Location:
along the border of Toronto and Pickering, extending from Lake Ontario to Steeles Avenue East and encompassing the Rouge and Little Rouge River Valleys and surrounding tablelands, including Rouge Marsh Area, Finch Meander Area, and Vista Trail Area

Area: 1,132 ha

Key Natural Features:
- largest natural area within the city and Toronto's largest park
- soon to be part of Canada's first national urban park
- rich biodiversity due to location on the northern edge of the eastern deciduous forest region, also known as the Carolinian life zone
- diverse habitats from marsh at the river mouth to eastern white pine forest near Highway 401, to the Scarborough-Pickering Townline Swamp, agricultural fields near Plug Hat Road, and deciduous forests in Woodlands Park near Steeles Avenue East
- richest diversity of breeding birds anywhere in the city, including forest interior species
- highest recorded amphibian and reptile biodiversity in Toronto
- 16 ESAs, one provincially significant life science Area of Natural and Scientific Interest, two provincially significant earth science Areas of Natural and Scientific Interest, and three Provincially Significant Wetland Complexes
- hiking trails
- Rouge Valley Conservation Centre offers interpretive walks and nature-based educational programs

Key Habitats:
- mature upland forests, successional forests, coastal wetlands, and meadows
- interior forest habitat (100 m or more from the forest edge), which is rare in the city
- one of the few amphibian breeding habitats in Toronto
- significant fish habitat, especially for reproduction
- high bluffs support breeding swallows, frequently seen feeding on aerial insects along the river
- open-water habitat within the Townline Swamp provides habitat for river otter and is likely the only place in Toronto where this species persists

Key Species:
- approximately 845 flora species, including species that are nationally and regionally rare
- 244 bird species, including 116 breeding birds such as northern goshawk, broad-winged hawk, ruffed grouse, Acadian flycatcher, blue-headed vireo, winter wren, black-throated green warbler, ovenbird, northern waterthrush, and scarlet tanager
- 29 mammal species, including northern flying squirrel
- 12 amphibian species, including blue-spotted salamander
- 9 reptile species, including Blanding's turtle and northern map turtle
- 60 fish species, including bowfin and northern pike
- white-tailed deer range throughout the Rouge Valley

ROUGE MARSH AREA

Location:
at the mouth of the Rouge River at Lake Ontario

Key Natural Features:
- largest lakeshore marsh in the Greater Toronto Area
- shares its natural area with the Town of Pickering; the natural area size and diversity is enhanced by having adjacent natural areas within two jurisdictions
- extensive marshes offer wildlife-viewing opportunities
- high diversity of native plants, including regionally and provincially rare plant species
- excellent location to view waterfowl, shorebirds, and land birds during migration
- sport fishing
- Rouge Marsh Area ESA and Rouge River Marshes Provincially Significant Wetland Complex
- multi-use trail along Lake Ontario shoreline

Key Habitats:
- marsh surrounded by deciduous and mixed forest and swamp
- one of the few breeding areas for amphibians in Toronto, including species that need multiple habitat types such as vernal pools and upland forests
- important fish habitat and breeding area
- includes a river-mouth sandbar that harbours rare species specific to sand-dune and beach habitats
- footbridge provides nesting habitat for cliff swallows

Key Species:
- foraging colonial birds such as great blue heron, lesser egret, lesser yellowlegs
- breeding birds include reclusive and unusual species of large marshes — Virginia rail, American bittern, blue-winged teal, least bittern, American coot, common moorhen, black tern, and marsh wren
- green frog, wood frog, northern leopard frog, and American toad
- fish species such as small- and large-mouth bass, Chinook salmon, and northern pike

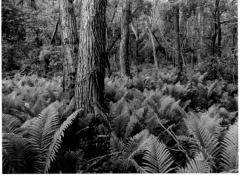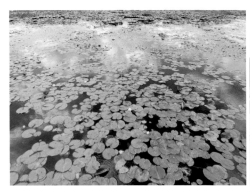

FINCH MEANDER AREA

Location:
along Rouge River near the intersection of Old Finch Avenue and Sewells Road

Key Natural Features:
• large, well displayed meander bend in the Rouge River — one of the best examples of fluvial process in Toronto area
• bluffs associated with valley rise 40 m above the river
• nearby Reesor Woodlot (east of Reesor Road) is dominated by hemlock, white pine, and cedar and has a cedar swamp along the stream
• Finch Avenue Meander/Sewells Forest/Reesor Woodlot ESA
• natural environment trails

Key Habitats:
• deciduous forest with areas of mixed forest, swamp, and bluff
• some rare vegetation community types including swamp and lowland forest dominated by bur oak

Key Species:
• variety of birds, including white-breasted nuthatch, hairy woodpecker, and Toronto rarities such as scarlet tanager and brown creeper
• bank swallows, now considered provincially threatened, nest in bluffs
• high diversity of cavity-nesting species
• northern leopard frog, gray treefrog, and wood frog breed in vernal pools along the valley

VISTA TRAIL AREA

Location:
along Little Rouge River, north of Twyn Rivers Drive

Key Natural Features:
• panoramic views of wooded tablelands, valley slopes, and towering open bluffs along the Little Rouge River
• former Beare Road landfill and future city park, located on the east side of the river, can be seen as a large hill in the distance
• natural environment trails and lookout

Key Habitats:
• predominantly deciduous and mixed forest, successional woodlands/savannahs, with small areas of coniferous forest, marsh, and swamp

Key Species:
• tableland and valley slopes include sugar maple with red oak, American beech, ironwood, and other hardwoods, and eastern hemlock
• floodplain is characterized by crack/hybrid willow, Manitoba maple, poplar, white and green ash, Scotch pine, and white cedar
• less-common bird species such as eastern towhee and blue-winged warbler rely on shrubby habitats, while extensive forests support pileated woodpecker, white-breasted nuthatch, and scarlet tanager

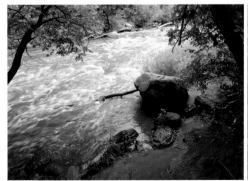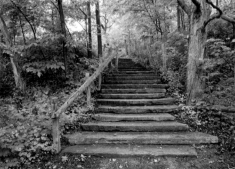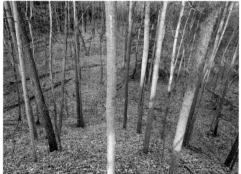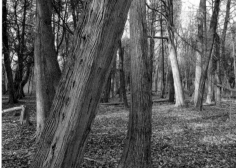

SOURCES AND SUGGESTED RESOURCES

City of Toronto Biodiversity Series: toronto.ca/planning/environment

City of Toronto Environmentally Significant Areas: toronto.ca/planning/environment

City of Toronto Parks and Trails: toronto.ca/parks

Goodwin, Clive. *A Bird-Finding Guide to Ontario*. Toronto: University of Toronto Press, 1995.

High Park Nature: highparknature.org

Kidd, Joanna. *Nature on the Toronto Islands: An Explorer's Guide.* Toronto: Toronto Parks and Recreation, 2001.

Mississaugas of the New Credit First Nation Toronto Purchase Specific Claim: www.newcreditfirstnation.com/uploads/1/8/1/4/18145011/torontopurchasebkltsm.pdf

North-South Environmental, Inc., Dougan & Associates and Beacon Environmental. *Environmentally Significant Areas (ESAs) in the City of Toronto.* Prepared for the City of Toronto, 2012.

Remiz, Frank. *Toronto's Geology (Including History, Biota, and High Park).* 2012. www.torontofieldnaturalists.org/documents/TorontoGeology-2012Jan24_web.pdf

Rouge National Urban Park: pc.gc.ca/eng/pn-np/on/rouge/index.aspx

Rouge Park: rougepark.com

Rouge Valley Naturalists : rougevalleynaturalists.com

Tommy Thompson Park: tommythompsonpark.ca/home/geninfo.dot

Toronto and Region Conservation Authority. The Living City: Terrestrial Natural Heritage. https://trca.ca/conservation/greenspace-management/terrestrial-natural-heritage/.

Toronto Entomologists' Association: ontarioinsects.org

Toronto Field Naturalists: torontofieldnaturalists.org

Toronto Ornithological Club: torontobirding.ca

Warren, William W. *History of the Ojibway People.* St. Paul: Minnesota Historical Society, 2009.

Williams, Ronald E. *Toronto: An Illustrated History of Its First 12,000 Years.* Toronto: Lorimer, 2008.

ACKNOWLEDGEMENTS

Books like this one often seem like straightforward objects that make themselves. In fact, they are intensely collaborative efforts which involve multifaceted problem-solving by many individuals over an extended time period. Further, a subject like this one would be impossible to address in a meaningful way without the passion, vision, and commitment of those who oversee the parklands on a day-to-day basis. I would like to thank the City of Toronto Parks, Forestry, and Recreation (PFR) and City Planning divisions for their initiation and support of this important investigation of the city I live in and care deeply about. Specifically, Jane Weninger, senior environmental planner, City Planning, who worked tirelessly leading the liaison group and made significant contributions to the concept and content of the book. Former PFR manager Leslie Coates deserves a big nod for initially proposing this idea after seizing upon a recently completed report on the ESAs. Garth Armour, PFR manager, has served as a crucial advisor — along with Jane Welsh, project manager, City Planning — in project development. My thanks also go to all the City of Toronto staff who have provided direction and resources and review at various points over the past few years.

A heartfelt thank you to the writers who have not only crafted compelling texts offering rich perspectives on the importance and meaning of Toronto's parklands but also created new sources of inspiration for my own work. In addition to their writings, Anne Michaels, Michael Mitchell, and Wayne Reeves generously contributed their advice about content along the way.

I must acknowledge the ongoing support of Ryerson University, where I am encouraged and supported to take on investigations like this one. At the School of Image Arts, I am fortunate to draw from a talented pool of artists/students who have assisted me: thank you, Ben Freedman, Alexa Phillips, Julianna Damer, and Parker Kay. Most importantly, I need to recognize the effort and input of Claire Harvie, who has played a key role from the early to final stages of this endeavour and whose critical eye, honesty, and hard work I have relied upon.

It has been a delight to work with everyone at ECW Press, and I will miss my visits to their calm (and pretty cool) east-end offices. I thank publishers Jack David and David Caron for their early support and ongoing encouragement. Editor Jen Knoch has been a touchstone of professionalism, playing a crucial role in her work with the writers, all while managing to keep this complex project on track. Production manager Troy Cunningham and publicist Susannah Ames have also played important supporting roles. I am indebted to Sunil Bhandari and Julia Commisso of Bhandari & Plater Inc., who have given their all towards solving the endless problems shaping this complex story from a visual perspective.

I need to express my gratitude to my wife, Debra Friedman, as well as friends and colleagues whose advice, suggestions, and help I depend on. Thank you, Linda Eerme for your work on early concept, editorial, and design elements in the project's first phase. Thank you, Jay Teitel for your editorial help, and thanks to David Harris, Peter Higdon, Bonnie Rubenstein, Stephen Bulger, Geoffrey James, Sophie Hackett, and Maia Sutnik for your feedback and friendly counsel.

Finally, I must thank all those friends of the parklands: groups, organizations, and individuals that I either sought out or encountered on one of my many rambles. In each instance, I made surprising discoveries about places I thought I knew and understood.

Robert Burley

CONTRIBUTOR BIOGRAPHIES

George Elliott Clarke

The fourth poet laureate of Toronto (2012–15) and seventh parliamentary poet laureate (2016–17), George Elliott Clarke is a revered poet. He has invented the term "Africadian" and pioneered the study of African-Canadian literature. He is a noted artist in song, drama, fiction, screenplay, essays, and poetry. Now teaching African-Canadian literature at the University of Toronto, Clarke has taught at Duke, McGill, the University of British Columbia, and Harvard. He has received numerous literary awards, eight honourary doctorates, plus appointments to the Order of Nova Scotia and the Order of Canada.

Anne Michaels

Anne Michaels is a novelist and poet. Her books are translated and published in over forty-five countries and have won dozens of international awards, including the Orange Prize, the Guardian Fiction Prize, and the Lannan Award for Fiction. She has been shortlisted for the Giller Prize (twice), the Governor-General's Award, and longlisted for the IMPAC Award (twice). Her novel *Fugitive Pieces* was adapted as a feature film. Her latest book of poetry, *Correspondences*, was shortlisted for the Griffin Poetry Prize in 2014. She is Toronto's current poet laureate.

Michael Mitchell

Michael Mitchell is a Toronto-based writer, photographer, and filmmaker. Over the past 40 years, he has contributed to numerous art journals, magazines, museum catalogues, and books, as both a writer and photographer. His photographic work is in numerous private and corporate collections as well as the Art Gallery of Ontario, the National Gallery of Canada, and Sweden's Museum of Modern Art. He has been a kayaker for many years, and his award-winning Arctic film *Caribou Kayak* is distributed by the NFB. He is a graduate of both the University of Toronto and Ryerson.

Wayne Reeves

Wayne Reeves is chief curator for City of Toronto Museums & Heritage Services. He manages the city's artifact, fine art, and archaeological collections and helps shape major exhibitions at Toronto's ten community museums. He is also a historical geographer who has written and lectured extensively about the long-term interplay between nature and culture in Toronto, including the establishment and evolution of the city's public greenspaces. He contributed essays to *Special Places: The Changing Ecosystems of the Toronto Region* and *GreenTOpia: Towards a Sustainable Toronto*, and was co-editor of *HTO: Toronto's Water from Lake Iroquois to Lost Rivers to Low-flow Toilets*.

Leanne Betasamosake Simpson

Leanne Betasamosake Simpson is a renowned Michi Saagiig Nishnaabeg musician, writer, and academic who has been widely recognized as one of the most compelling Indigenous voices of her generation. She is a band member of Alderville First Nation. Leanne is the author of four books, including *This Accident of Being Lost, Islands of Decolonial Love,* and *Dancing on Our Turtle's Back,* and she is the editor of three anthologies. Leanne is faculty at the Dechinta Centre for Research and Learning in Denendeh and has lectured at a variety of universities in Canada and the United States. She holds a Ph.D. from the University of Manitoba.

Alissa York

Alissa York's internationally acclaimed novels include *Mercy, Effigy* (shortlisted for the Scotiabank Giller Prize), *Fauna* and, most recently, *The Naturalist*. She is also the author of the short fiction collection *Any Given Power*, which contains stories that have won the Journey Prize and the Bronwen Wallace Award. Her essays and articles have appeared the *Guardian, The Globe and Mail, Brick* magazine, and elsewhere. York has lived all over Canada and now makes her home in Toronto with her husband, artist Clive Holden.

"Perhaps it will be the city that reawakens our understanding and appreciation of nature, in all its teeming, unpredictable complexity."

Jane Jacobs, *The Greening of the City*, New York Times, 2004